IMAGES
of America

ITALIANS OF NEWPORT
AND NORTHERN KENTUCKY

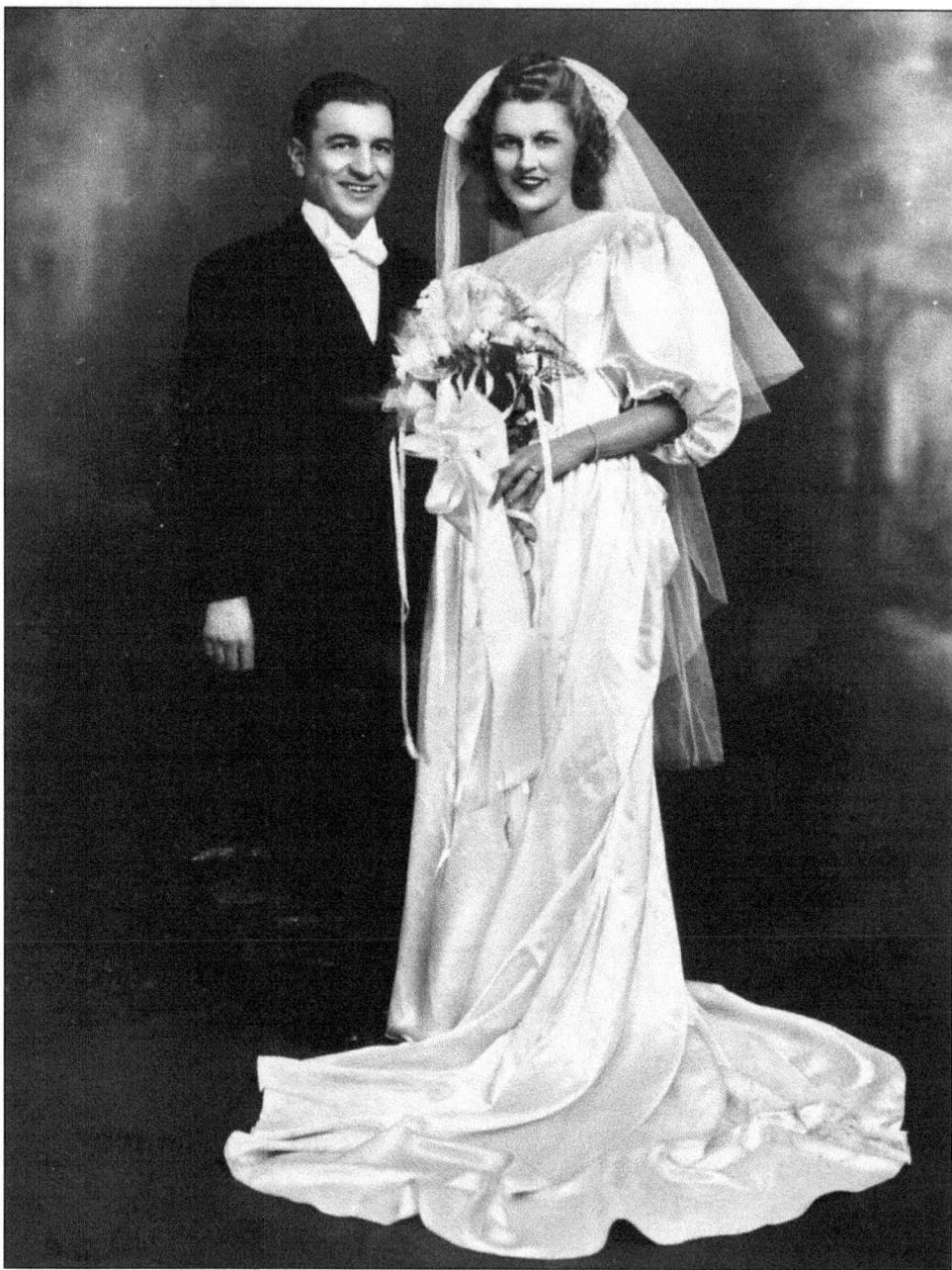

PATRICK JOSEPH AND ALMA WOLFZORN CIAFARDINI, FEBRUARY 8, 1947. In loving memory of our father, born Pasquale Vincento Guiseppi Ciafardini, better known as Patrick "Pat" Ciafardini, who, along with our mother, embraced the Italian way of life and taught us the true meaning of family. (Courtesy of the Ciafardini family.)

ON THE COVER: THE WEDDING OF MILDRED GIANCOLA AND PAUL LEHR, JULY 5, 1930. Seated from left to right are (first row) an unidentified flower girl, Josephine Giancola Arcaro (bride's sister), Pete Ledonne (ring bearer), and Mildred; (second row) Esther Larvo, Charles Lehr, Frank Giancola (bride's brother), Paul, and unidentified. (Courtesy of Madelyn Lehr.)

IMAGES
of America

ITALIANS OF NEWPORT
AND NORTHERN KENTUCKY

Pamela Ciafardini Casebolt
and Philip G. Ciafardini

ARCADIA
PUBLISHING

Published by Arcadia Publishing
Charleston, South Carolina

Library of Congress Catalog Card Number: 2006939752

For all general information contact Arcadia Publishing at:
Telephone 843-853-2070
Fax 843-853-0044
E-mail sales@arcadiapublishing.com
For customer service and orders:
Toll-Free 1-888-313-2665

Visit us on the Internet at www.arcadiapublishing.com

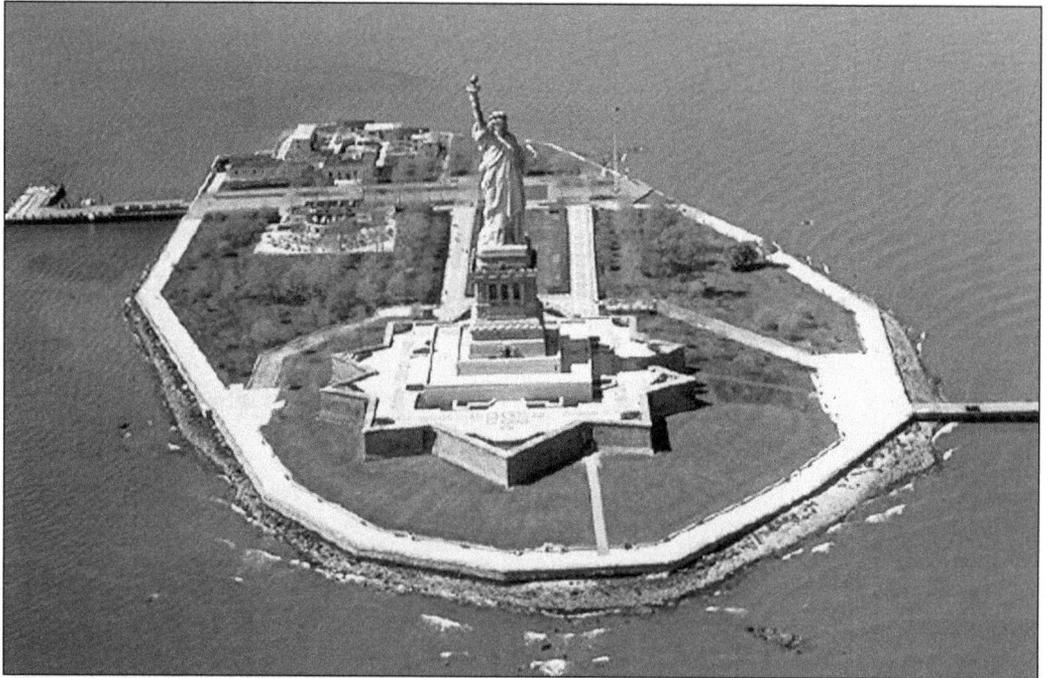

LIBERTY ENLIGHTENING THE WORLD. The Statue of Liberty National Monument, which was a gift from the people of France to the United States, was dedicated on October 28, 1886. Known around the world as the symbol of freedom and democracy, it was the first glimpse of America for many immigrants entering at Ellis Island. The statue is located in New York Harbor. (Courtesy of National Park Service.)

CONTENTS

ACKNOWLEDGMENTS

It is with grateful hearts that we thank our mother, Alma Wolfzorn Ciafardini, and our aunts, Gilda Ciafardini Nelson, Anita Ciafardini Myers, Gloria Ciafardini Huber, and Bea Chappel Ciafardini, for sharing many photographs and memories with us as we prepared *Italians of Newport and Northern Kentucky*. We also wish to thank our spouses, Rick and Mary, for their support as we worked to complete this book.

A special thank-you goes to individuals and business leaders in the community, who took the time to search for photographs and to provide us with the history so they could be added to the collection. Their names are recorded in the credits or listed in the bibliography. We also deeply appreciate Jim Reis, vice president of Campbell County Historical and Genealogical Society and author of *Pieces of the Past* volumes 1, 2, and 3, for reviewing this book from a historical perspective, and the Kenton County Public Library, as well as the Campbell County Historical and Genealogical Society for housing reference material, including newspaper articles, used to validate our findings. Additionally, we wish to thank Arcadia Publishing, especially our acquisitions editor, Kendra Allen, for their assistance in answering our questions throughout the process.

It is difficult to find the words to express our gratitude to the wonderful Italian families who shared their family histories and photographs with us so that they would be preserved for future generations. You were, and still are, the inspiration for this book. It was an honor to record your experiences and contributions to the city of Newport and the Northern Kentucky area.

We also wish to thank those of you who purchased this book. We hope you will enjoy this pictorial history of the Italian immigration into the Northern Kentucky area as we present a glimpse into the lives of the immigrants, their families, and the community as we share their collective stories told within this book.

INTRODUCTION

Over 100 years ago, the last of the mass migrations from Europe began with the Italian emigration from Italy. During that time, over four and a half million Italians came to America. Most immigrants who came to Northern Kentucky entered through Ellis Island after 1892. On arrival, the immigrants would face inspections for overall good health and ability to work.

In general, the Italian emigration from Italy was spurned by natural disasters that rocked Southern Italy. Earthquakes, disease, internal strife, and widespread poverty caused many Italians to look for a better way of life. Employment brokers from America would go to Italy and sign up workers to come to the United States to work in the construction fields or the tailoring business. With transatlantic travel becoming more affordable, it seemed a good idea to at least go to America and look for work and earn enough money to be self-sustaining and to send money back home. Those who came with this in mind and returned home were known as "birds of passage." An estimated 25 percent of the Italian immigrants returned to Italy permanently. Those who remained still accounted for at least 10 percent of the overall foreign-born population of the United States; they also represented about 28 percent of Italy's total population.

Those who decided to stay in America would first be faced with finding a place to live, as well as employment. The Italians who came to the Northern Kentucky area found a great deal of Italians in Cincinnati, Ohio, around Sacred Heart Italian Church located in the downtown area of Fifth and Broadway Streets. The church provided not only a place of worship but also fellowship. Streetcars made moving back and forth from Northern Kentucky an easy way to find work on either side of the Ohio River. The railroads allowed for job opportunities and travel to places like West Virginia to sell goods or to work in the coal mines.

As cheap land became available in Northern Kentucky, the new immigrants began to build their houses and raise their families. Just settled, they faced the challenges of World War I (1914–1918), the Great Depression (1929–1939), World War II (1939–1945), and the Korean War (1950–1953). Through it all, they remained determined to stay the course. Northern Kentucky had become their home and their roots were firmly planted.

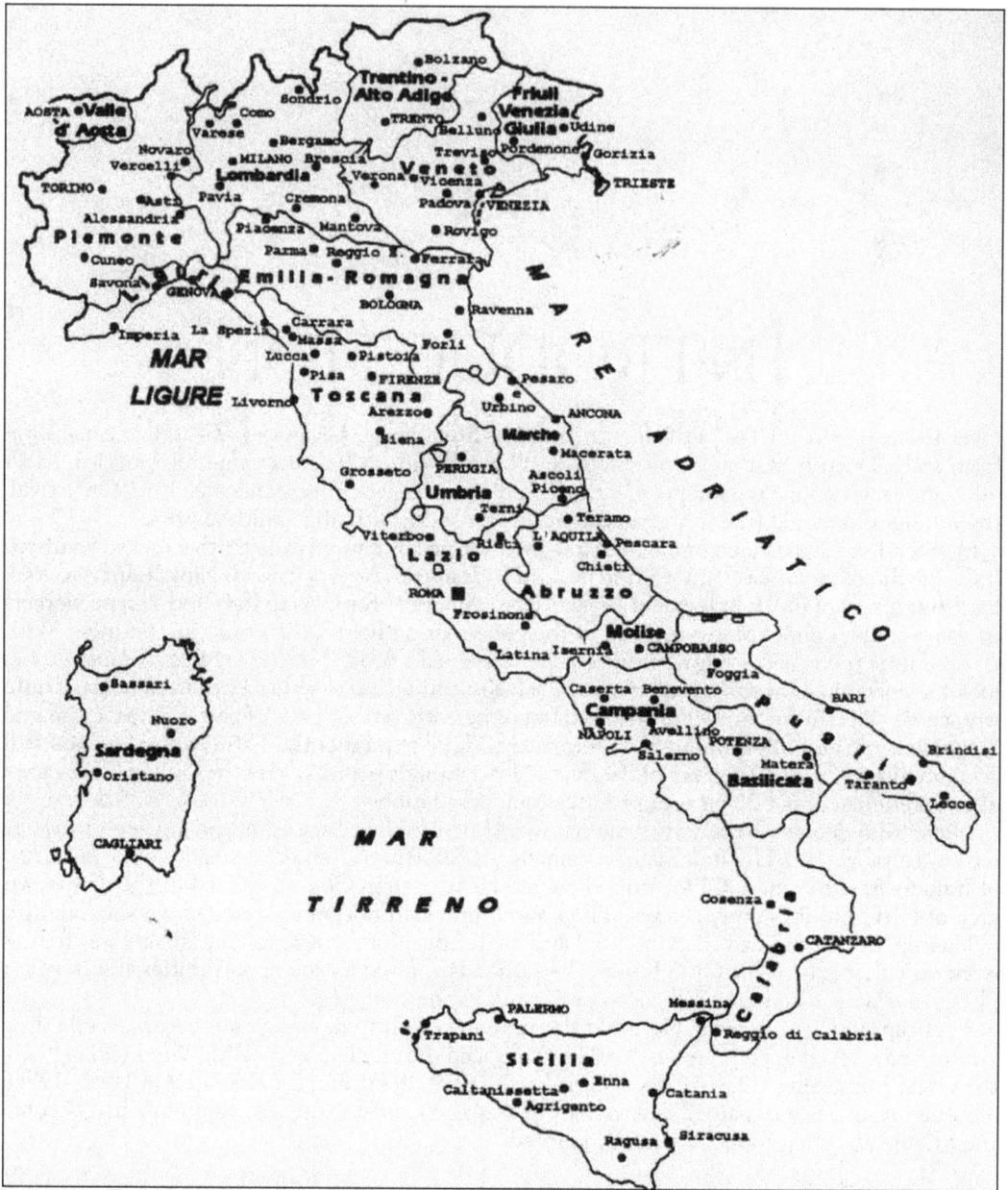

MAP OF ITALY. In the Republic of Italy, established in 1946, there are 20 regions that are similar to the United States of America. The provinces are named for the largest city in the province and they are equal to our counties. Italy's municipalities are towns, hamlets, or communes that are equal to our cities. In 1963, the region of Abruzzi e Molise was split into two regions, that of Abruzzo and the other Molise. The province of Campobasso was split as well, and Isernia was established as a new province. (Courtesy of Stephanie Longo.)

One

THE JOURNEY

They left behind a beloved country and family members to come to America for a better way of life. They were the Italian immigrants who made their way to America by ocean liners through Castle Garden, Ellis Island, or through a neighboring shore between 1887 and 1924, during the peak of the emigration from Italy. These immigrants were field laborers, stonemasons, shepherds, and tailors. Most of the immigrants came from Italy's southern regions of Abruzzo, Molise, Campania, Calabria, and Sicily. Many of the immigrants came from the same towns, some were related, and others at least knew each other or knew members of the families in Italy. Some had prearranged marriages, often being promised at birth to one another. They were poor and for the most part lacked any formal education.

The journey to America was not one of ease or luxury. First the immigrants would have to obtain permission from the Italian government to leave the country and then have their papers or passports prepared before they would be given permission to emigrate. The first leg of their journey was to travel to their port of departure, which was usually Naples, Italy, to board their designated ship and proceed to travel 10 to 14 days by ocean liner. Often the Italians traveled as third-class or steerage passengers. They were located in the lower level of the ship and endured dirty, dingy, and noisy quarters. Poor ventilation and extreme heat added to their discomfort. Once they reached Ellis Island and were cleared to enter the United States, they embarked on their new lives.

After leaving New York, many would first land in Pennsylvania, West Virginia, Virginia, and Ohio, ultimately working their way to Kentucky. Once they arrived in Kentucky, they settled in the neighborhoods of Newport, Covington, Clifton (Spaghetti Knob), and Cote Brilliante and began to fulfill their dreams. They went about building a community of faith, demonstrated a strong work ethic, and defended their Italian way of life. They were some of the first Italians who helped build the city of Newport and Northern Kentucky.

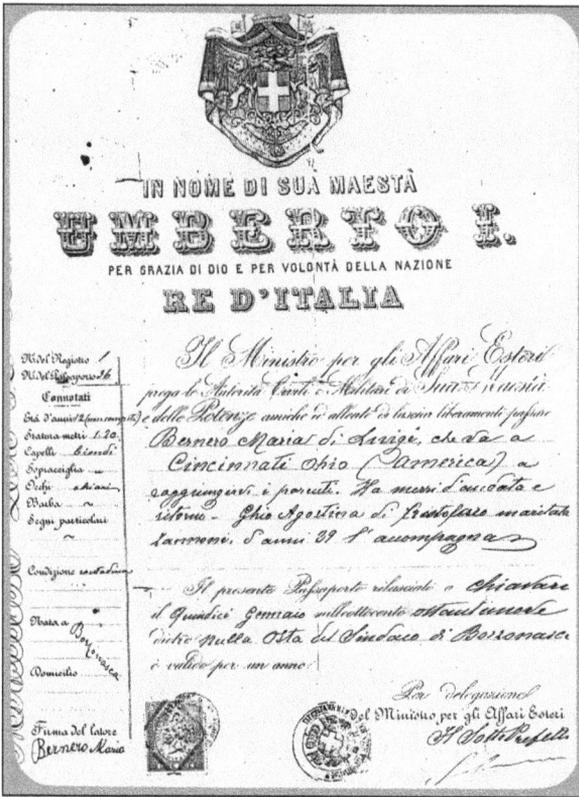

PASSPORT FROM THE KING OF ITALY, C. 1888. Maria Bernero, born November 7, 1876, requested travel to America and was granted this passport. Maria was only 12 years old when she traveled here with her cousin. She left her home and family in Italy due to poor health from a childhood fever. (Courtesy of Sr. Virginia Ann Wolfzorn, Congregation of Divine Providence [CDP].)

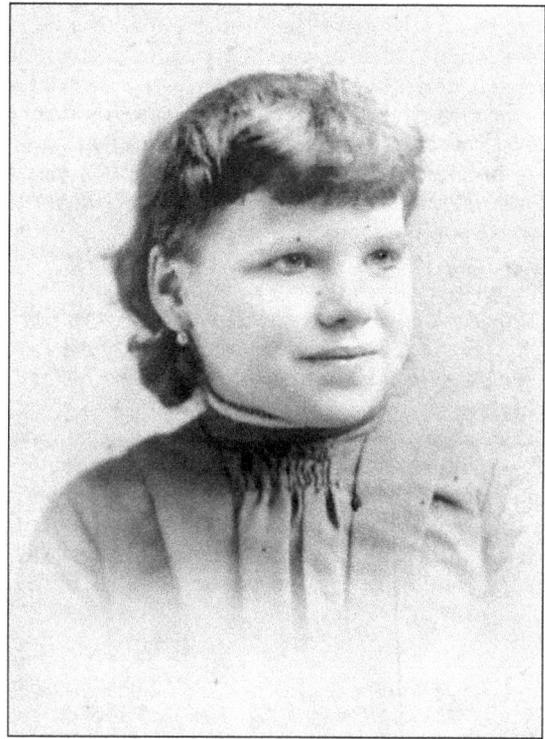

MARIA BERNERO, C. 1888. This photograph was taken for Maria Bernero to use along with her passport to come to America. Maria was the daughter of Luigi and Maria Longinotti Bernero and came from the town of Temossi, Italy. Her aunt Cecilia and uncle Antonio Longinotti, whom she lived with in Cincinnati, sponsored her journey. (Courtesy of Sr. Virginia Ann Wolfzorn, CDP.)

Ralph Fiascone, c. 1913. Ralph entered the United States through Canada and worked for seven years before sending for his wife, Rosa (below). He had already secured a job with Newport Rolling Mill and had established a home at 225 Main Avenue in Clifton. The Fiascones lost their home during the Great Depression and moved to Saratoga Street in Newport. Ralph then found work in the tailoring business. (Courtesy of Beverly Piccirillo Beuke.)

Rosa Petracco Fiascone Passport, c. 1920. This was Rosa's official passport (below left), with the photograph she used when she arrived in Boston on March 21, 1920 (below right). Rosa was a homemaker her entire life and along with her husband, Ralph, raised four children: Angela, Armando "Herman," Mary Edelina "Edith," and Gilda. (Courtesy of Beverly Piccirillo Beuke.)

671

REGNO D'ITALIA

PASSAPORTO

PER L'ESTERO

ROMA
Tipografia G. Scotti

74

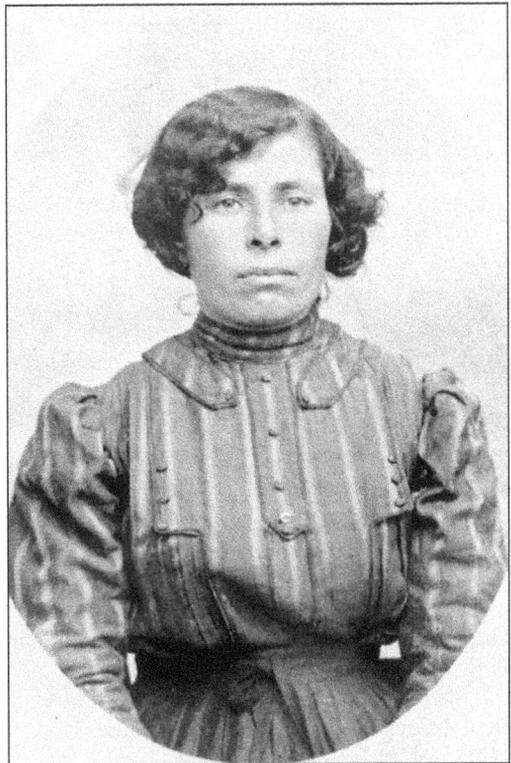

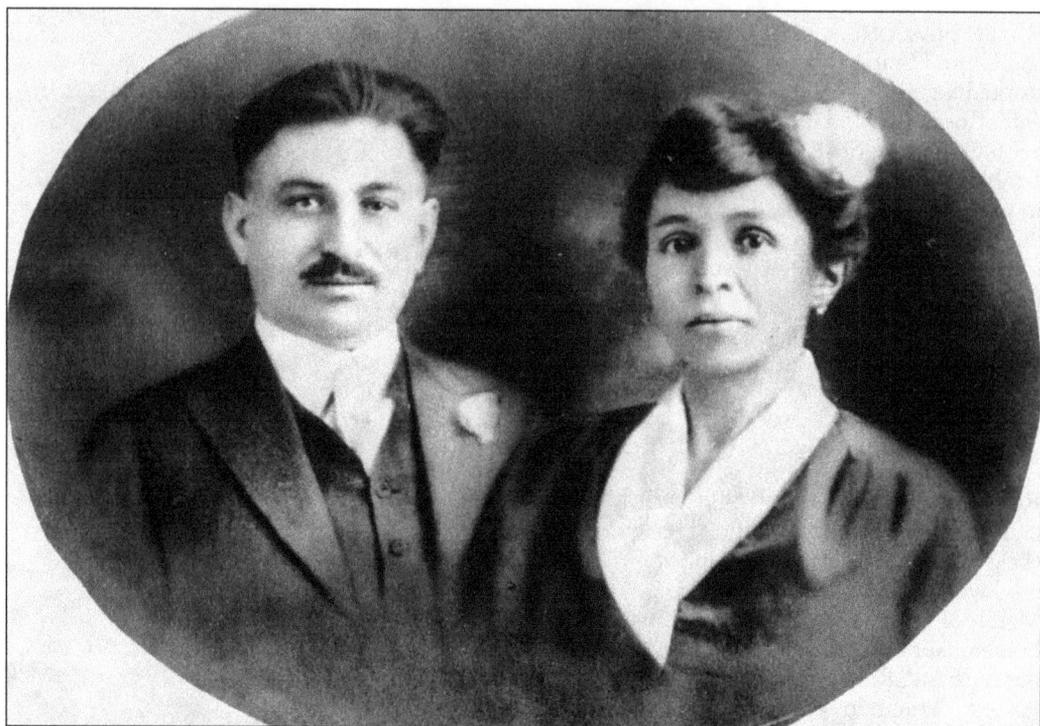

GIOVANNI AND CARMINA "CARMELA" IALUNGO CIAFARDINI, C. 1907. Giovanni "John" left his town of Trivento, Campobasso, Molise, and arrived at Ellis Island on April 23, 1908, aboard the ship *Campania* that departed from Napoli, Italy. He was 20 years old when he arrived. His wife, Carmela, originally from the town of Bagnoli del Trigno, arrived approximately one year later with their infant daughter, Rosa. (Courtesy of the Ciafardini family.)

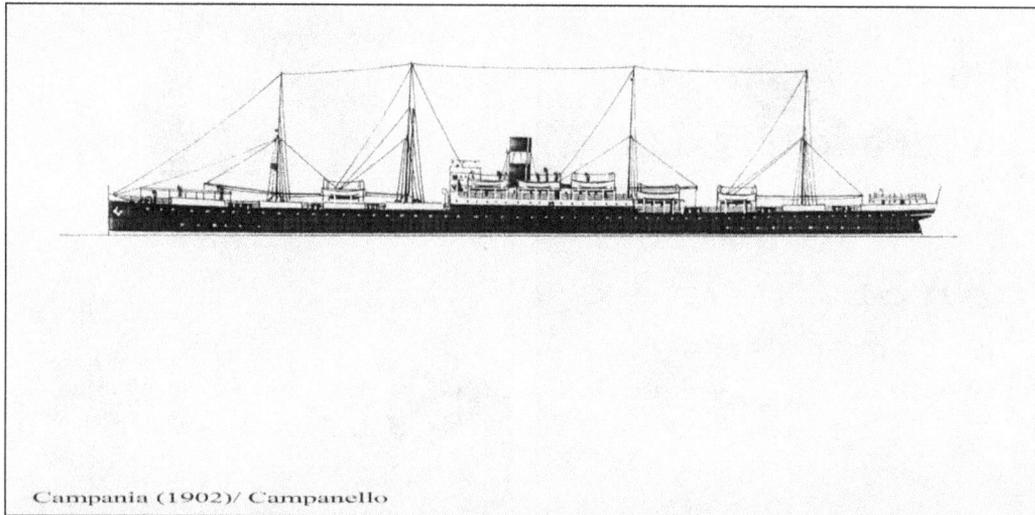

Campania (1902)/ Campanello

CAMPANIA, C. 1902. In 1902, Palmers Shipbuilding and Iron Company of Newcastle, England, built the *British Empire*, which was later sold to Navigazione Generale Italiana Line in 1906 and renamed *Campania*. It offered Mediterranean–New York service under the Italian flag. The ship held 40 first-class, 50 second-class, and 2,200 third-class passengers. (Courtesy of the Statue of Liberty–Ellis Island Foundation.)

ROSA CIAFARDINI, C. 1924. Rosa, born on May 13, 1908, emigrated from Italy with her mother, Carmela, arriving in America in 1909. Like many other families, their journey is left untold. Family members continue to try to locate records of their arrival. The family legend is that they arrived via a cattle boat, a journey that took 31 days. (Courtesy of the Ciafardini family.)

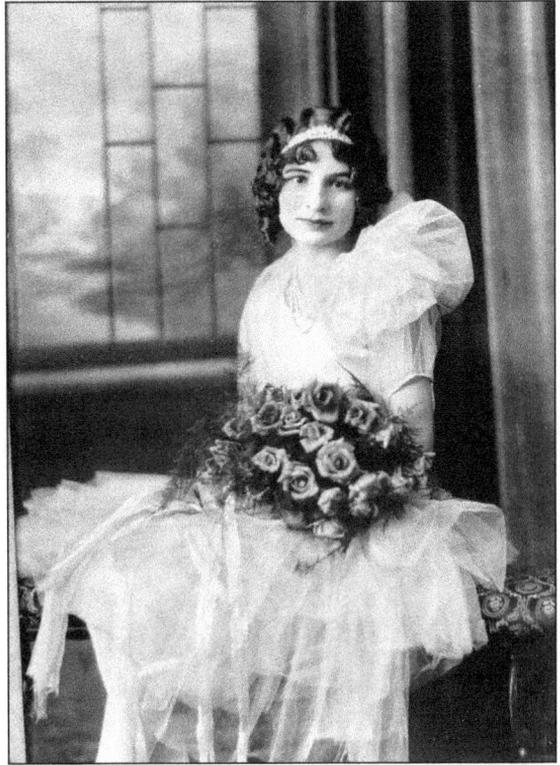

PASQUALE "PAT" GRECO, AGE 12, C. 1917. Pat was six years old when he emigrated from Italy, arriving on May 3, 1911, with his mother, Amerina Pellillo Greco, and joining his father, Vitale, in America. At the age of 14, Pat worked at Bakers on Saratoga Street in Newport making laundry tags. He then learned to sew on a sewing machine at Oak Tailoring Company. (Courtesy of the Pat Greco family.)

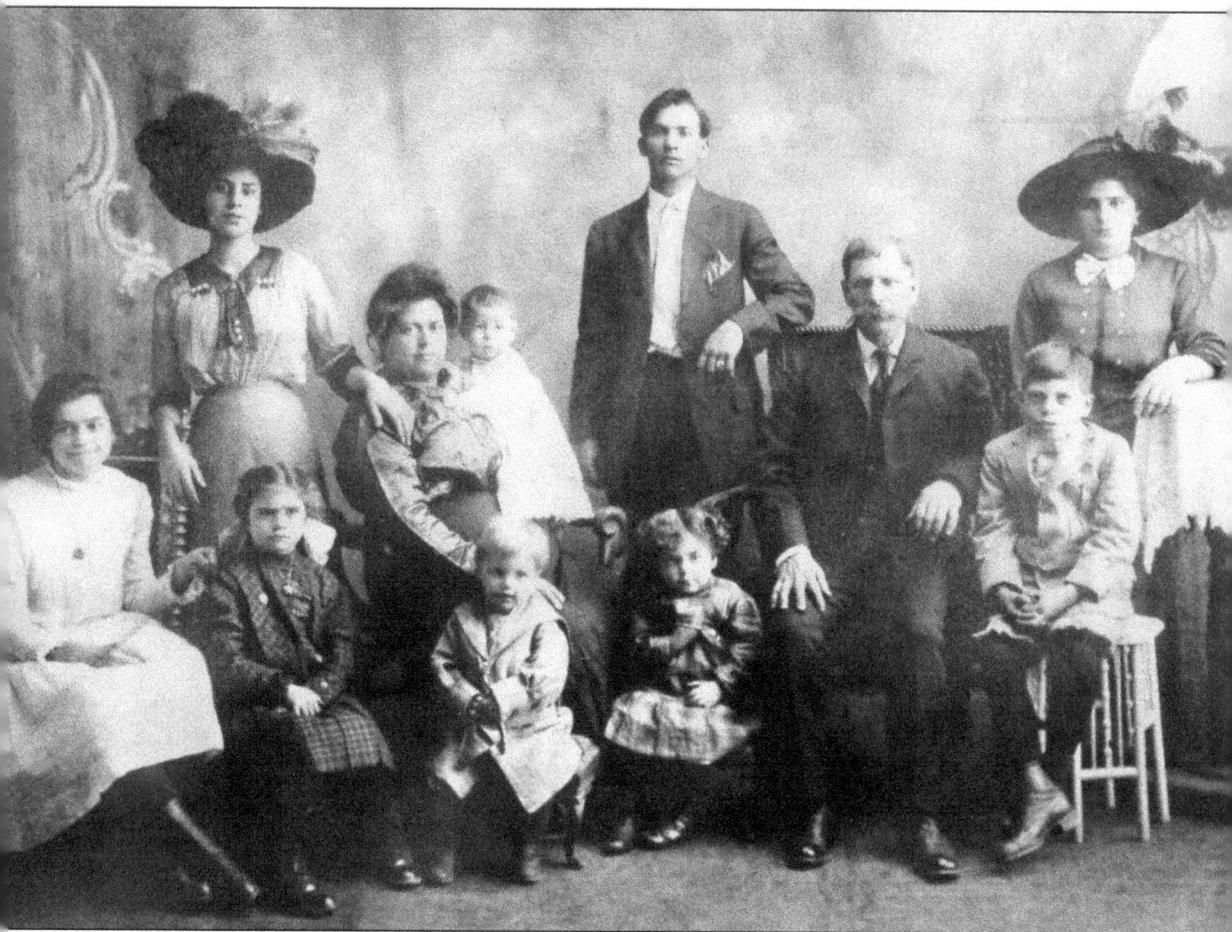

MICHAEL AND MARCETTA SAVALINA ZAPPA FAMILY, C. 1912. Michael Zappa (seated third from right) came to America on April 15, 1887, and became a citizen on October 18, 1900, in Campbell County Court. Michael was a truck driver for the City of Clifton and resided at 50 Biehl Street in Clifton. Zappa family members are, from left to right, (first row) Mary Concetta Petronio, Marg "Mary Margaret" Collerusso, Joseph (little blond boy, son of Phillip and Dena Francia), Louise Carmela "Alice" Accurso, Michael, and Alfred "Ralph;" (second row) Elizabeth Buemi, Marcetta holding baby Tony, Phillip Francia, and Phillip's wife, Dena. (Courtesy of the Buemi family.)

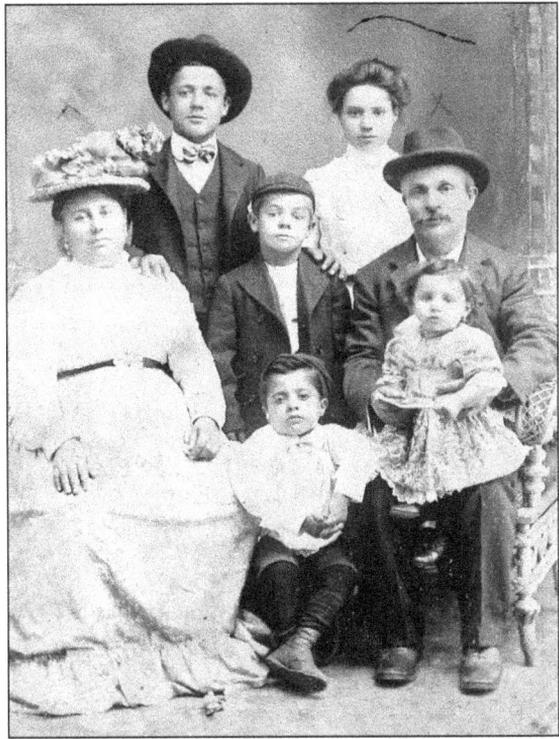

ARCHANGELO AND RUFINA ARMENTI GIANCOLA FAMILY. Archangelo came to America from the town of Castelpetroso, Cambopasso (now Isernia), Molise, arriving in Pennsylvania in 1892. Rufina arrived in 1893 with their two children, Mildred and John, and delivered Eugene on the ship coming to America. Shown from left to right are (first row) Rufina, Paschal (seated on the floor), and Archangelo with Mary; (second row) John, Eugene, and Mildred "Millie." (Courtesy of R. Toni Bungenstock.)

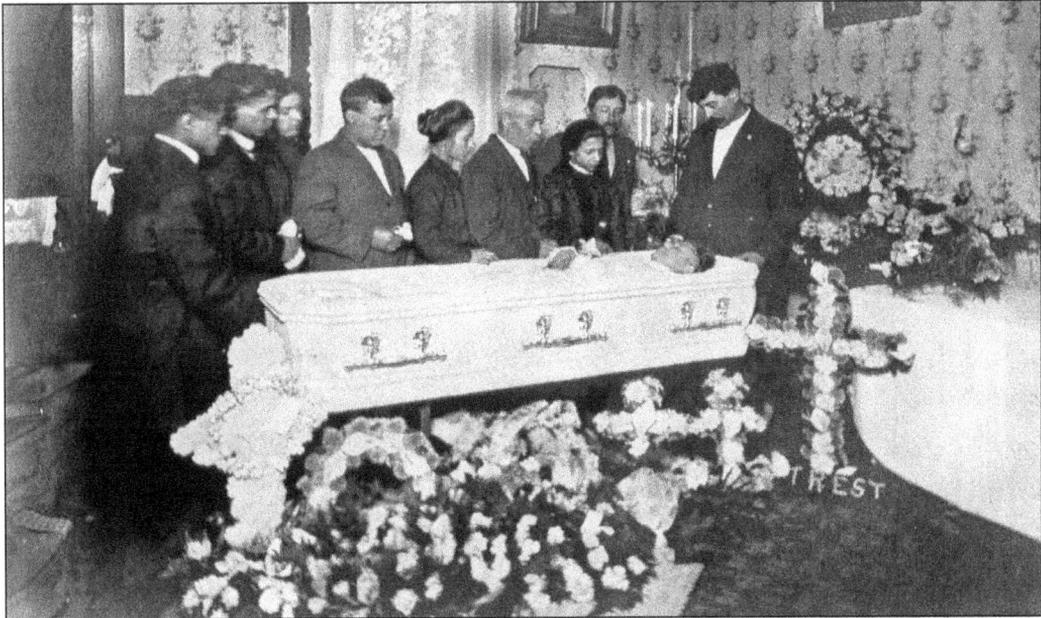

GIANCOLA FAMILY DEATH PHOTOGRAPH. Many Italian families would take one last photograph of their loved one at the time of their death. It was fittingly called the "death photograph." Pictured from left to right are Pasquale Giancola, Eugene Giancola, Bertina Zappa Giancola, John Giancola, Millie Giancola Forte, Michael Archangelo Giancola, Mary Giancola Ventura, Carmen Armenti, Nick Forte, and the deceased immigrant Rufina Armenti Giancola. (Courtesy of Gayle Forte Groeschen.)

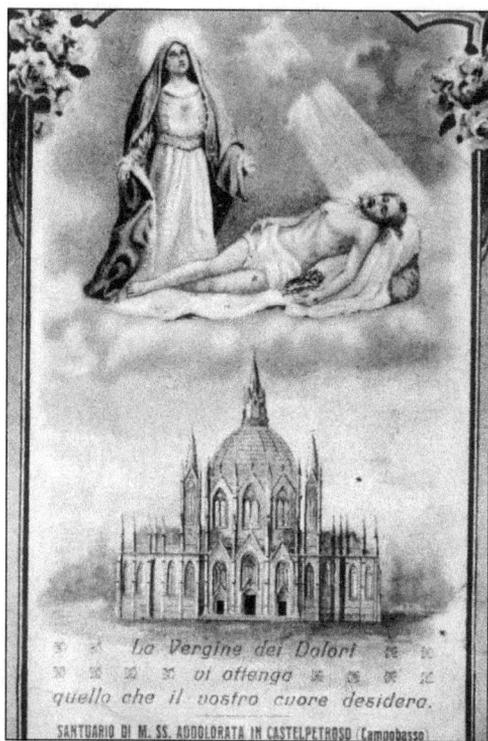

SANCTUARY OF THE SORROWFUL MOTHER, CASTELPETROSO, ISERNIA, MOLISE, ITALY. This beautiful domed church is built on the location where Our Lady of Sorrows appeared on March 22, 1888, before two shepherd girls named Bibiana and Serafina. Today the sanctuary is taken care of by a group of Franciscan priests and brothers. Some of the Northern Kentucky families from Castelpetroso include Arcaro, Armenti, Farro, Forte, Giancola, Pugliese, and Vacca. (Courtesy of Gayle Forte Groeschen.)

La Vergine dei Dolori vi ottenga quello che il vostro cuore desidera.

SANTUARIO DI M. SS. ADDOLORATA IN CASTELPETROSO (Campobasso)

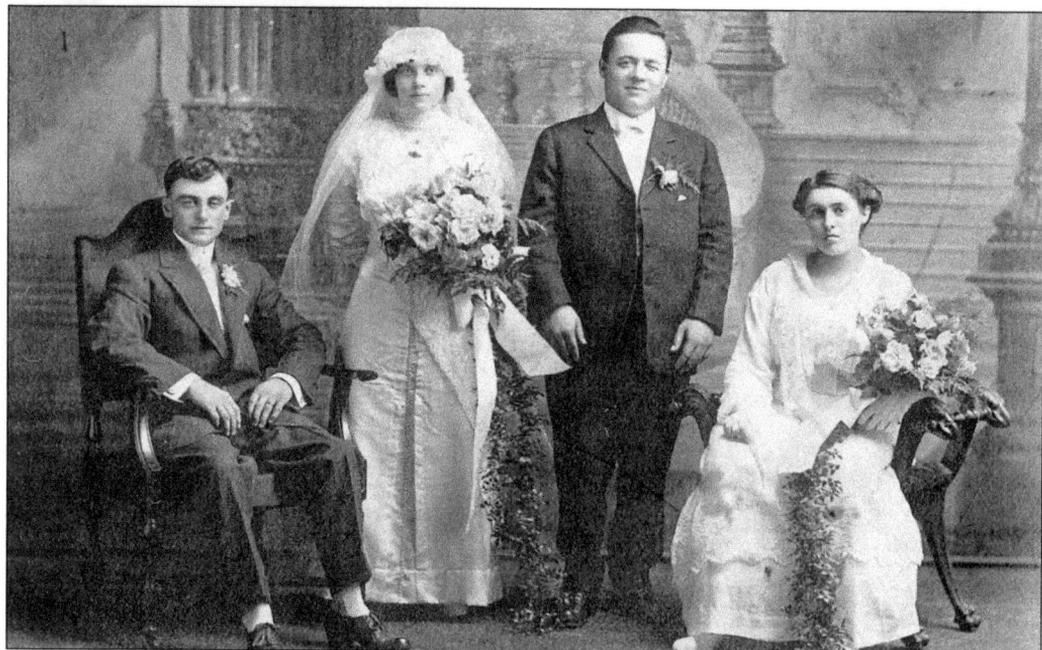

THE WEDDING OF ENRICO FORTE AND MADELENA FARRO, C. 1914. Enrico (seated) and Madelena (standing) Farro Forte's wedding was witnessed by John Sr. and Bertina Zappa Giancola. Upon arrival in the United States, Enrico worked the coal mines of Pittsburgh for two years. His original intent was to come to America, work to send money back home, and eventually move back to Italy. He ended up loving the country and decided to stay. (Courtesy of the Forte family.)

Marco and Caterina Litrenta Meconio. The Meconios emigrated from Strongoli, Crotone, Calabria, on June 9, 1909, aboard the *Konig Albert*. They settled in the coal-mining town of Williamson, West Virginia, where Marco owned a produce store. Later they moved to Cincinnati, then onto Eighteenth Street in Newport, where they raised their family. (Courtesy of the Michelina Meconio Sharp family.)

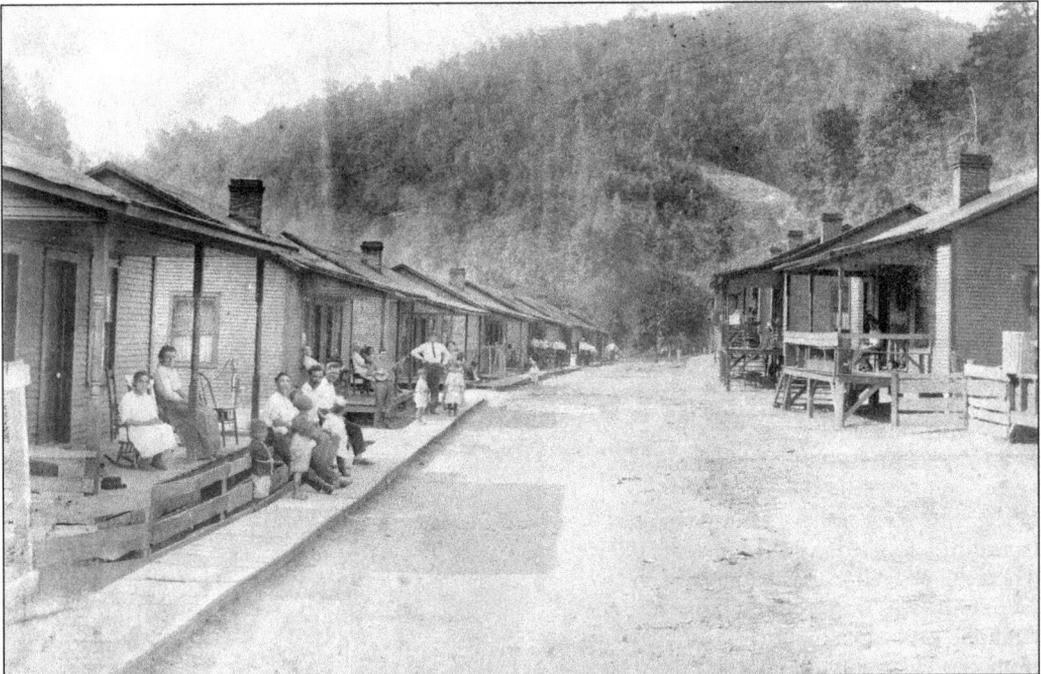

Williamson, West Virginia, c. 1909. The coal-mining town of Williamson, West Virginia, located in Mingo County, was rich with coal, and even today, it is one of the top five coal mining counties in the eastern United States. (Courtesy of the Michelina Meconio Sharp family.)

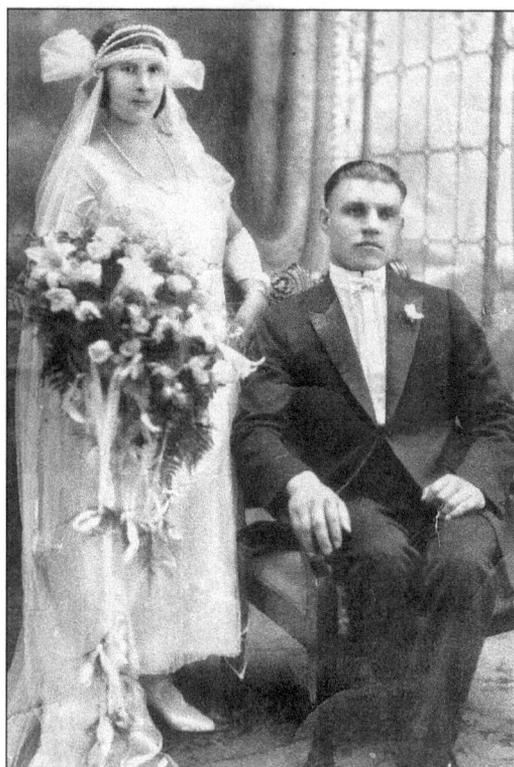

RAFFAELE VACCA AND ANGELINA BASILE WEDDING, JULY 22, 1923. Angelina arrived on February 17, 1921, along with her sister Pasqualina, from Tarono Castello, Cosenza, Calabria, where she worked as a farm laborer. They joined their parents who were living in New Jersey. Raffaele emigrated from the town of Castelpetroso, Italy, and after serving in World War I, he and Angelina were married in New Jersey and later moved to Clifton. (Courtesy of the Vacca family.)

JOHN MICHAEL AND JOHANNA "JAY" COLETTA POMPILIO, C. 1911. Johanna and John are pictured here with their oldest son, Tony, and John's cousin (standing). Johanna was three years old when she arrived in America in 1897. Her family was from the town of Matrice, Campobasso, Molise. John's family was from Castelgandolpho, Foggia, Puglia. John arrived in 1906 at 18 years of age. They were married on July 20, 1910. (Courtesy of the Pompilio family.)

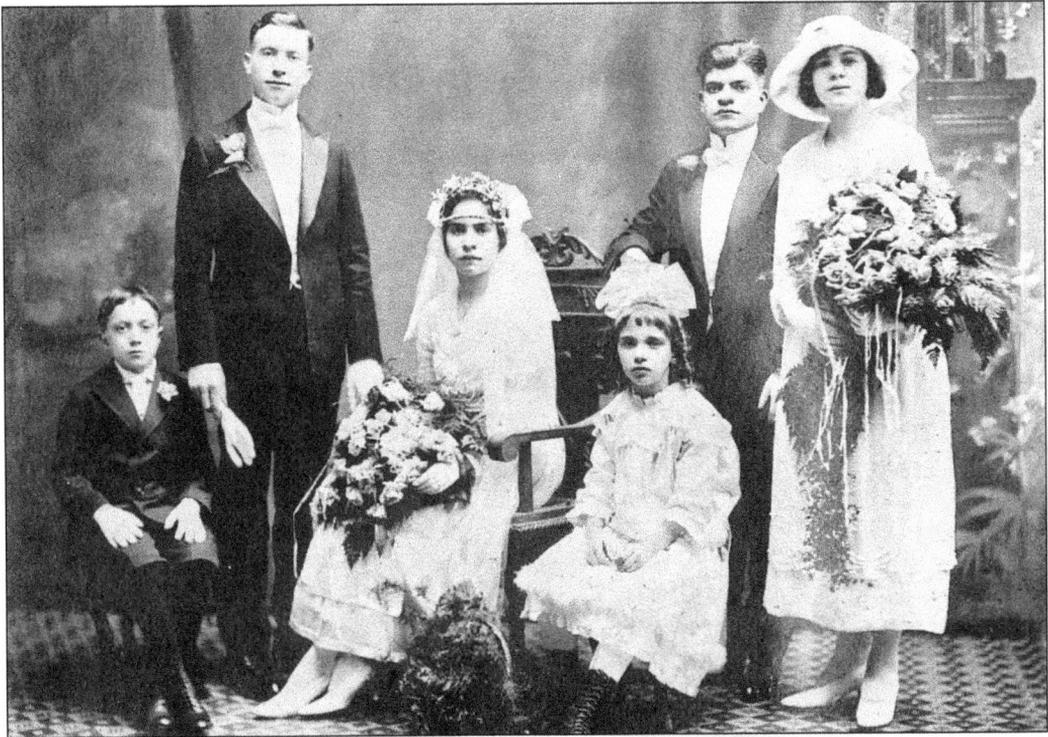

ERNESTO PELLILLO AND MICHELINA GALLO WEDDING, NOVEMBER 29, 1919. Ernesto, a shoemaker, arrived in America at the age of 19 on June 9, 1914, aboard the *Niagara*. Michelina arrived with her mother, Albina, on March 22, 1911, aboard the *Europa*. The wedding party pictured here from left to right are Nick Barone (seated), Ernesto, Michelina Gallo, ? Pellillo, Domenico Gallo, and Mary ?. (Courtesy of Mary Pellillo.)

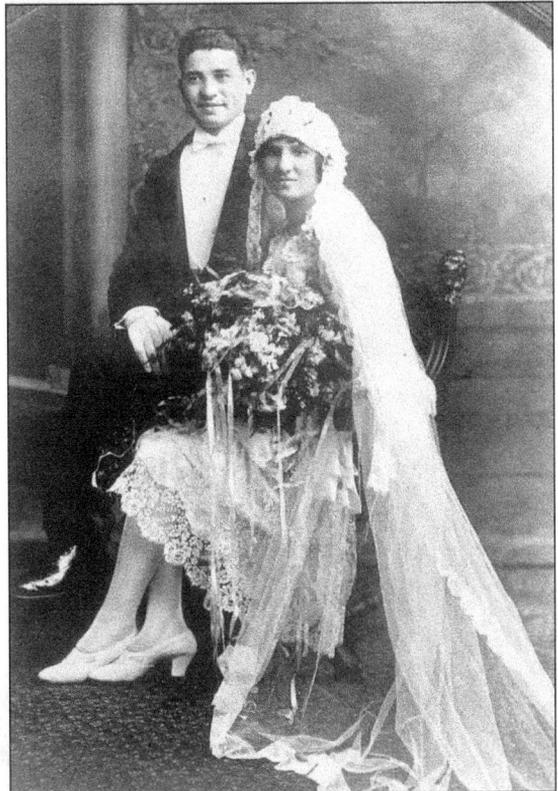

ROY DILILLO AND CHRISTINE PAOLUCCI WEDDING, MAY 4, 1928. The Dilillo family lived at 168 Main Avenue in Clifton. Roy was a tailor and worked for Leonard Custom Tailoring Company in Cincinnati. In the early years, Christine was a seamstress; in later years, she worked for Kahns, which was also located in Cincinnati. Together they raised three children, Joe, Philip, and Anna Mae. (Courtesy of Mary Dilillo.)

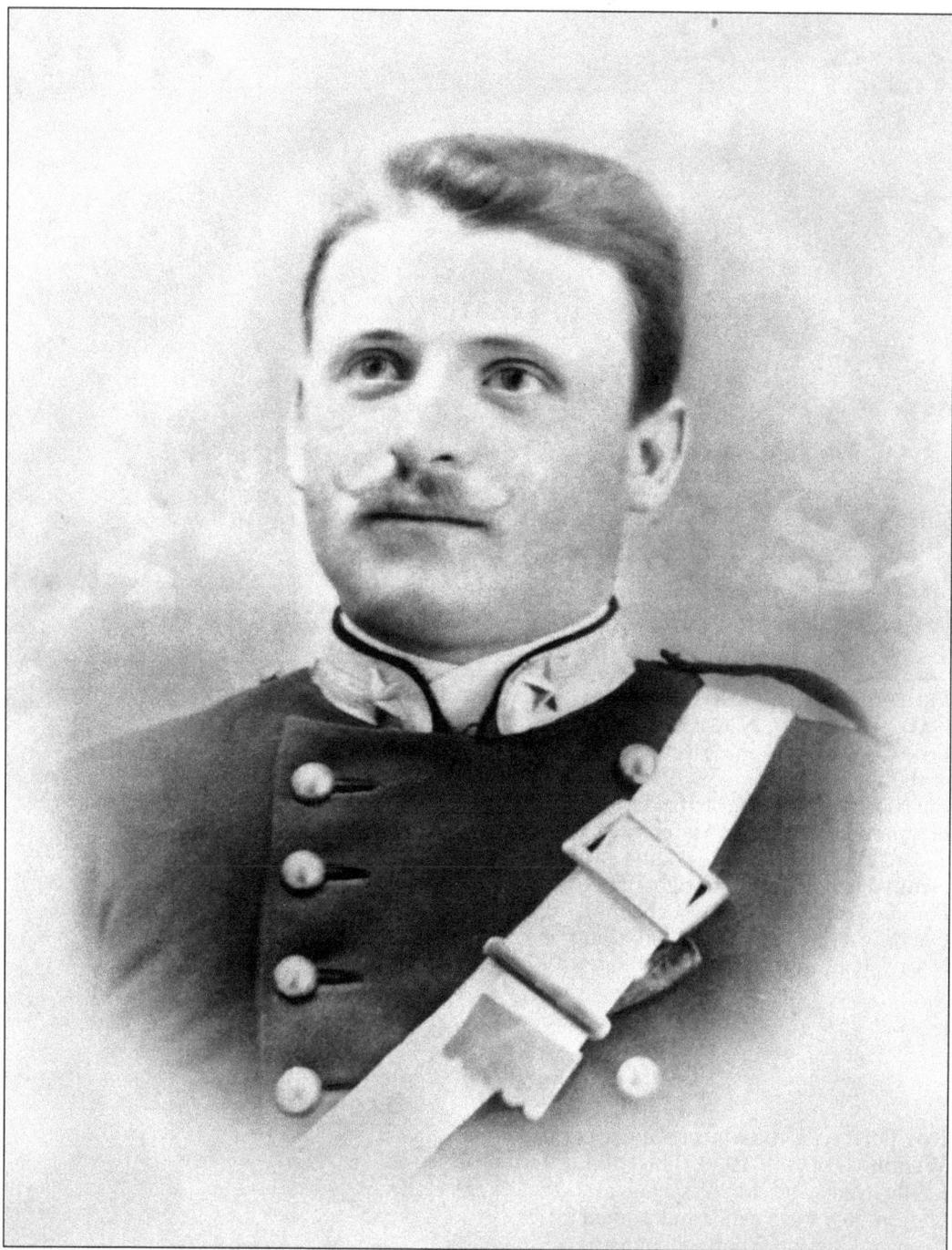

CAPT. LORENZO "LAWRENCE" JACOBS. Born Lorenzo Dello Iacovo in Rome, Italy, on October 16, 1872, he was a police captain in Benevento, Campania, Italy, before immigrating to America in 1904. The surnames of many Italian immigrants were often changed in error. Some changed at Ellis Island and others when immigrants went into the military. Dello Iacovo's name was changed when he took his children to school and the pronunciation was misunderstood; from then on, the family was known as Jacobs. (Courtesy of R. Toni Bungenstock.)

**LAWRENCE JACOBS AND HIS WIFE,
RAFFAELLA.** Lawrence and Raffaella
lived at 139 Chesapeake Avenue in Cote
Brilliante. As farmers, they invested
in the land and owned a great deal of
property on Chesapeake. They also
owned property on what is now called
Knob Hill in Fort Thomas, where they
farmed a peach orchard. (Courtesy of R.
Toni Bungenstock.)

**THE WEDDING OF PASCHAL GIANCOLA
AND ANGELA JACOBS, 1924.** Italians were
well known for celebrating important
events. The wedding of Paschal and
Angela, witnessed by Joseph Jacobs and
Clara Arnold, took place at St. Francis
de Sales Church in Cote Brilliante
on June 28, 1924. The celebration
continued in the backyard of the Forte
home on Putnam Street in Newport.
The festivities lasted for four days.
(Courtesy of R. Toni Bungenstock.)

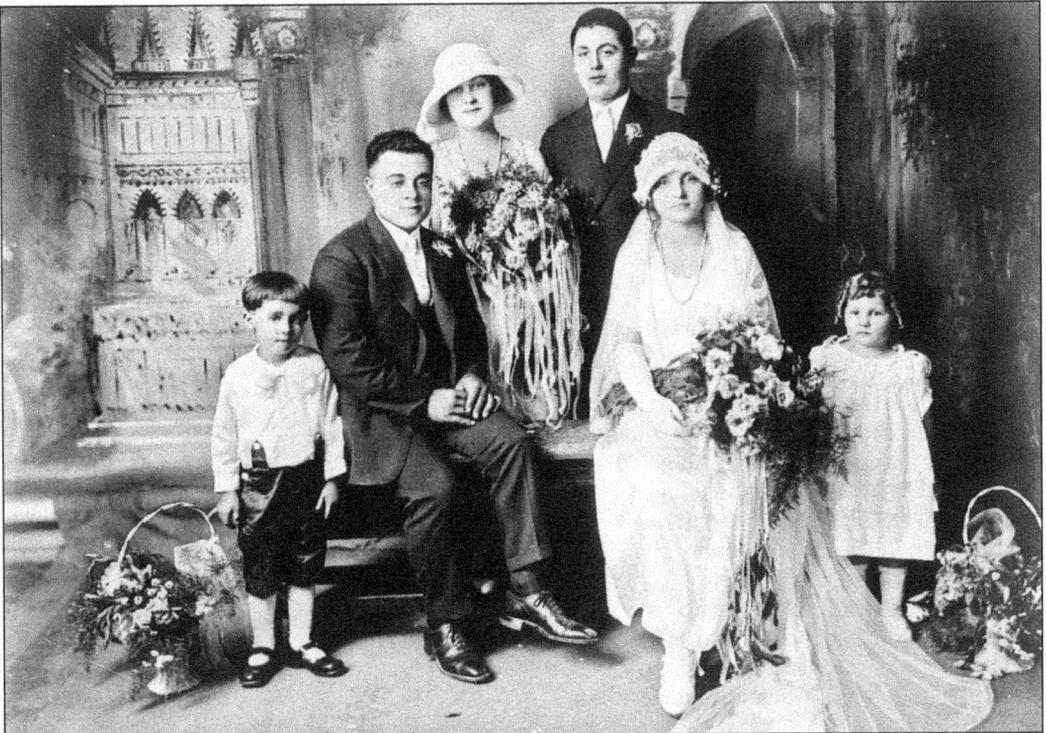

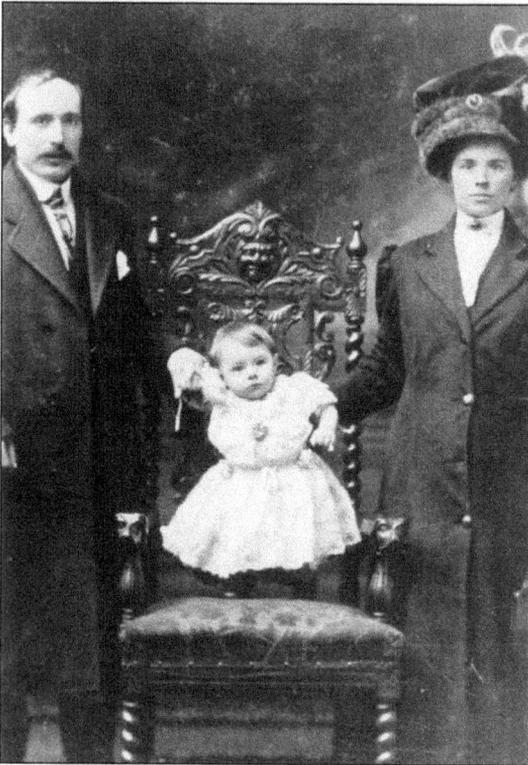

GUISEPPE AND MADDALENA MONTI GUIDUGLI WITH THEIR FIRST CHILD, MARY, C. 1910. Guiseppe and Maddalena were married in the town of Calomini, Lucca, Tuscany, on June 19, 1909. Their honeymoon included their ocean voyage to the United States. Guiseppe bought Maddalena's hat and coat when they stopped in Paris, France, on their journey to America. They arrived in New York on July 3, 1909. (Courtesy of Sr. Maddalena Guidugli, CDP.)

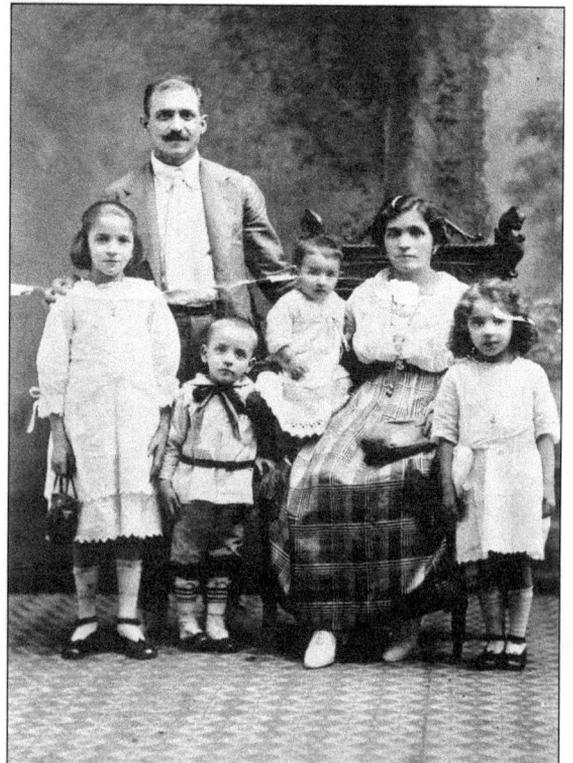

PAUL AND JOSEPHINE CANCARO AUTERI FAMILY. Paul came to America around 1912–1913, and his wife, Josephine, arrived in 1914. Paul was a shoemaker and worked at Krippendorf Dittman Company in Cincinnati. Josephine worked at Hyde Park Clothes in Newport. The family, from left to right, is Rosina (who died at the age of 11), Paul, Pete, Mary Auteri Mattingly, Josephine, and Angelina Auteri Buemi. (Courtesy of Angie Auteri Buemi.)

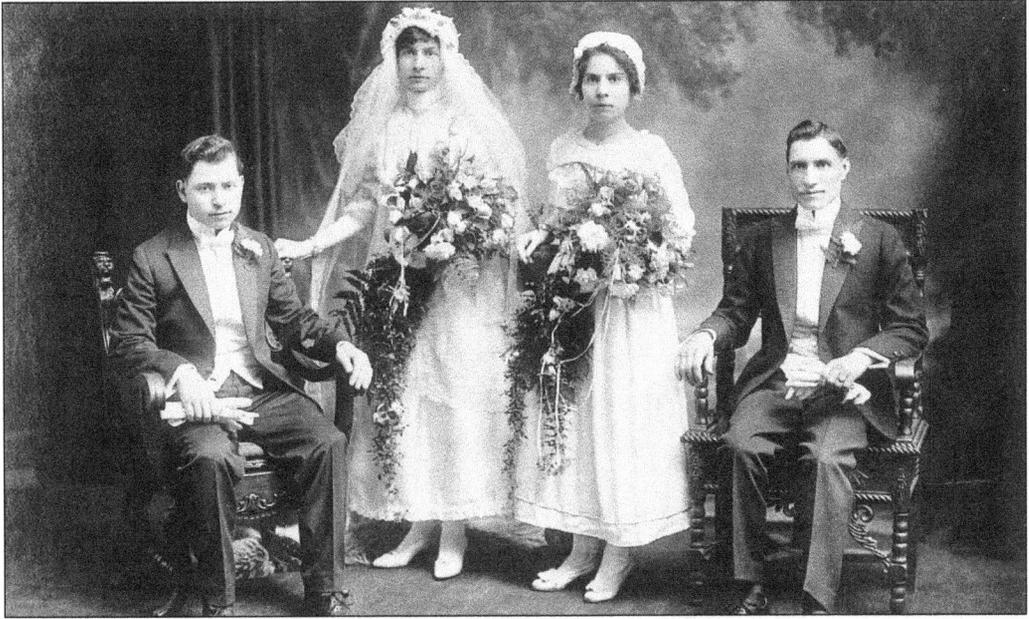

ENRICO "HENRY" PETRACCO AND ANTOINETTE GALLO WEDDING, 1915. Witnesses for the wedding were Maggie Gallo (second from right) and Tony Petti (right). Henry was a cobbler in Italy and always made his wife's shoes from scratch. He later worked in the garment industry boxing clothes and as a presser for J. M. Gidding and Company, later known as Gidding Jenny, located in downtown Cincinnati. (Courtesy of Pete Petracco.)

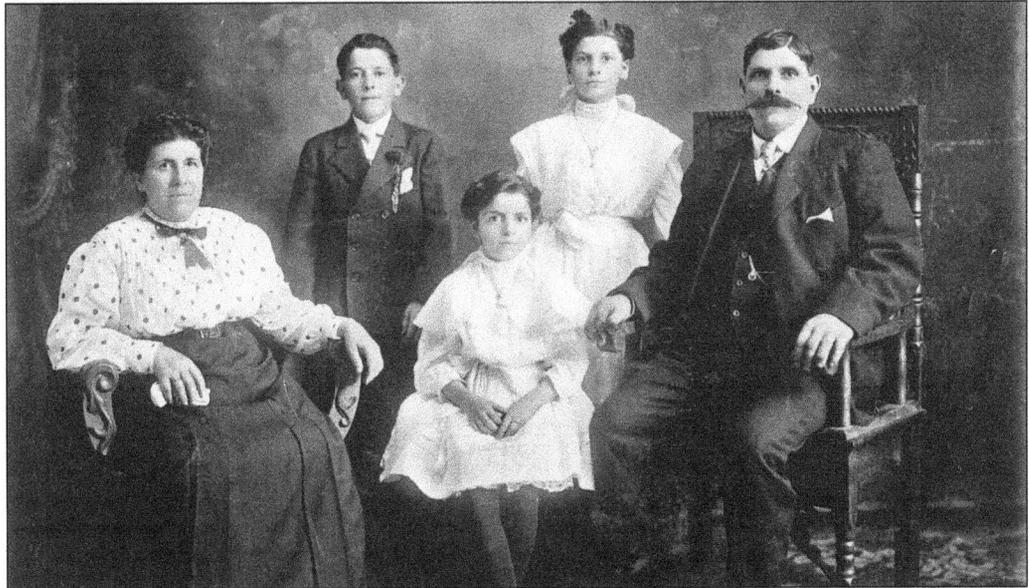

THE PALMERINO SABATINO FAMILY. Palmerino came from Abruzzo and entered the United States on May 7, 1887. He declared his intention to become an American citizen on December 13, 1893, and actually became a citizen in Campbell County, Kentucky, on October 26, 1897. Family members from left to right are (seated) Ermenio (née D'Andrea, who was a schoolteacher in Italy), Louise, and Palmerino; (standing) Tony and Josephine. Their daughter Helen is missing from the photograph. (Courtesy of Mary Dilillo.)

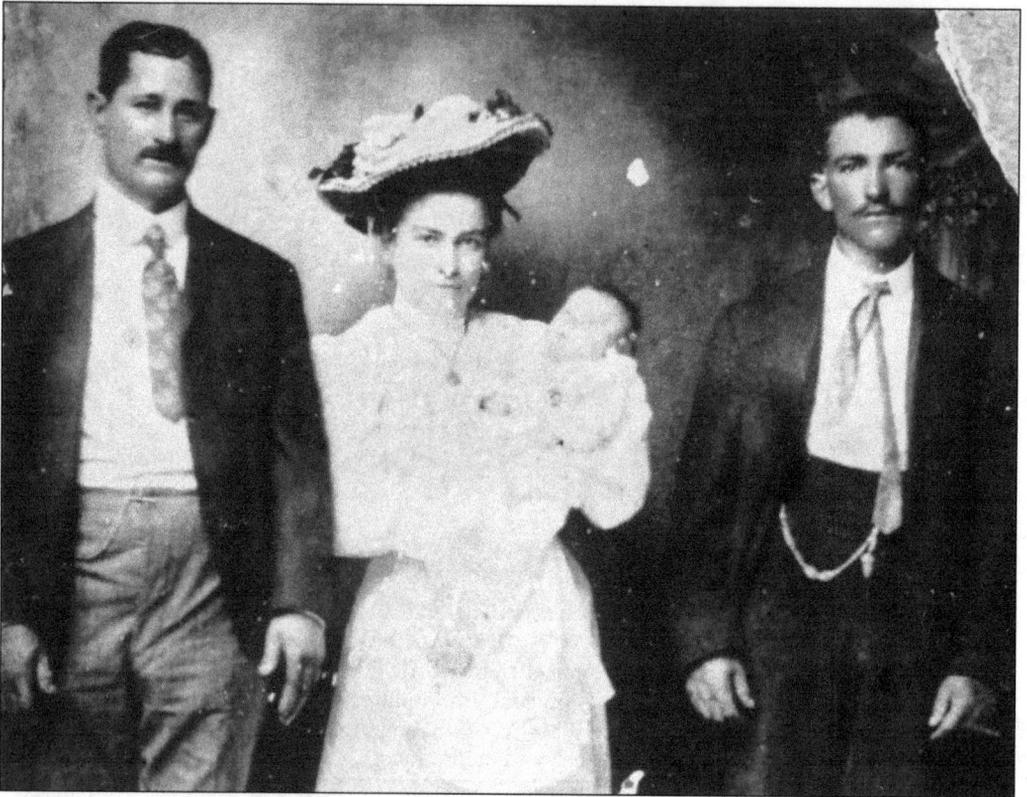

VITO ANTONIO AND CONCETTA SCIARRILLO SARGE. Vito (left) and Concetta were from Sant Arsenio, Salerno, Campania, Italy. They arrived at Ellis Island on September 20, 1906. Vito found work at Newport Rolling Mill as a buffer; later he went into the scrap business, using his horse and buggy to pick up scrap. Concetta opened a grocery store and icehouse on Biehl Street. They are pictured here with their first-born son, Frank, and a visiting relative. (Courtesy of Carmen Sarge.)

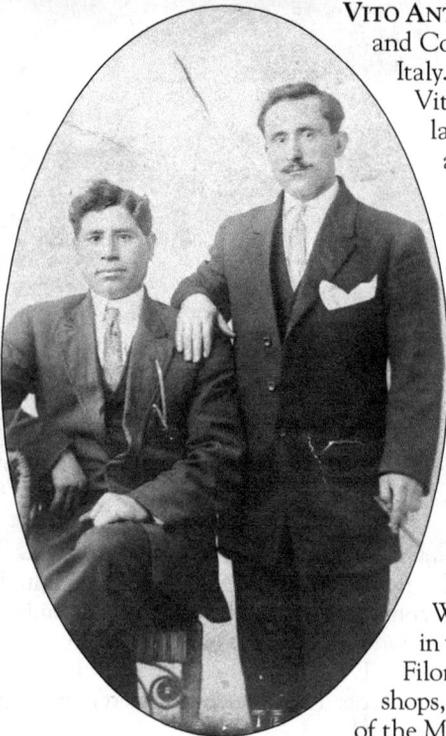

STOWAWAYS. At the age of 17, Michael Marino (seated) and friend Alphonse Raniero arrived at Ellis Island in 1901. Michael worked his way to Northern Kentucky as a cowboy and in the coal mines of Bluefield, West Virginia. In 1908, he arrived in Clifton and moved in with the Raniero family. There he met and then married Filomena Zappa. He worked as a presser at various tailor shops, such as Silverstein Tailoring in Cincinnati. (Courtesy of the Marino family.)

PIETRANTONIO "EDWARD" AND MADDALENA GIANCOLA WITH CHILDREN. Edward, at age 35, arrived in America on March 25, 1903, aboard the ship *Ravenna*. Maddalena, at the age of 25, arrived on the ship the *Prinz Adalbert* on June 22, 1904, with their children Tony, age three, and Josephine, age six. The Giancolas first lived in Cincinnati before moving to Newport in the 1930s. (Courtesy of Gayle Forte Groeschen.)

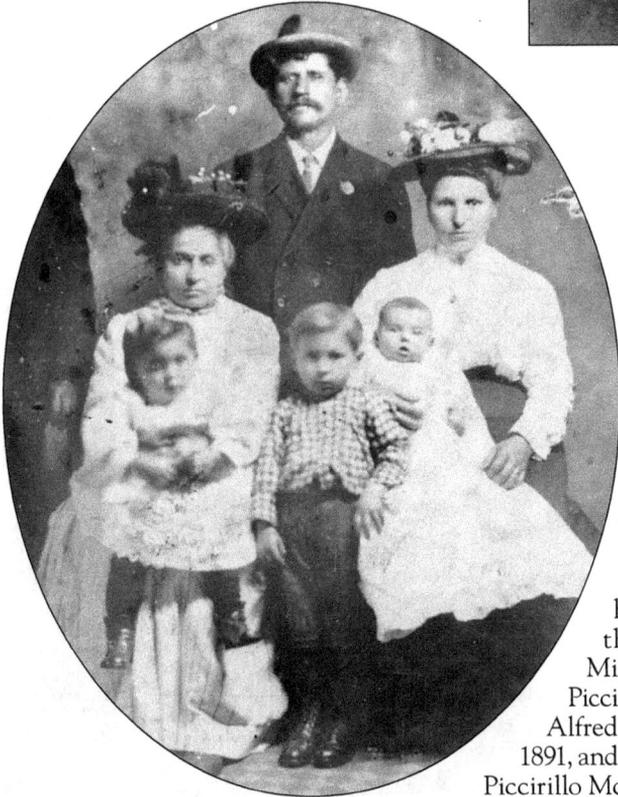

MICHAELANGELO PICCIRILLO WITH GRANDCHILDREN. Michaelangelo (standing in the rear) is pictured with family members; from left to right are his wife, Maria Pozzuto Piccirillo, holding their granddaughter Mary, grandson Michael (standing), and Carolina Zappa Piccirillo (wife of their son Giovanni) holding Alfred. Michaelangelo emigrated from Italy in 1891, and Maria came in 1902. (Courtesy of Sandy Piccirillo McFarland.)

DOMENICO "DOMINICK" AND ALBINA ZAPPA GALLICCHIO, C. 1906. Domenico was born in 1885 in the town of Bisaccia, Italy. He came to America in 1903 and married Albina Zappa in 1906. Dominick was a stationary fireman at the Fifth Third Bank Building in Cincinnati, Ohio. His responsibility was to care for the boiler and heating system for the building. (Courtesy of Joyce Smith Deidesheimer.)

MICHAEL GALLICCHIO, C. 1910. Michael was the last of three brothers in a family of eight to emigrate from Italy, where his family raised horses for the Italian government. He came to America when he was 16 years old aboard the *Duca de Genova*, which arrived at Ellis Island on March 14, 1910. Michael initially settled in Cote Brilliante and raised four children, Robert, John, Anthony, and Rosemarie. (Courtesy of Bob Bramel.)

LOUIS "LUIGI" ZECHELLA AND CLARA ZAPPA WEDDING, APRIL 6, 1916. The courtship of Luigi and Clara was typical of many Italian courtships of the time. They always had to have an escort whenever they were together, and together usually meant visiting at Clara's home. Luigi and Clara were married for over 50 years and raised seven children: Edith, Rosie, Tony, Clara, Millie, Lou, and Jim. (Courtesy of Mary Cooper.)

EUGENE "GENE" GIANCOLA AND ROSINA "ROSIE" PORFIRIO WEDDING, C. 1916. Gene and Rosie immigrated to America in 1893 and 1913 respectively. Gene was a much-respected citizen who held leadership roles in every facet of life in Clifton, later called South Newport. Not only was he active in civic organizations, but he was also committed to his church. Rosie was a homemaker and worked as a seamstress for Hyde Park Clothes. (Courtesy of R. Toni Bungenstock.)

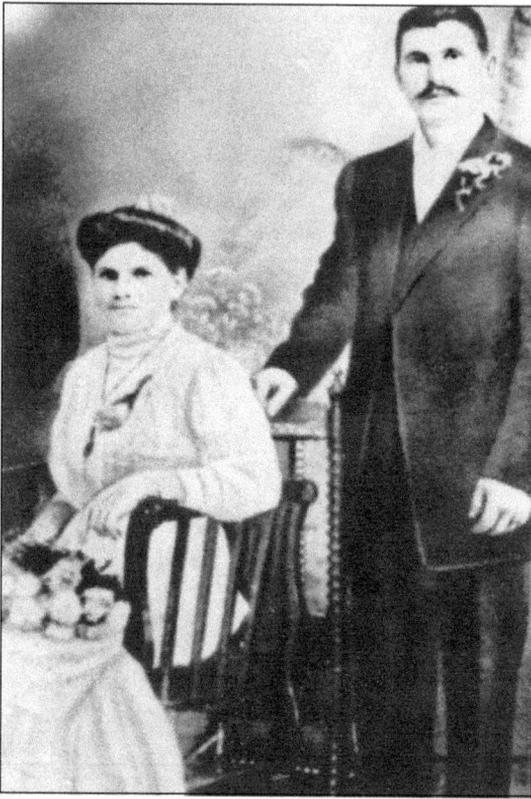

ENRICO "HENRY" AND ROSINA "ROSE" COLECCHIA ZAPPA WEDDING, C. 1896. Henry and Rose arrived in the United States in April 1896. Henry Sr. initially worked for Newport Rolling Mill, where he was seriously injured on the job. In 1927, he died of cancer at the age of 52. Rose lived to be 79. (Courtesy of Bertha Zappa Stahl.)

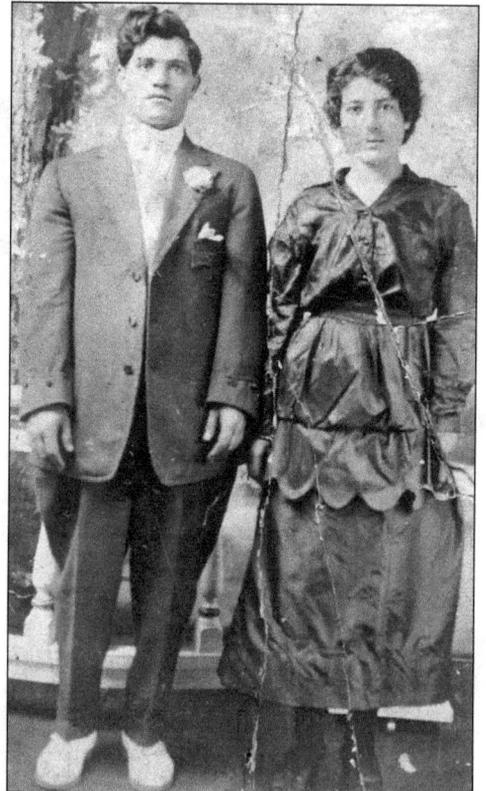

FORTUNATO AND CARMELLA STELLITANO PANGALLO. Fortunato and Carmella were both from the mountain village of Roccaforte del Greco, Reggio di Calabria, in the region of Calabria, Italy. Fortunato arrived in America on May 5, 1910, and Carmella arrived on June 2, 1915. Urged to marry by their parents, their marriage lasted for 53 years, until Fortunato's death on June 23, 1971. (Courtesy of the Pangallo family.)

Two

SPAGHETTI KNOB

The city of Clifton's story begins when it was incorporated on February 15, 1888. At that time, there were about four existing houses in the city. By 1889, some 200 acres were being developed. Clifton bordered Newport along the railroad tracks to the north, Southgate on the south, Alexandria Pike (U.S. 27) on the east, and the Licking Pike on the west. Clifton fought off annexation by Newport for 29 years, losing its battle to remain independent on November 26, 1935. The citizens of the southern end of Newport never accepted defeat and coined their city "South Newport."

In the early 1900s, Clifton became a stronghold for the Italian immigrants who came to the Northern Kentucky area, thus the nickname "Spaghetti Knob." At that time, the Italians were the last of the ethnic migrations into the area. They joined the already established Germans and Irish who immigrated into the area from 1816 to 1854. Cheap land prices and a resemblance to their homeland made Clifton a desirable place for the Italians to live. Although the area was barren, with no infrastructure, it was ripe for backyard gardens and raising animals to slaughter and prepare for the dinner table. The Italians were proud of their heritage and celebrated it with traditional foods, wine making, music, and family. Since a vast majority of Italian immigrants were Catholics, they celebrated their patron saints with traditional feasts, street parades, and festivals, a custom that they brought over from Italy. The Feast of the Assumption of the Blessed Virgin Mary was at the heart of the Italian community.

Through the years, the Italians on Spaghetti Knob engaged themselves in all aspects of everyday living. They established both social and civic organizations such as the Third Alarm, which raised funds for the Clifton Fire Department. They participated in the South Newport Booster Civic and Social Club and many other organizations.

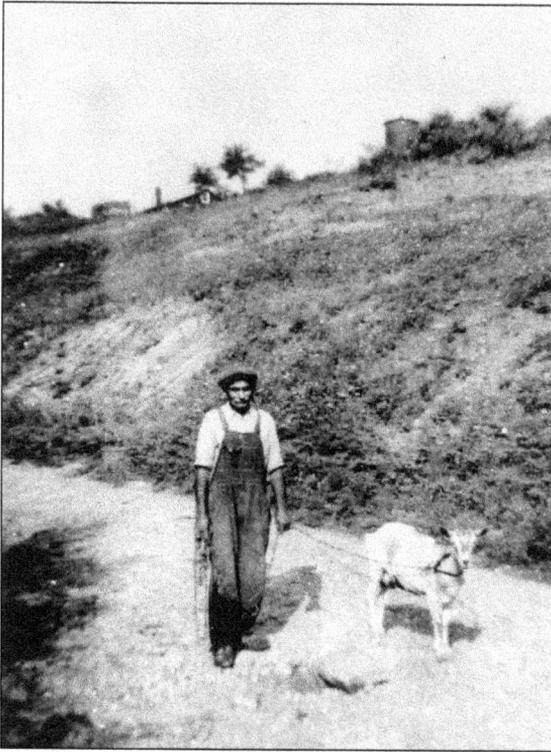

JOSHEPPI LESTINGI. In the early 1900s, Clifton was barren, with no infrastructure in place, and was largely unpopulated. Goats, chickens, and pigs were commonplace on "The Hill." Here Josheppi Lestingi takes a walk with his goat on Amelia Street, located at the bottom of Santini's Hill, later known as Grandview Gardens. (Courtesy of the Lestingi family.)

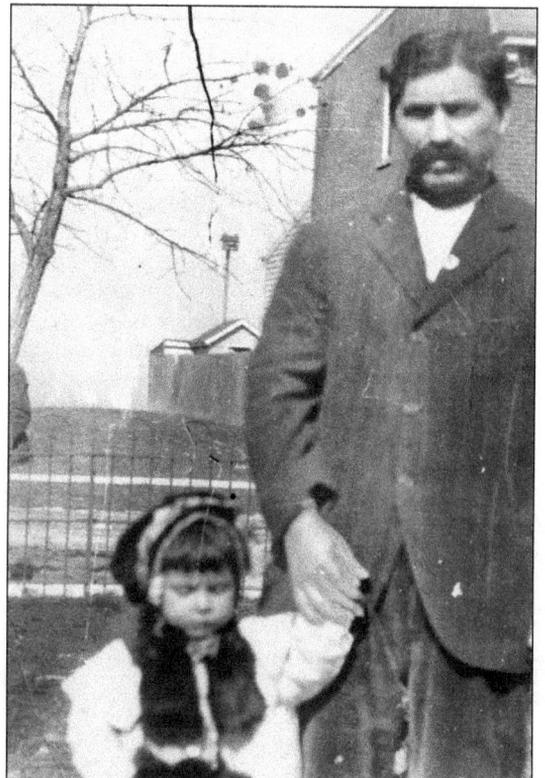

ENRICO "HENRY" ZAPPA AND DAUGHTER BERTHA ON SPAGHETTI KNOB, C. 1918. This photograph was taken facing 205 Main Avenue, the house that Henry built in 1909 for his family. Visible in the background is the PNC Tower (formerly known as the Union Central Life Insurance building), located in downtown Cincinnati. In addition to Bertha, the Zappas raised eight more children: Clara, Nicolas, Mary, Angie, Helena (who died at the age of five), Henry "Happy" Jr., Stella, and Anna. (Courtesy of Bertha Zappa Stahl.)

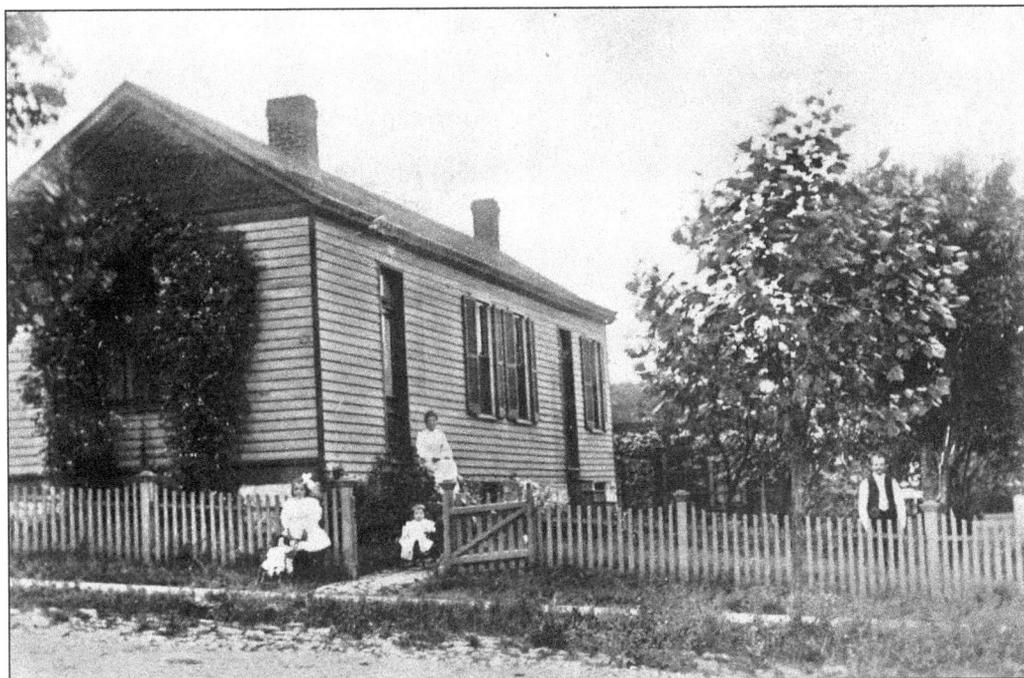

THE LEDONNE FAMILY BIRTHPLACE, C. 1909. Above, this framed shotgun-style house on Schneider Avenue (now 172 Main Avenue) was the original family home of the Anthony Ledonne family. Shown in this photograph are Anthony and Helen with their daughters Mary (age six) and Ida (age 18 months). As the family grew, they built the brick house next door where, in addition to Mary and Ida, they raised their children Pete, Palmer, John, Joe, Evelyn, and Delores. At right, Helen Sabatino Ledonne is busy painting the family home. In the early 1900s, this house was one property with a cottage next to it that was used as a grocery store. (Courtesy of Mary Dilillo.)

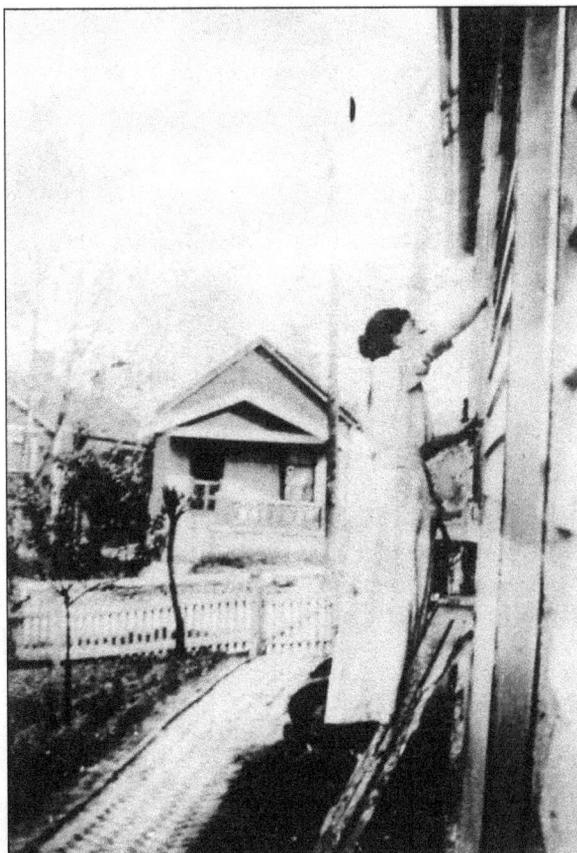

FRANK LESTINGI. Frank Lestingi was born on December 13, 1898, in the town of Conversano, Italy, and received his American citizenship in Akron, Ohio, on March 21, 1929. He married Margaret Spizzica on January 26, 1933. Frank held a variety of jobs, such as laying cobblestone for 50¢ a day and filling in the canal in Cincinnati, before ending his work career as a presser at Hyde Park Clothes. (Courtesy of Lestingi family.)

MARGARET SPIZZICA LESTINGI, 1933. Margaret was born on July 14, 1912, in the city of Messina, Sicily. She was 21 years old when she married Frank Lestingi, and she became an American citizen on April 6, 1943. Margaret worked at Spizzica's Grocery Store in Cincinnati, which was owned by her parents, Joseph and Caterina Spizzica. Later she worked as a seamstress at Hyde Park Clothes. (Courtesy of the Lestingi family.)

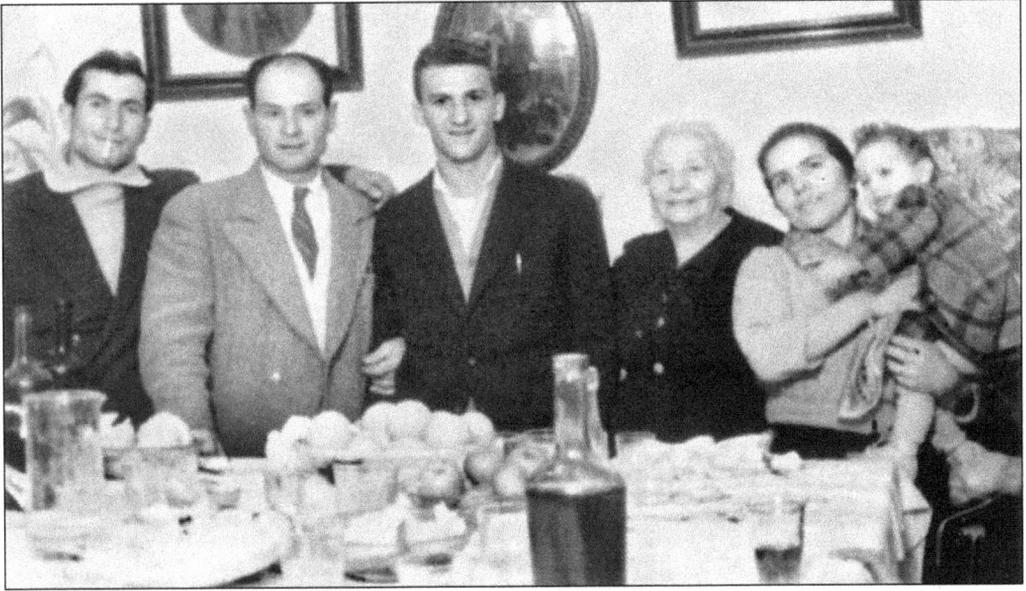

JOE LESTINGI VISITS ITALY, C. 1953. Young Joe had the opportunity to visit his uncle Dominic and grandmother Annunziata Napolene Lestingi in 1953 while serving in the U.S. Navy during the Korean War. In World War II, Dominic, fearing he would have to fight Joe's father Frank, avoided being drafted in the Italian Army by puncturing his eardrum with a long hairpin. Shown from left to right are Sammy (Dominic's son-in-law), Dominic, Joe, Annunziata, and Nancy (Dominic's daughter), holding her child. (Courtesy of the Lestingi family.)

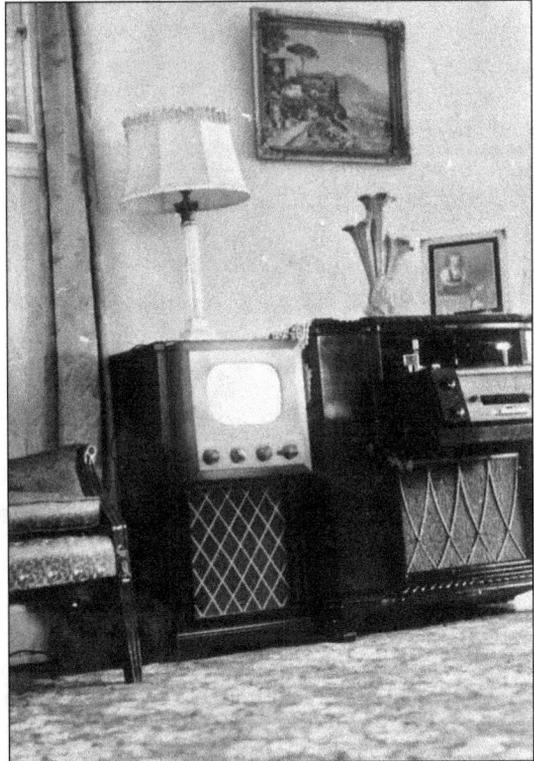

LESTINGI LIVING ROOM, C. 1947. This vintage photograph showing a new black-and-white television in 1947 is indicative of the many inventions that came to be during the lifetimes of these new immigrants. (Courtesy of the Lestingi family.)

The Fortunato and Carmella Stellitano Pangallo Family. Fortunato supported his family over the years by first working in the coal mines in West Virginia and later at a tailoring company in Cincinnati, Ohio. He also did maintenance work for the City of Clifton. He proudly served his country during World War I. Carmella attended to every need of her children and grandchildren. They raised 14 children (two additional children died at birth). They left the

lasting legacy of having one of the largest Italian families living in the Newport area. Today their descendants total over 318, including great-great-grandchildren. From left to right are (first row) Fortunato Jr., Roy, and Jim; (second row) Sue, Frank, Carmella, Fortunato, and Carmella; (third row) Catherine, Rocco, Tony, Eleanor, Beppi, Mimi, Agnes, and Marco. (Courtesy of the Pangallo family.)

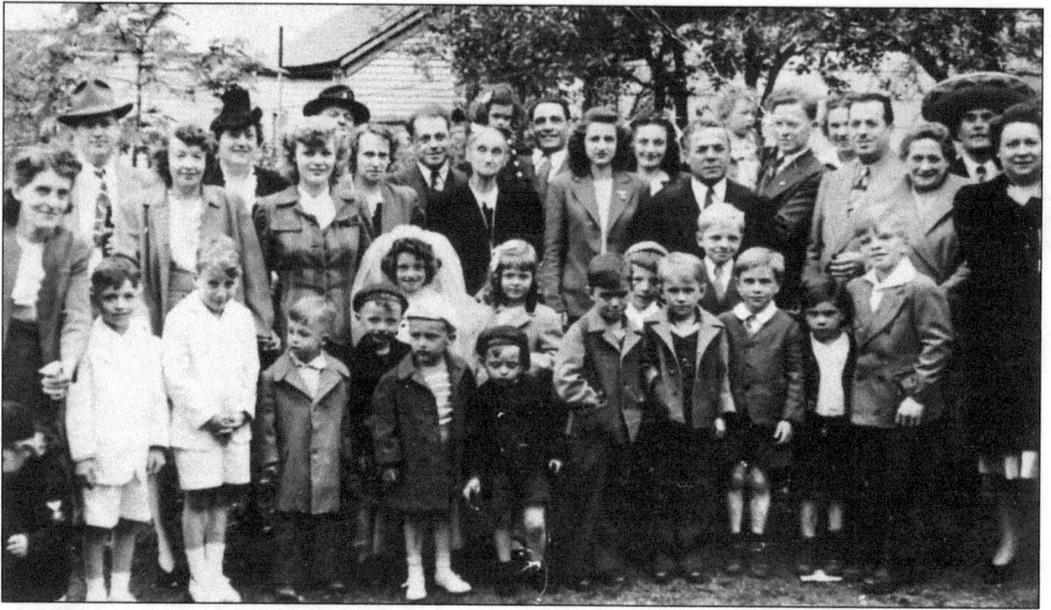

A GATHERING AT YOUNG'S COTTAGE. This photograph taken in 1944 after the first Holy Communion ceremony at St. Vincent de Paul Church exemplifies the multicultural neighborhood of South Newport. The three children in white participated in the ceremony; they are Maureen Young, Eddie Eviston (the smallest boy), and Ed Hunkemoeller (next to Eddie). Other families in this photograph are members of the Young, Scott, Eviston, Ferrara, Giancola, Greco, and Ledonne families. (Courtesy of the Ciafardini family.)

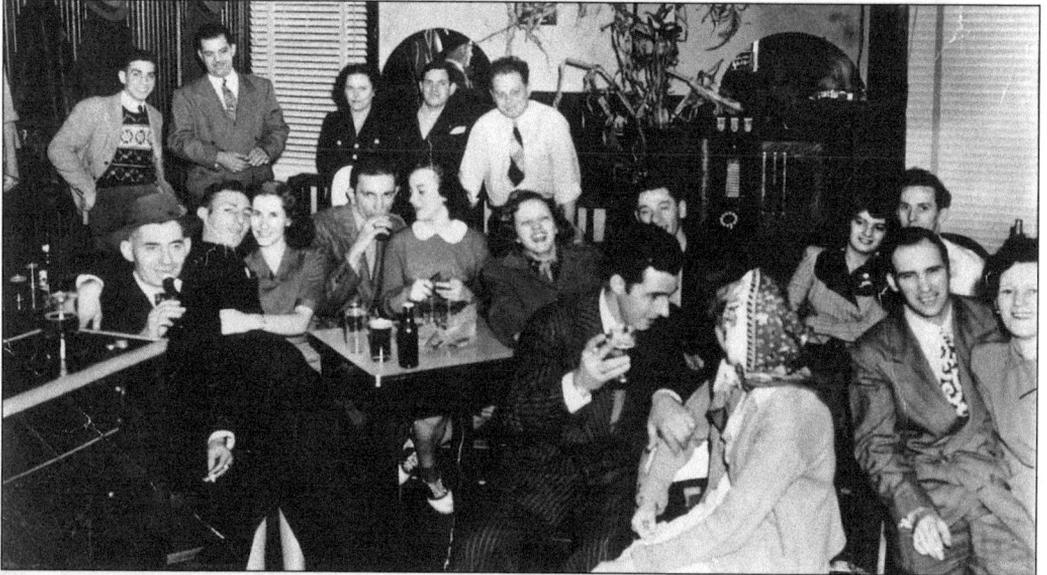

YOUNG'S COTTAGE, C. 1948. Patrons shown in this photograph from left to right are (first row) Al Piccirillo, Grace Beike, and two unidentified; (second row) John Piccirillo Sr., Bonnie Sarge, Tony Sarge, Marie Dunn, and Earl Dunn; (third row, seated behind the table) Johnny Piccirillo, Betty Piccirillo, Dominic Calla, and Adaline Barnet; (fourth row) Herman Fiascone, Jim Gallucci, Catherine Owen, Eugene Owen, and Dave Young, owner. (Courtesy of Anthony "Tony" and Bonnie Sarge.)

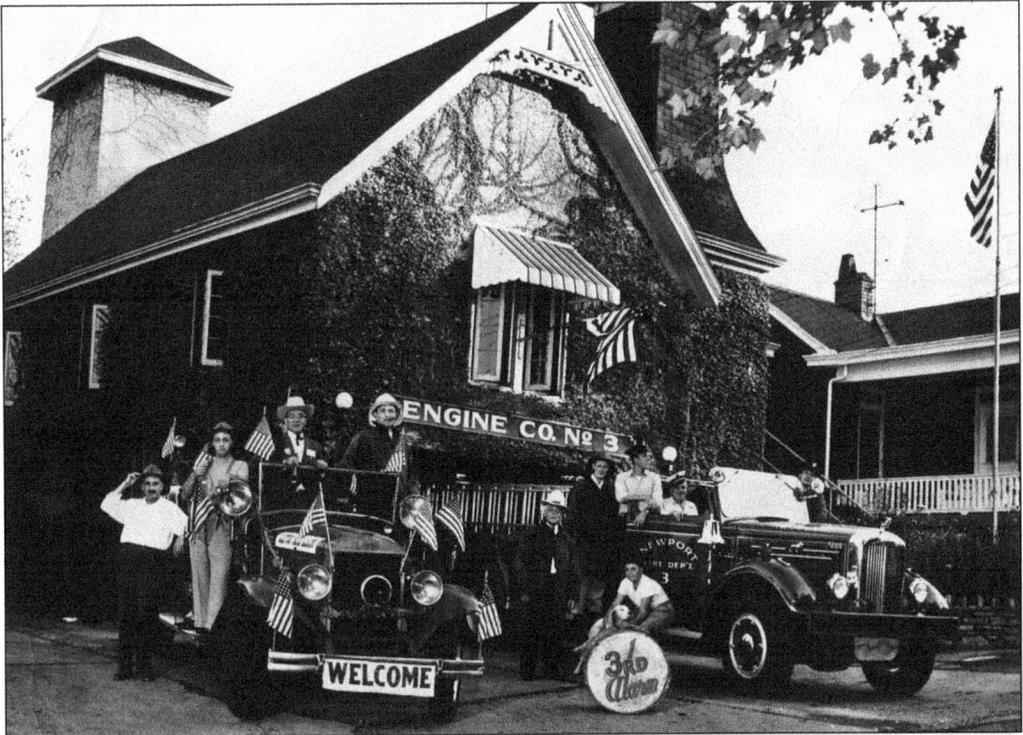

ENGINE COMPANY NO. 3. This firehouse has a long history in South Newport. Originally it was the Lindsey home, which was sold to the City of Clifton and became the city building and courtroom. Later it became a firehouse, and the Clifton Third Alarm would conduct fund-raising events in order to help support the firehouse. Some of the members of the organization are shown in this picture. (Courtesy of the Ciafardini family.)

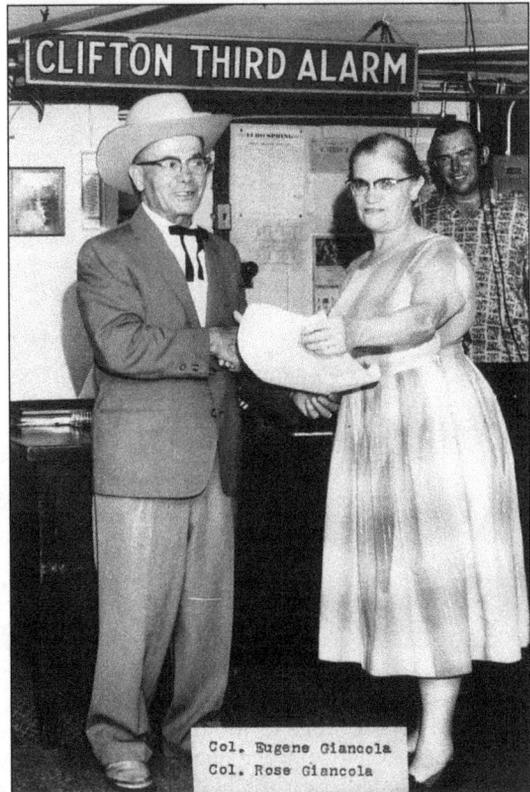

Col. Eugene Giancola
Col. Rose Giancola

KENTUCKY COLONELS EUGENE AND ROSIE GIANCOLA. A Kentucky Colonel is an honorary title granted to individuals by the governor of Kentucky. It is the highest honor issued by the State of Kentucky. Those who are nominated for the honor must have demonstrated contributions to the community, state, or nation. (Courtesy of Gayle Forte Groeschen.)

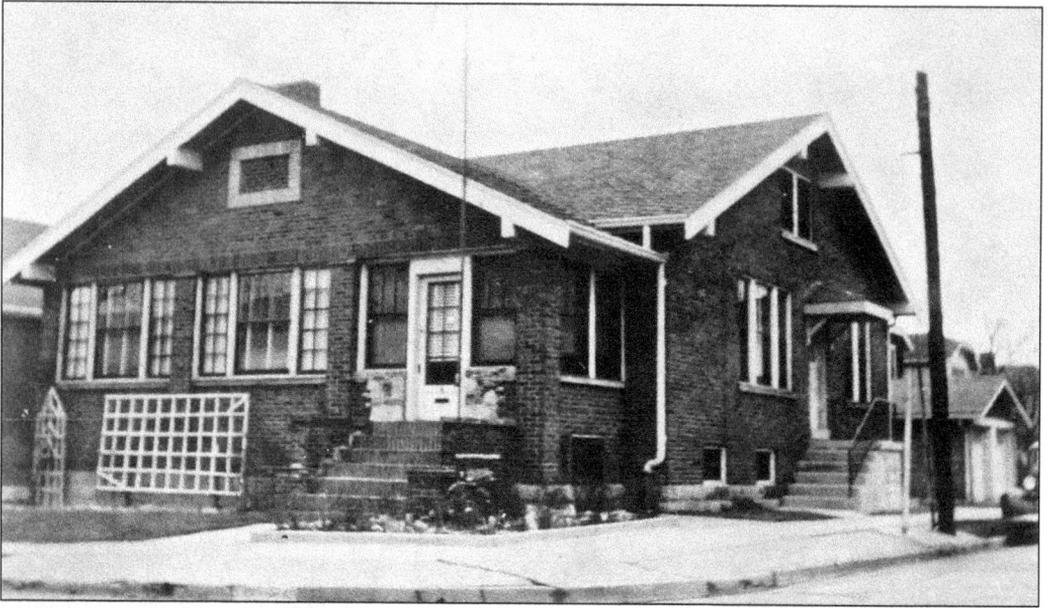

EUGENE AND ROSIE GIANCOLA HOME. This home on the corner of Main Avenue and Ash Street in South Newport was open to all. Countless meetings were held there for the Clifton Third Alarm. During World War II, the *Hill Top Herald*, a local newspaper sent to area servicemen and distributed within the community, was printed in the basement. (Courtesy of R. Toni Bungenstock.)

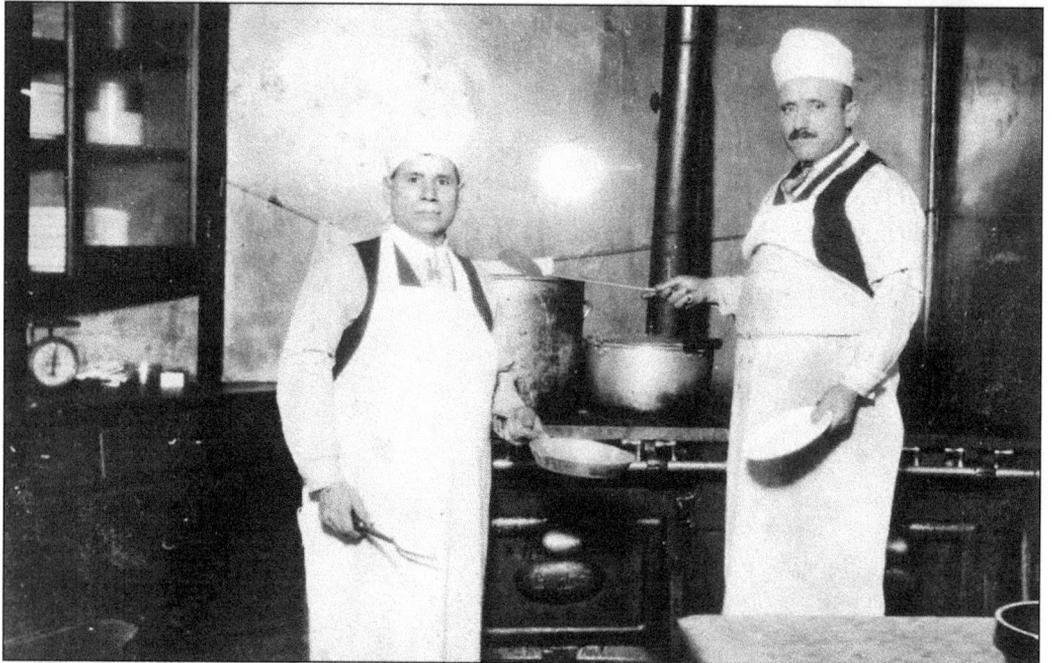

ITALIAN COOKING. Although the women did most of the cooking in an Italian family, the men often prepared meals, too. Meals consisted of what was available from the garden; spaghetti sauce simmered on the stove for hours, with the wonderful aroma filling the house. Pictured at the left is Eugene Giancola; the man on the right is Alphonse Raniero, who is standing on a box or platform in order to stir the large pots. (Courtesy of R. Toni Bungenstock.)

THE VACCA CHILDREN. The four children of Raffaele and Angelina from left to right are Mary Burdette, Josephine Brown, Al, and Dante "Danny" (holding Josephine's son Jimmy). Raffaele worked for the railroad out of the Cincinnati Union Terminal. The family resided at 24 West Thirteenth Street. (Courtesy of the Vacca family.)

ANTONIO AND MARIA DIGIACOMO MUSILLI FAMILY, C. 1930. Antonio and Maria emigrated from San Pietro Avellana, Isernia, Molise, in late 1913 or early 1914. The Musillis bought their home on Clifton Avenue in 1920. Shown in the photograph are Antonio and Maria with daughters Jennie (left) and Josephine. (Courtesy of Jennie Musilli Wogan Nadaud.)

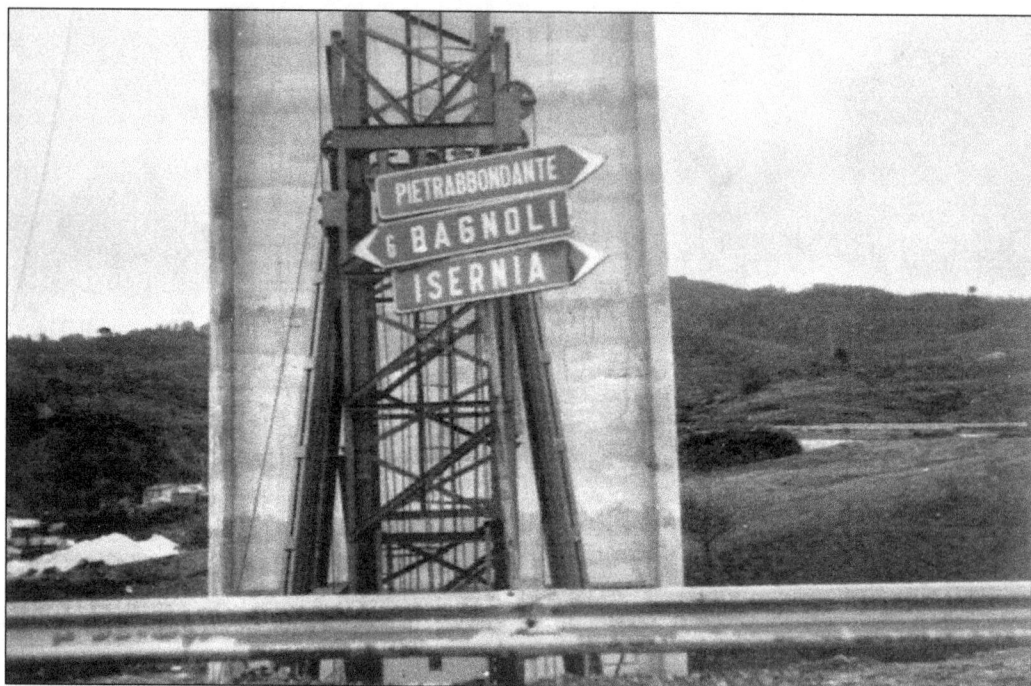

STREET SIGN. Bagnoli del Trigno is located in the Trigno Valley, Isernia, Molise. Prior to 1963, it was part of the province of Campobasso. The Greco, Pellillo, and Ialungo families emigrated from that area and settled in Clifton. (Courtesy of the Pat Greco family.)

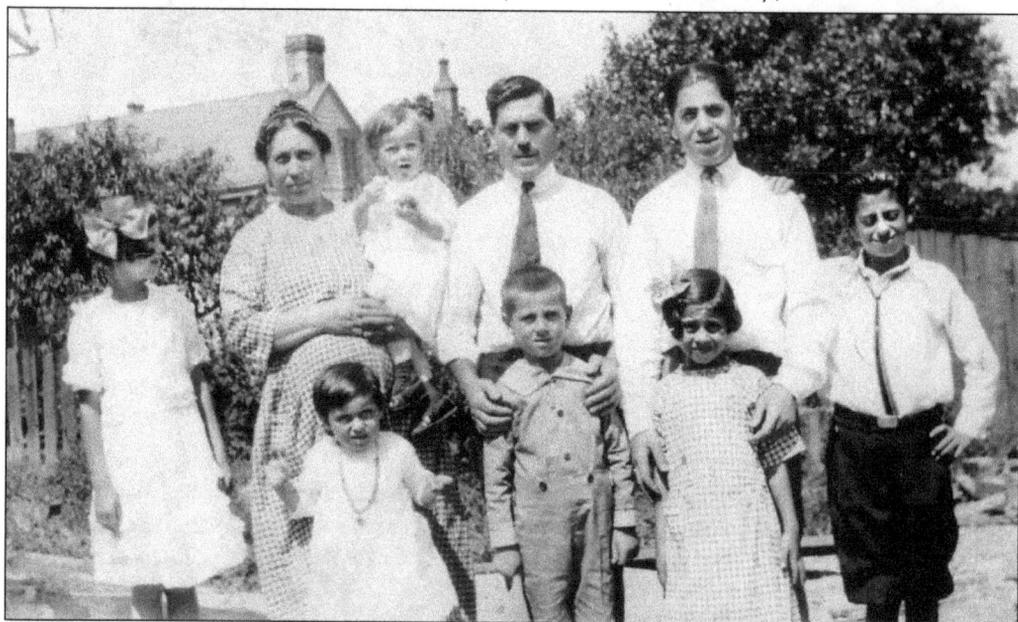

VITALE AND AMERINA PELLILLO GRECO FAMILY. Vitale came to America on May 4, 1905, and worked as a field laborer. By 1911, his wife and son Pasquale "Pat" joined him in America, and they began their new life together. Family members from left to right are (first row) Madge, Bill, and Stella; (second row) Millie, Amerina holding baby Sylvia, Vitale, Pasquale, and Victor. (Courtesy of the Pat Greco family.)

WINE PRESS. Winemaking was a family event. Fruit was separated from the stems, placed in large containers, and crushed with bare feet. Then the press crushing removed the grape juice. Yeast was added for fermentation, and the liquid was poured into sulfur-charred whiskey barrels, which were sealed and stacked on their sides so that the sediment would rise to the top and out the bunghole. The barrels were stored and aged for months. (Courtesy of the Pangallo family.)

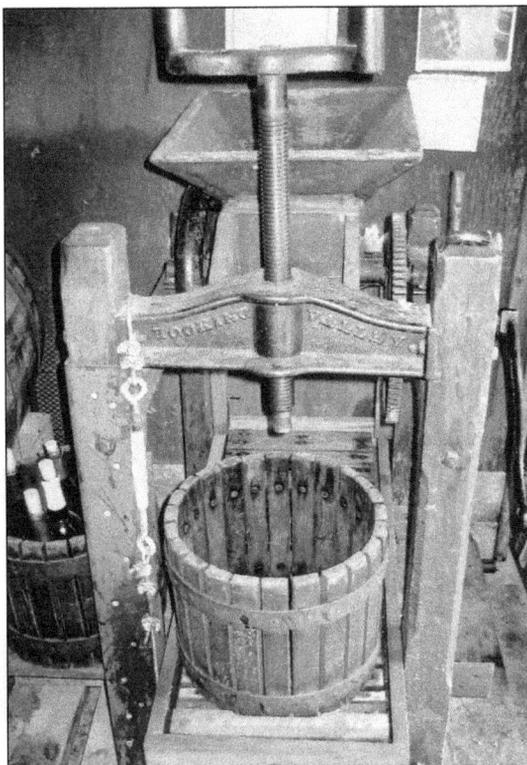

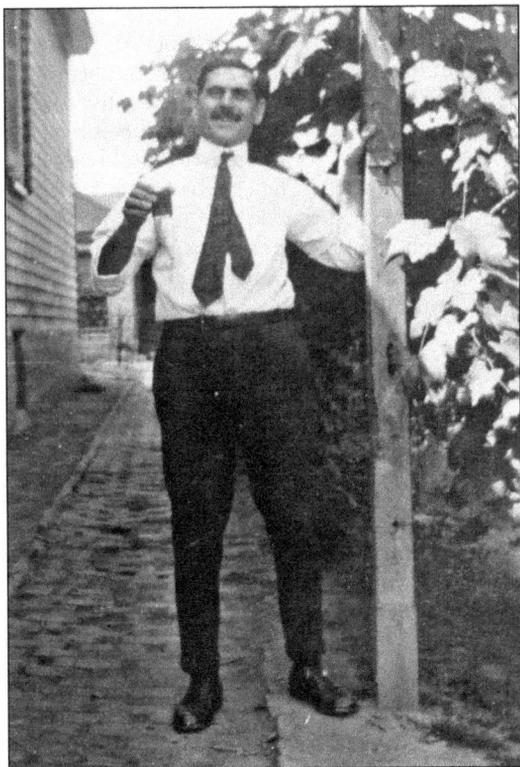

ITALIAN SALUTE. Vitale Greco stands next to the grapevines in his side yard at 165 Main Avenue. Vitale, like all the other Italians on Spaghetti Knob, grew and harvested his own grapes for winemaking. Typically, each family made several hundred gallons of wine per year. Some of the batches became vinegar for cooking and salad dressings. (Courtesy of Vickie and Gerry Greco.)

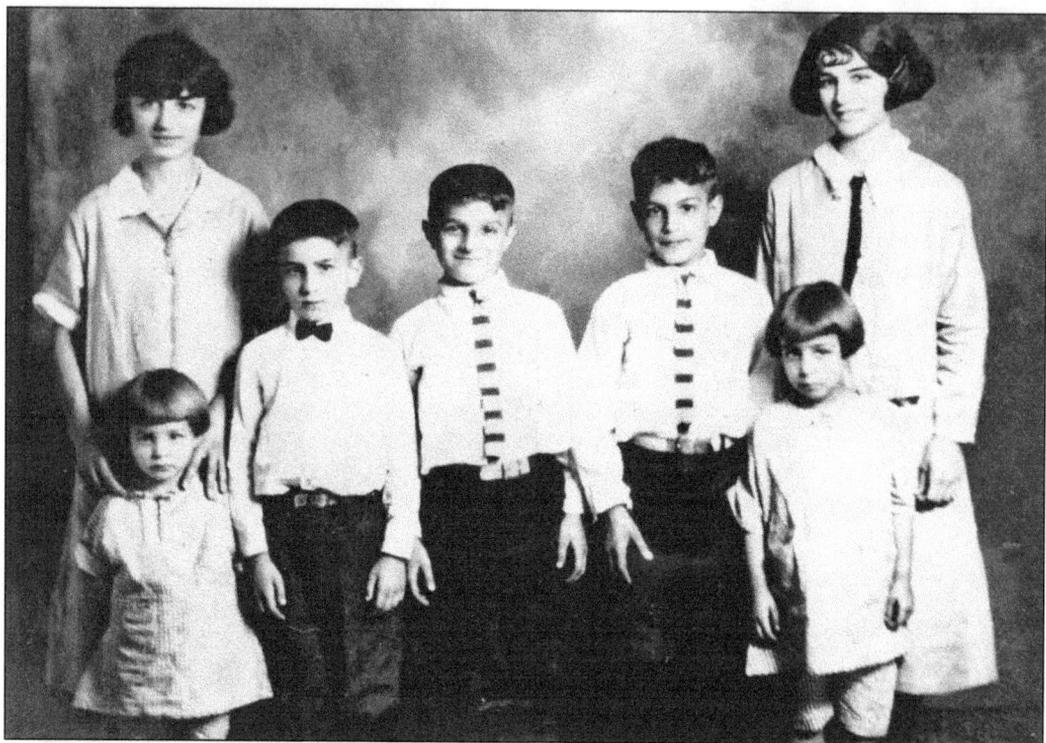

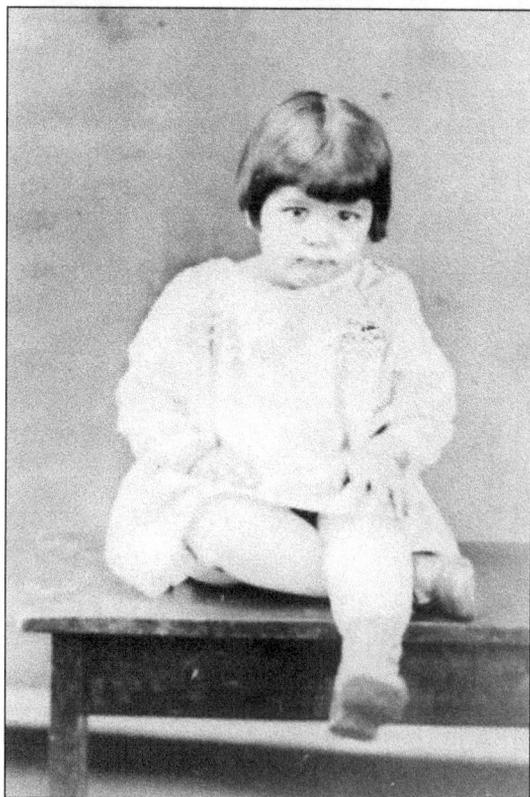

JOHN AND CARMELA CIAFARDINI
CHILDREN. After Carmela passed away
on December 7, 1924, John put his smaller
children into four different orphanages
in West Virginia. The two oldest lived
with relatives until they could be out
on their own. John remarried and had
another family. The children from left to
right are (first row) Gloria, Pasquale "Pat,"
Joseph, Nicholas, and Gilda; (second row)
Caroline "Lena" and Rosa. (Courtesy of the
Ciafardini family.)

ANITA CIAFARDINI, C. 1927. Anita, as
a baby, was taken care of by relatives. At
about the age of three, she was placed in
St. Joseph Orphanage, located in Cold
Spring, Kentucky. It wasn't until she was
eight years old that she first met her sisters
Gilda and Gloria at Orphanage Day at
Coney Island in Cincinnati. (Courtesy of
the Myers family.)

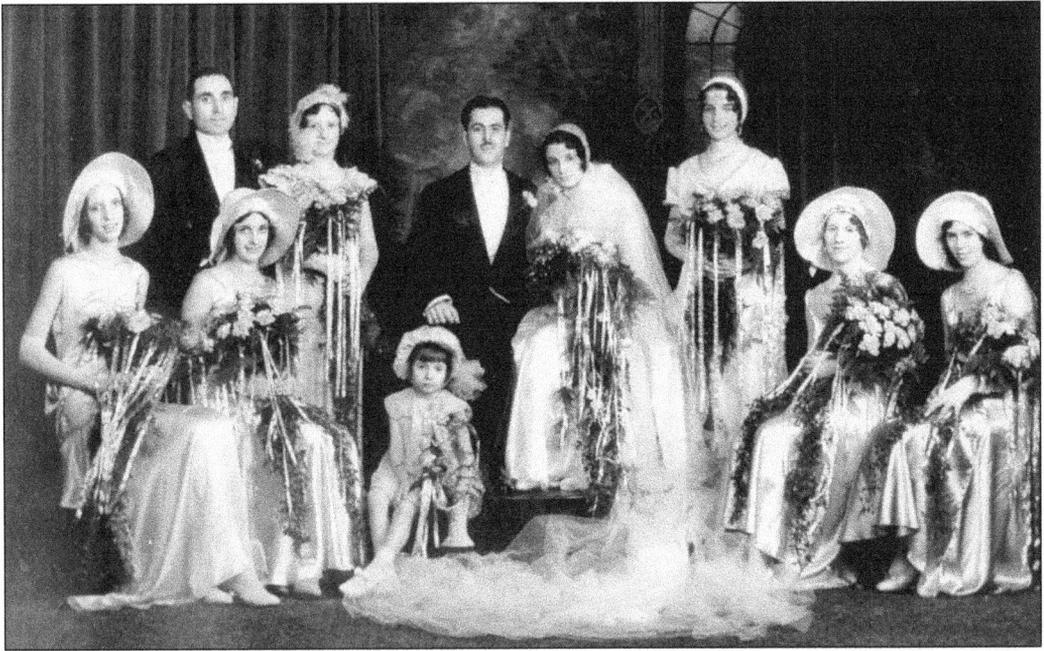

THE WEDDING OF CAROLINE "LENA" CIAFARDINI AND PASQUALE "PAT" GRECO. Pat and Lena married on September 23, 1931. As soon as they could, they began bringing home Lena's brothers and sisters, one at a time, from the orphanages to live with them at 210 Main Avenue in Clifton. Pat and Lena had three children of their own, Patty Ann (who died tragically at the age of 22), Albert "Buddy," and Rosalie. (Courtesy of the Ciafardini family.)

THE GRECO-CIAFARDINI HOME. Pat and Lena Greco purchased 210 Main Avenue in 1935, when its original owner lost it during the Depression. In 1955, the house was sold to Pat and Alma Wolfzorn Ciafardini, where they raised their family of seven children: Tony, twin girls Pat and Pam, Bernie, Monica, Philip, and Rosina. Pictured in the photograph is Pat and Lena's daughter Rosalie. (Courtesy of the Pat Greco family.)

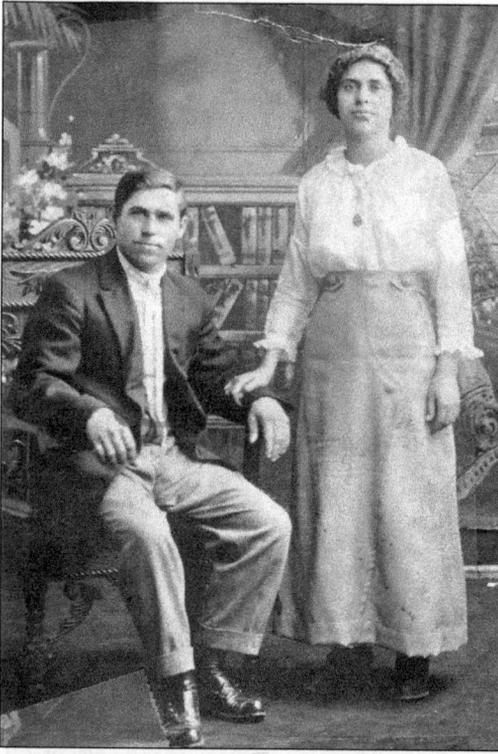

PAUL BUEMI SR. AND ELIZABETH "LIZZIE" ZAPPA BUEMI. Paul was born in the village of Fondachelli-fantina, Messina, Sicily, on May 24, 1888. He came to America in 1903 and lived in West Virginia before settling in Clifton. Elizabeth was born on May 28, 1898, on a return visit to Italy. She and Paul married on January 28, 1915. Mainstays of Spaghetti Knob, Paul and Lizzie raised five children: Carmelo, Mary Marcella, Joseph, Theodore, and Paul Jr. The Southern Railroad employed Paul Sr., and Lizzie was employed as a seamstress. (Courtesy of the Buemi family.)

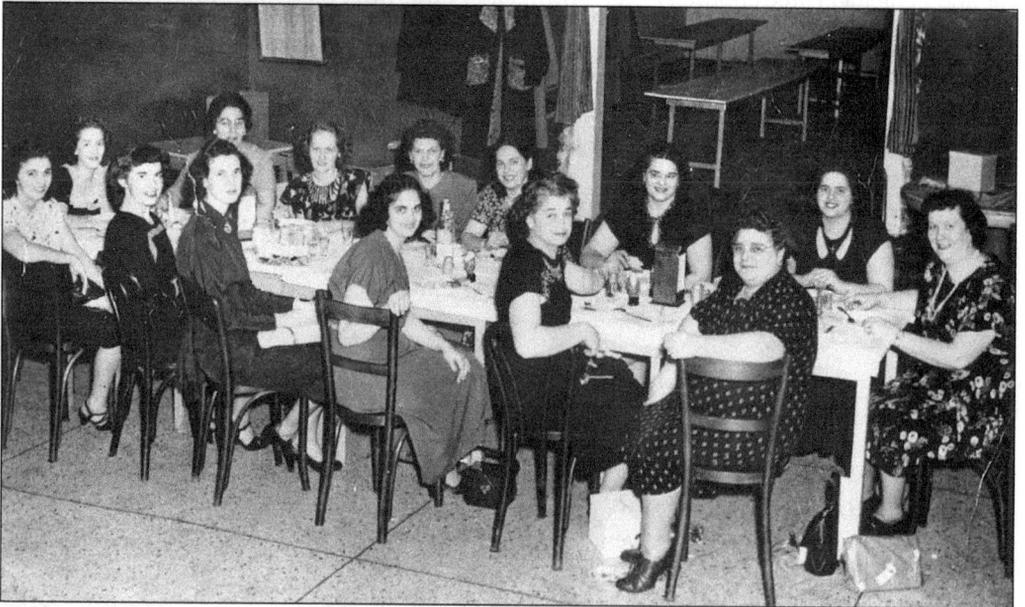

THE FAMILY CLUB, C. 1948. Family members enjoying dinner at Santini's Bar and Restaurant are, from left to right, (first row) Angie Auteri Buemi, Lois Veddern Petronio, Lucia Petronio Fricke, Geraldine Collerusso Schloemer, Mary Zappa Petronio, and Dena Zappa Francia; (second row) Evelyn Plummer Buemi, Elizabeth Zappa Buemi, Margie Accurso, Louise "Alice" Accurso, Marcella Buemi O'Brien, Mary Margaret "Marg" Zappa Collerusso, Jean Collerusso Raniero, and Mrs. ? Warner, a friend of Dena Zappa Francia. (Courtesy of the Buemi family.)

ALBINA ZAPPA GALLICCHIO WITH HER CHILDREN, 1917. Albina is shown here with her children Helen and Tony. The Gallicchio family lived at 46 Biehl Street in the house Dominick built for them. Albina died in 1919 at 26 years of age. Tony worked for the City of Newport, retiring as an assistant fire chief in the 1970s. Helen was a great contralto and loved to sing in area choirs. (Courtesy of Joyce Smith Deidesheimer.)

THE DOMINICK GALLICCHIO FAMILY, 1937. The Gallicchio family from left to right are Tony, Dot Kaufman Gallicchio, Frances Poole Gallicchio, their cousin Lucy (behind Frances), Dominick, Ike Smith, Helen Gallicchio Smith, and Helen's daughter Joyce. (Courtesy of Joyce Smith Deidesheimer.)

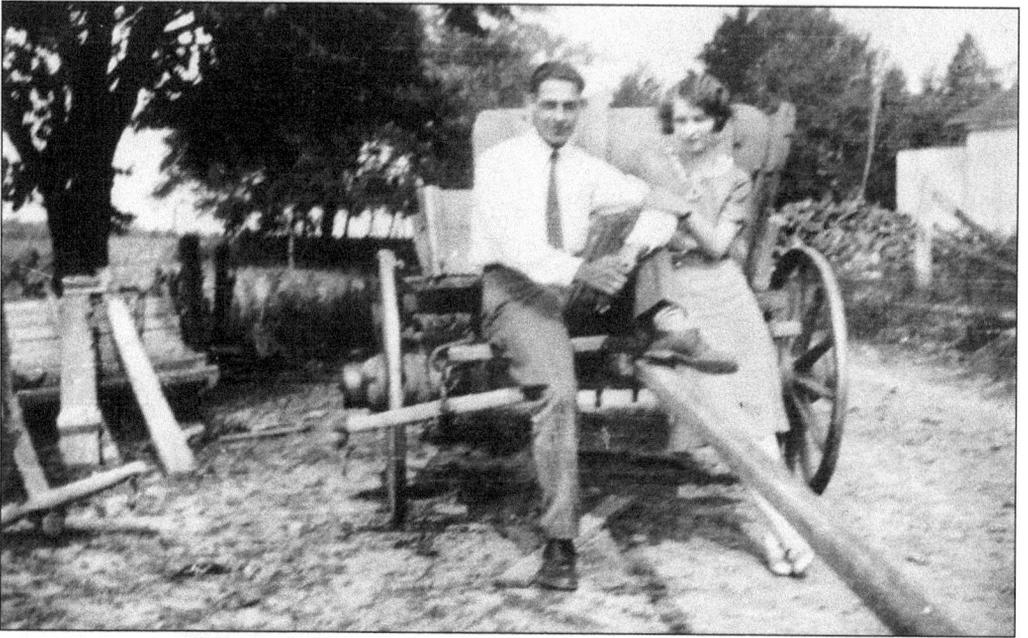

NICHOLAS AND LAURA BRANN FERRARA. Resting against the wagon in the backyard of 61 Biehl Street in South Newport is first-generation Italian American Nicholas Ferrara with Laura Brann Ferrara. Nick was one of 12 children born to Romolo and Felicita Digiacomo Ferrara, who emigrated from Ateleta, L'Aquila, Abruzzo, Italy, in 1905 and 1903 respectively. (Courtesy of Tom Ferrara.)

THE FERRARA FAMILY. This Ferrara family photograph was taken in the 1950s in the family living room. From left to right are Bonnie, Laura Brann Ferrara, Tom, and Nicholas. Son Tom served the community as a Newport city commissioner from 1982 to 1990. (Courtesy of Tom Ferrara.)

MICHAEL AND FILOMENA ZAPPA MARINO WEDDING, JUNE 24, 1916. With the onset of World War I coming, Filomena's father, Enrico Zappa Sr., came to America and worked for six months at a time, then returned home to escort his children, one at a time, to America. Unable to escort her, and with war imminent, he sent Filomena on a ship with friends. She joined her other siblings Enrico, Carolina, and Mary Asunta in Clifton in 1915. (Courtesy of the Marino family.)

THE MARINO GIRLS. Michael and Filomena lived in Newport their entire lives, raising their three daughters—Rose (left), Antoinette (center), and Angela (right)—on Biehl Street in South Newport. Although the Marino name did not survive in the area, their spirit does through the Flaig, Leising, Stevers, Lotz, Snodgrass, Riegler, Thompson, and Deimling families. (Courtesy of the Marino family.)

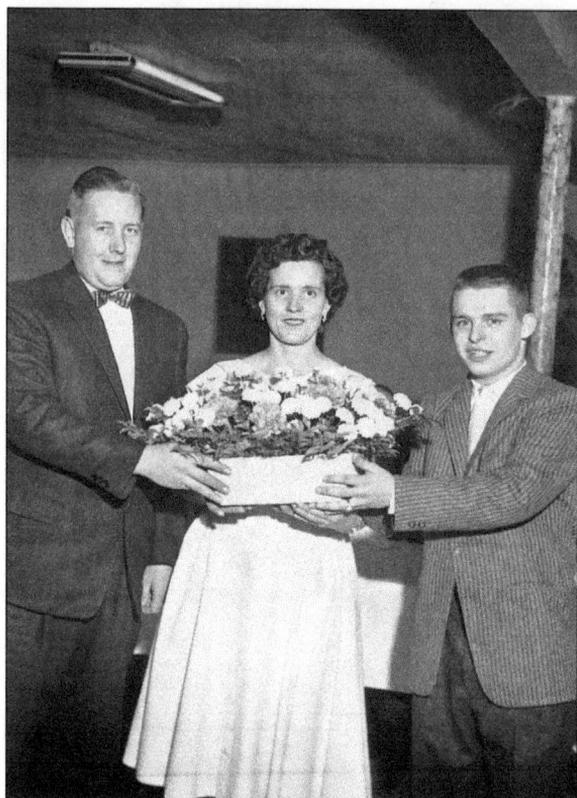

YOUNGEST PRESIDENT, C. 1959.
Ronnie Piccirillo, at age 19, was the youngest president of the South Newport Boosters Civic and Social Club. He is shown here with his mother, Mary Cornett Piccirillo, and Floyd Randall. The organization sponsored sporting events and Easter egg hunts for the children in the area. They also held dances and amateur boxing matches for the community, raising funds for various charities. (Courtesy of Sandy Piccirillo McFarland.)

POLITICS, 1951. South Newport was and still is a politically active neighborhood. An explanation for this may be that for years they had to fend off annexation attempts from Newport. Residents of South Newport continue to campaign for office and are supported by the community. Pictured here are friends and neighbors showing political cards for native son Bob Sidell, who was just elected mayor of Newport in 1951. (Courtesy of Tom Ferrara.)

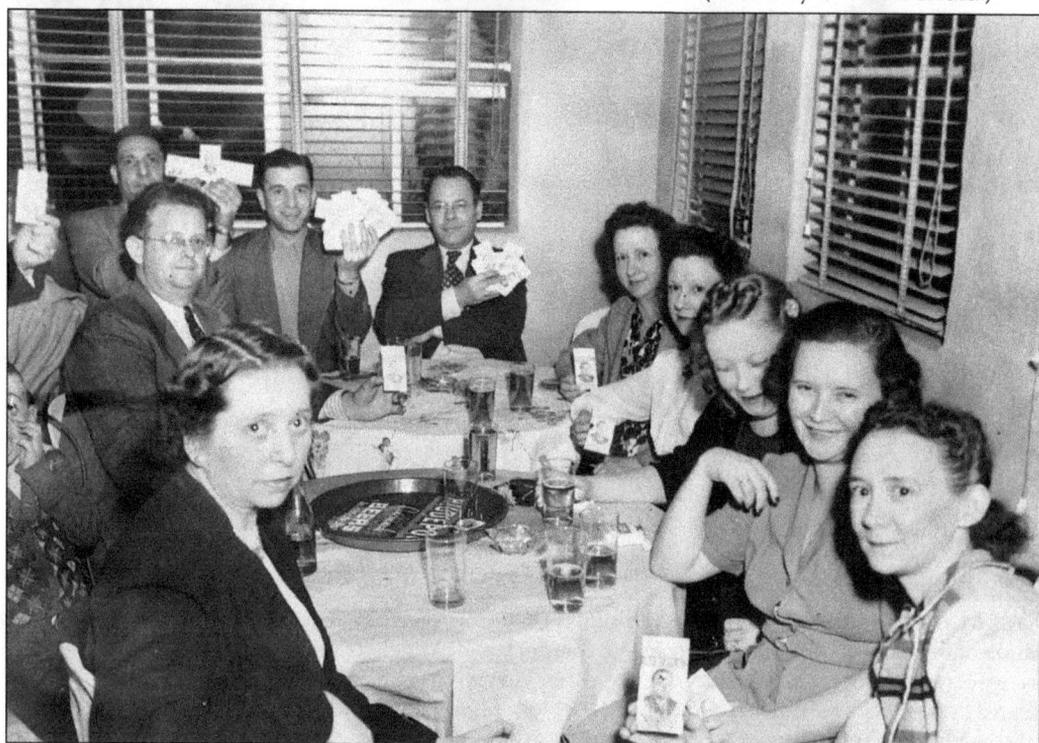

BACKYARD CARD GAME. In many Italian households, Sundays were reserved for getting together with extended family, cooking, and playing cards. Shown here from left to right are Tony Petti, Henry Petracco (on the ladder), Alex Barone, Albert Barone, and Ernest Pellillo enjoying a beautiful day in the backyard. (Courtesy of Mike Barone.)

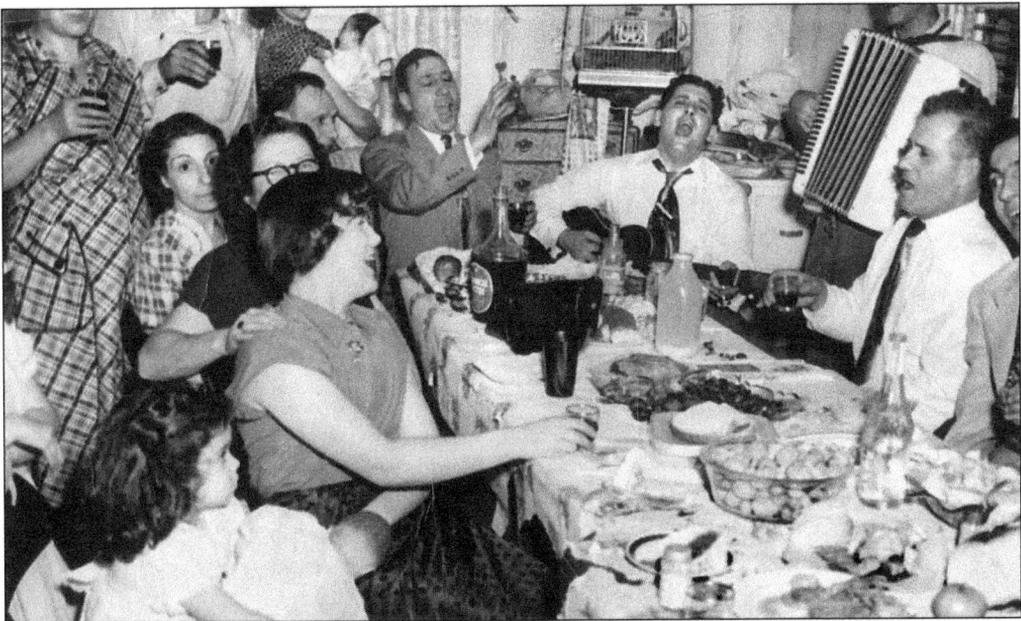

CHRISTMAS, C. 1946. At the Italian dinner table, there was always room for one more. Music and merriment were important to the Italian way of life. Here among family are friends and neighbors enjoying a special time together at the Pangallo home. Around the table from left to right are Diane Baioni, Jenny Pangallo, Margaret Lestingi, Frank Lestingi, Tony Calla, Reno Baioni, Fortunato Pangallo, and Dominic Calla. (Courtesy of the Pangallo family.)

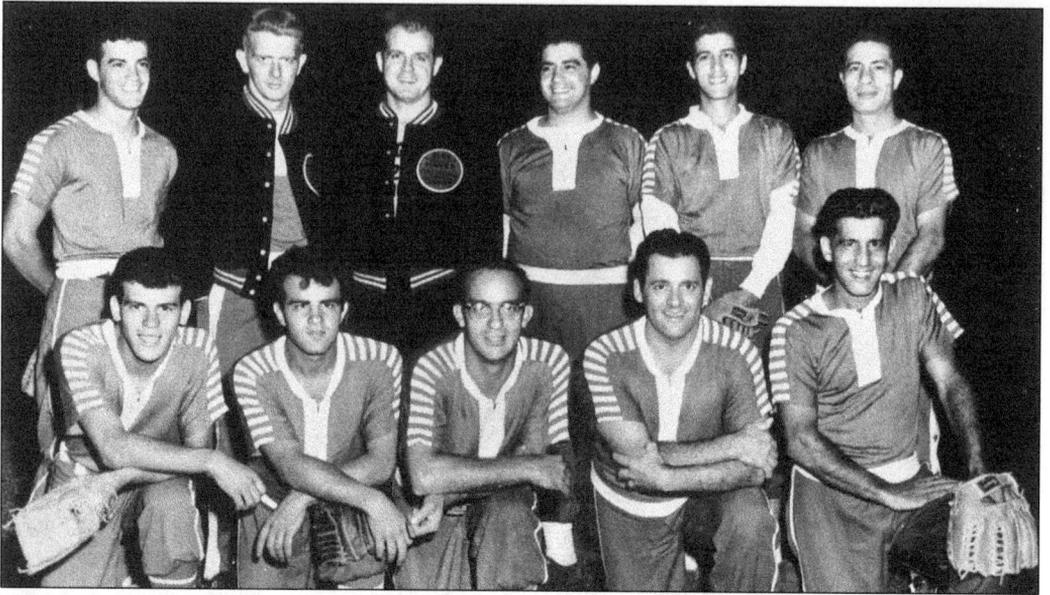

PANGALLO BASEBALL. A favorite pastime on the hill was baseball. Manor Catering sponsored this team of mostly Pangello family members with team manager Reno Baioni. From left to right are (first row) Roy, Vincent "Jimmy," Joe Zimmerman, Reno Baioni, and Joe "Beppi"; (second row) Fortunato Jr., Norbert "Red" Fenker, George "Jeep" Grawe, Tony, Frankie, and Mike. (Courtesy of the Pangallo family.)

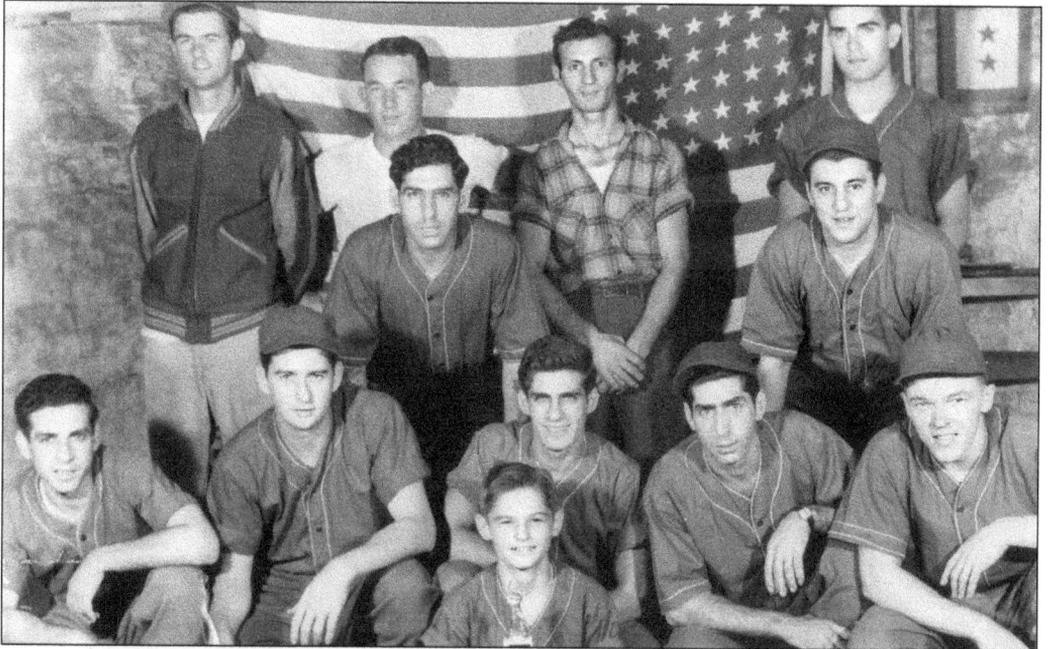

THE HILL TOP VETS. This baseball team was sponsored by the Hill Top Vets, a saloon located across from Engine Company No. 3 on Main Avenue in South Newport. Players from left to right are (first row) Herman Fiascone, Jack Simon, Teddy "Toots" Buemi, Bobby Simon (the boy), Carmen Buemi, and Harley Schultz; (second row) Joe Buemi and Al Vacca; (third row) Bill Simon, Marvin Daniels, Johnny Piccirillo, and Bobbie Myler. (Courtesy of the Vacca family.)

GRECO'S GROCERY STORE. After World War II, Victor "Toddy" and Dorothy Greco opened a neighborhood grocery store. Family grocery stores were conveniently located in neighborhoods where families could easily walk to get groceries, meats, and vegetables, not to mention ice cream. The Grecos operated the store until supermarkets entered the scene in 1962. (Courtesy of Vickie and Gerry Greco.)

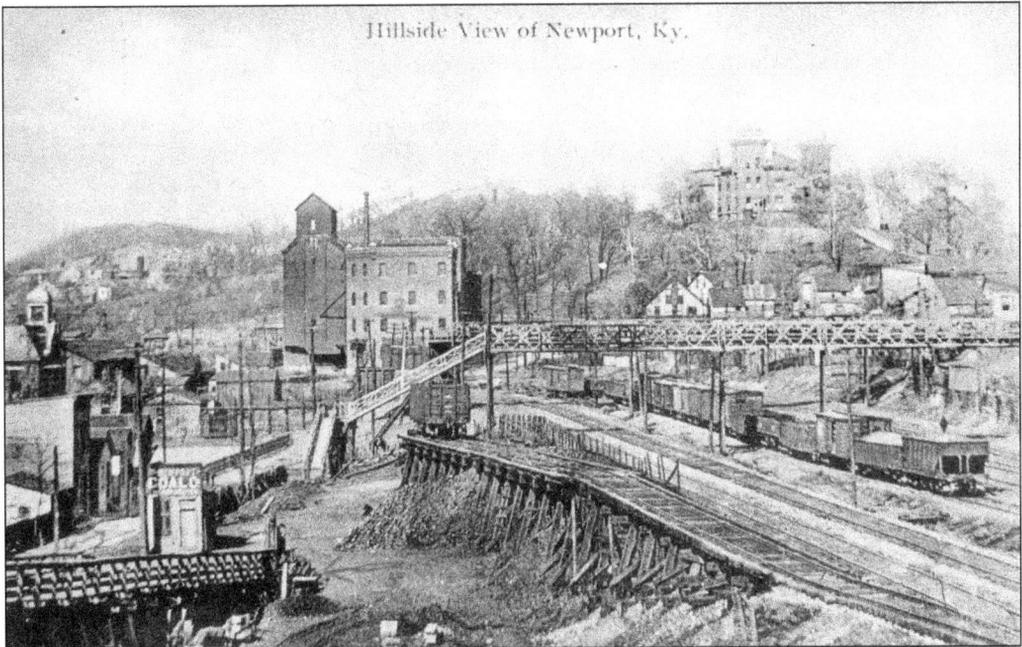

HILLSIDE VIEW OF NEWPORT, KENTUCKY, LOOKING SOUTHEAST. This photograph shows a southeasterly view of Newport from the former Wagon Bridge. This bridge linked Spaghetti Knob to downtown Newport. It also shows the railroad lines that ran along the Thirteenth Street hillside. The former landmark of Mount St. Martin is viewable on the hillside of Monmouth and Fifteenth Streets. (Courtesy of www.nkyviews.com.)

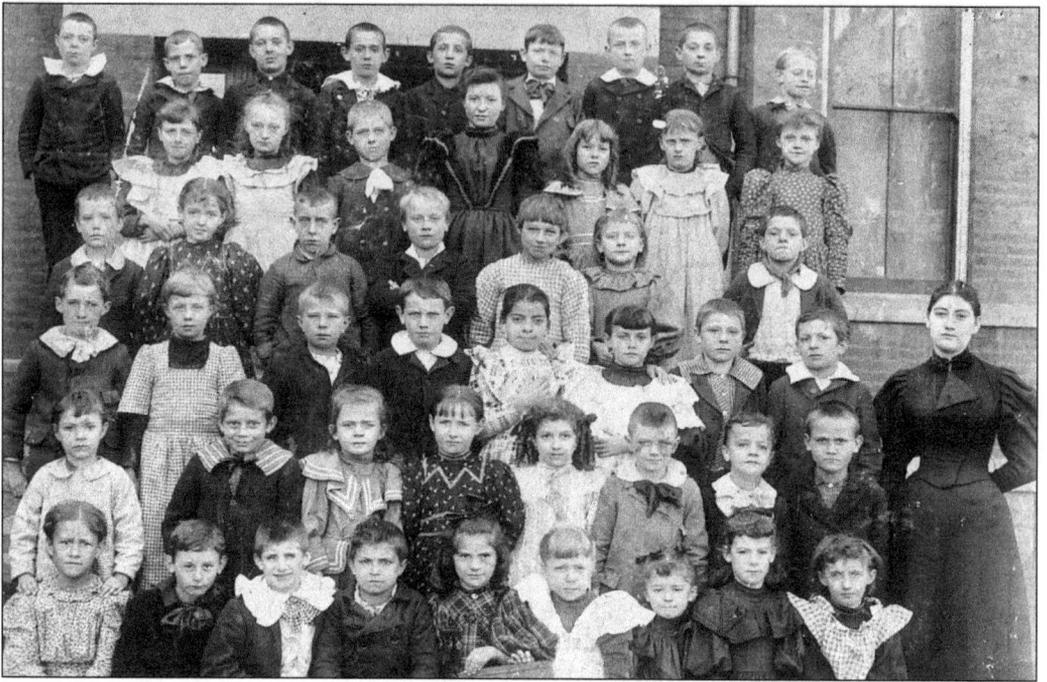

YORK STREET PUBLIC SCHOOL, C. 1905. In the early 20th century, most of the schools in Northern Kentucky were public, a fact that did not go unnoticed by the Roman Catholic Diocese of Covington. As populations increased in the area, requests were heard for more parishes with a church school centrally located within neighborhoods. Plans to add schools within neighborhoods began in 1910. In this photograph, Helen Sabatino (third row center) is about eight years old. (Courtesy of Mary Dilillo.)

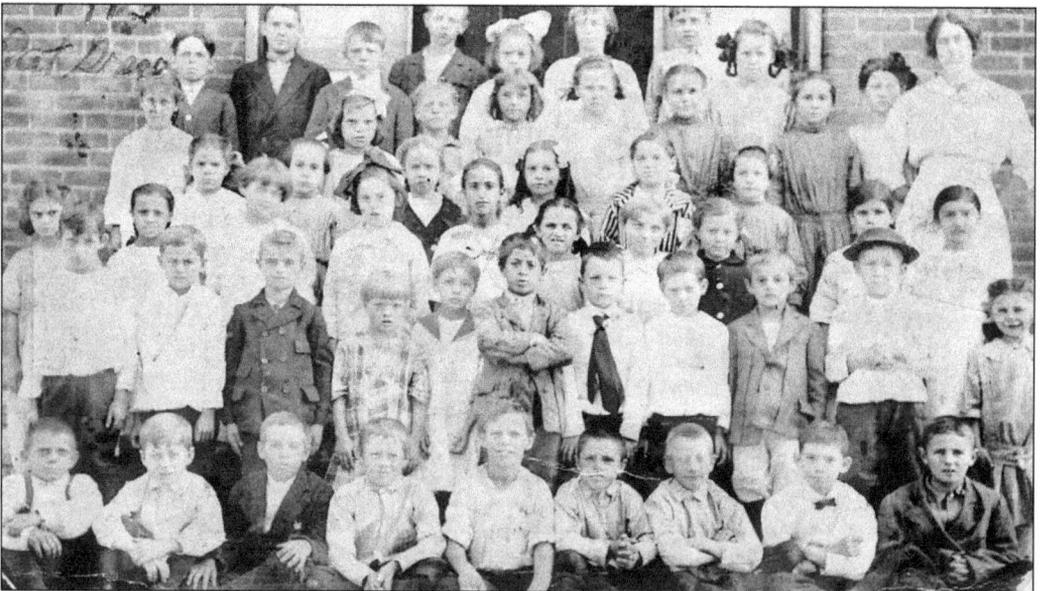

GRANDVIEW SCHOOL, C. 1913. Pat Greco (second row center with his arms folded) is pictured with fellow students in front of Grandview School, located on Main Avenue and Grandview in Clifton. (Courtesy of the Pat Greco family.)

Three

St. Vincent de Paul Parish

As the Italian population increased in Clifton, they, and the Catholic Diocese of Covington, desired to establish a Catholic elementary school in the area. Corpus Christi and St. Stephen Catholic Churches in Newport were already well established and administratively overburdened. In 1911, St. Francis de Sales Parish in Cote Brilliante was formed from St. Stephen Parish. However, as early as 1911, Clifton residents, mostly of Italian and German descent, petitioned Bishop Camillus Paul Maes of the Diocese of Covington for a church in their area. Bishop Maes was informed that an association was formed as early as September 1910 to save money for the project. They had $28.40 on hand, with 93 members contributing 10¢ a month.

According to Bishop Maes's note of April 7, 1915, Clifton residents figured it would cost $9,000 to build a combination church to seat 250 people and a two-room school. At that time, there were 86 families with 100 children of school age. Rejecting a previous site on Oak and Home Streets, a second site was purchased on Main Avenue, formerly Schneider Avenue, to build the combination church and school. In September 1916, Rev. Herman J. Wetzels opened the first St. Vincent de Paul. The parish school opened with 70 students under the guidance of the Sisters of Divine Providence. In 1922, the parishioners built a parish house. A new church was erected in 1923 that was known as the "basement church," and in 1927, an addition was made to the original building. At that time, the parish also bought a house on Sixteenth Street to use as a convent for the sisters.

In the history of St. Vincent de Paul Catholic Church, seven pastors would serve the needs of the parishioners. The two pastors who served the longest were Rev. Herman J. Wetzels and Rev. Ralph J. Stoeckle. Over the years, the parish was central to the life of the Italians, Germans, and Irish who largely made up the congregation. Until the closing of the school in 1984 and the church in 2001, the parish offered educational opportunities to the children and met the spiritual needs of its parishioners.

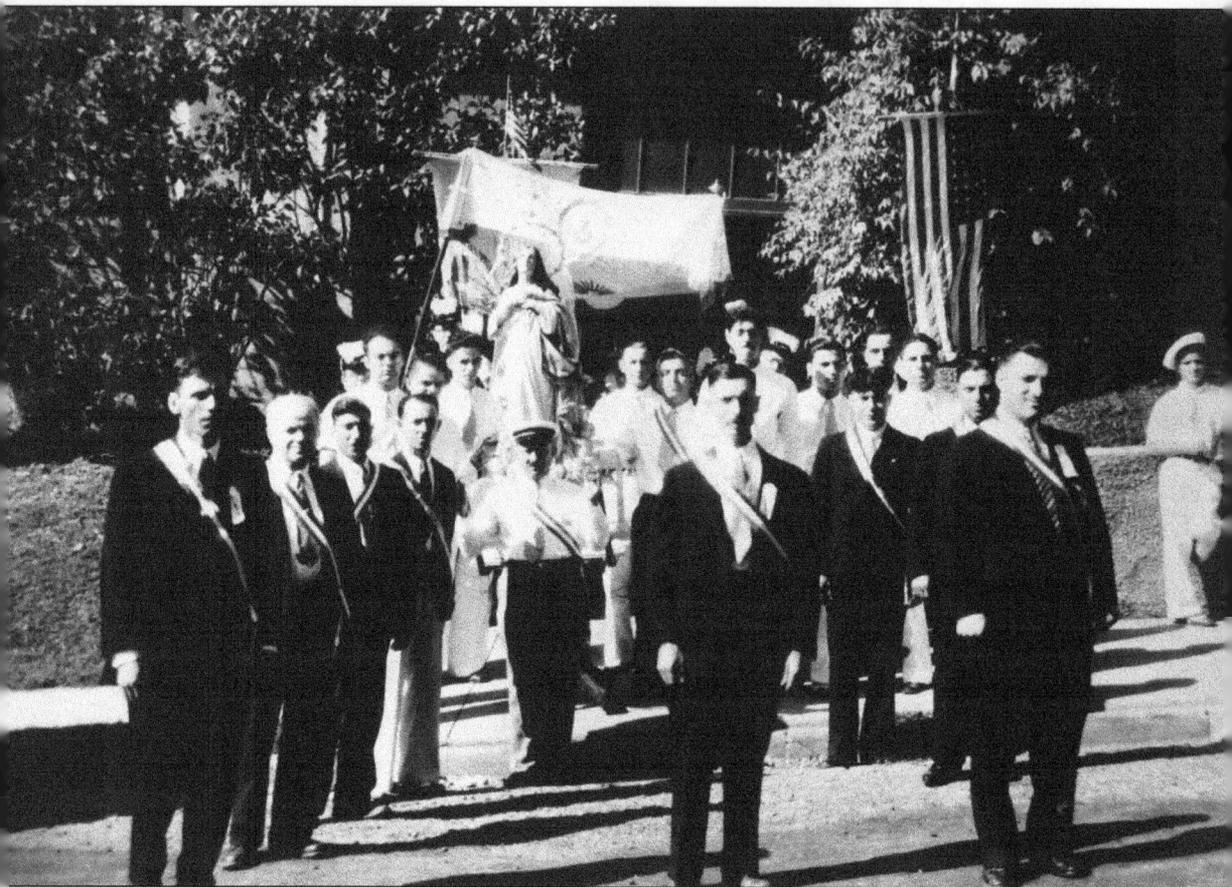

FEAST OF THE ASSUMPTION OF THE BLESSED VIRGIN MARY, C. 1930. The first celebration of the feast was introduced on August 14 and 15, 1926, and chaired by Eugene "Gene" Giancola. The celebration began by carrying a statue of the Blessed Virgin Mary through the streets of Clifton. It was an honor to carry the statue, and bids were taken for the corner positions. Worshippers along the parade route threw money onto a flag carried horizontally by the women, which was then donated to the church. The procession from the left side is (front) Antonio Romito, Anthony Ledonne Sr., Joseph "Tony" Calla, Pat Greco, unidentified, and Carl Pellillo (next to the pole). At the center in front of the statue is Alphonse Raniero. The procession continues with, from front center to back at the right side of the statue) is Ferdinand Ferrara, (behind Ferdinand) Ralph Fiascone, followed by Carmen Sarge. Pictured at the far right foreground is Willie Tallarigo with Louis Zechella standing between and behind Ferdinand and Willie; to the right of Louis is Joseph Colley. Tony Colley is behind Joseph, and the tallest man is Victor "Toddy" Greco standing next to Ralph. The others shown in the photograph are unidentified. (Courtesy of Carmen Sarge.)

STATUE OF THE BLESSED VIRGIN MARY, 2006. The Italian community of Clifton presented this statue to St. Vincent de Paul Parish in 1926. Although shown in a recent photograph, the statue has been well kept and is now in the care of the Holy Spirit parishioners at St. Stephen Church in Newport. (Courtesy of the authors.)

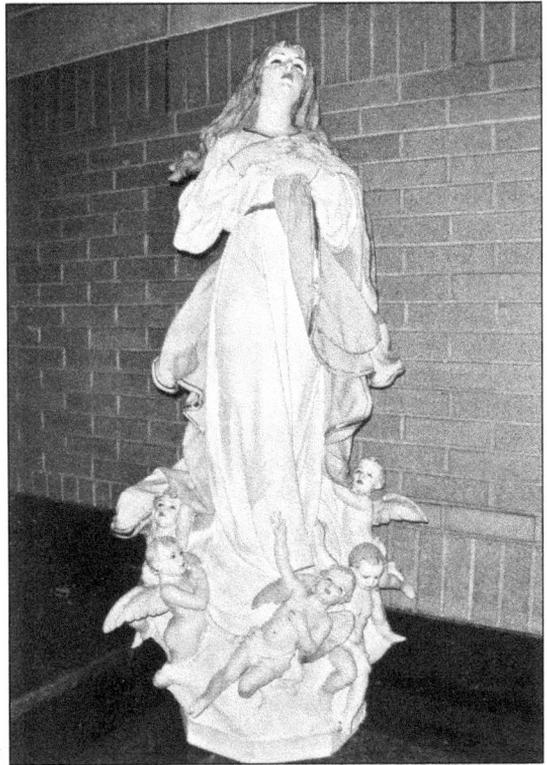

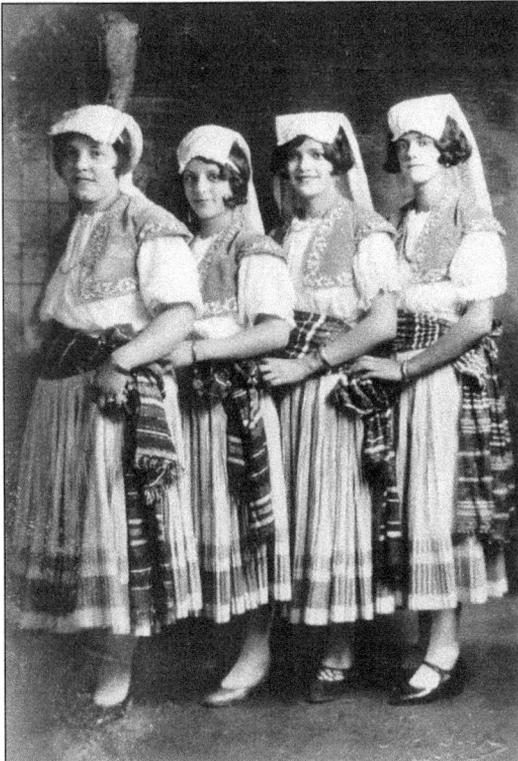

FEAST OF THE ASSUMPTION WAITRESSES, 1927. Adding a festive touch, first-generation Italian Americans (shown from left to right) Mildred Giancola, Helen Jacobs, Elizabeth Zappa, and Susanna Ferrara, dressed in authentic Italian costumes, served as waitresses for the Italian dinner at St. Vincent de Paul School following the August 15, 1927, celebration of the Feast of the Assumption. (Courtesy of Madelyn Lehr.)

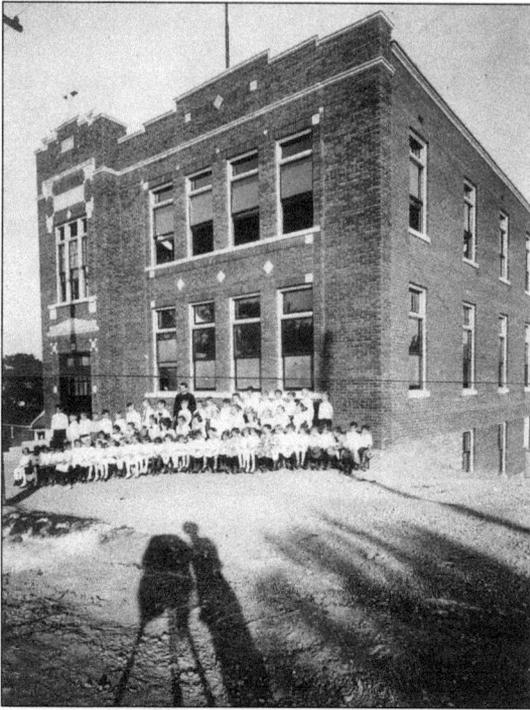

SAINT VINCENT DE PAUL CHURCH AND SCHOOL, C. 1916. This combined church and school was the building where many Italian immigrants took their marriage vows. The left side (see below) of the building was added in 1927 to provide more classrooms; however, it maintained the integrity of its original architectural style and has been added to the National Register of Historic Places. (Courtesy of the Sisters of Divine Providence.)

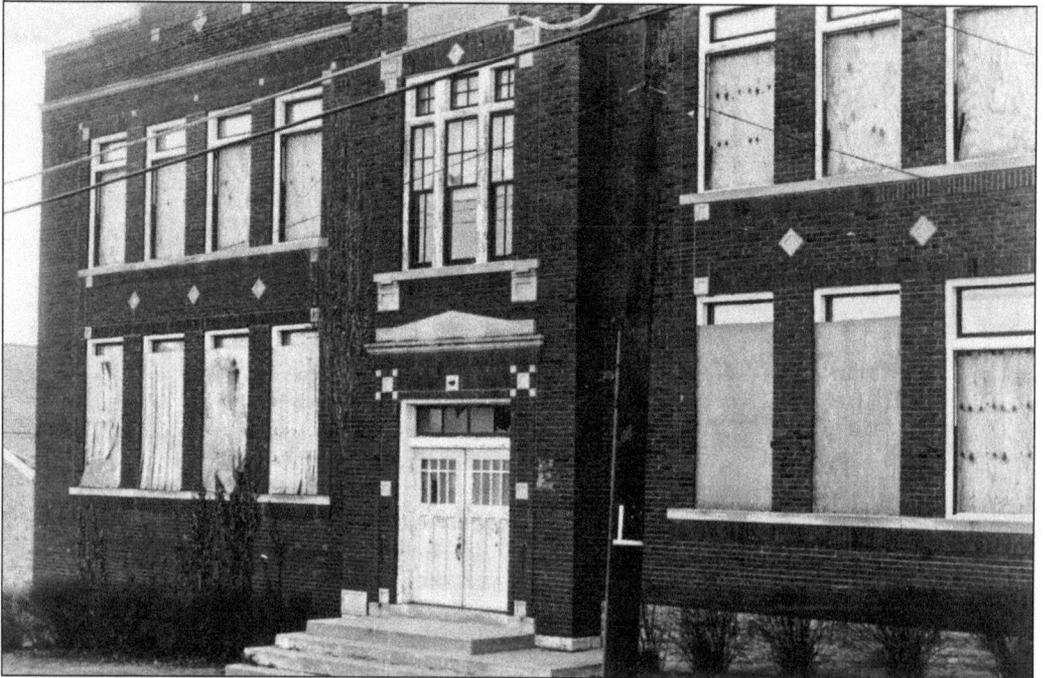

ST. VINCENT DE PAUL SCHOOL AFTER CLOSING. This photograph of St. Vincent de Paul School in disrepair was taken just prior to 1989. St. Vincent de Paul School was closed in 1984, and in 1989, the building was converted into modern apartments by a development group led by St. Vincent de Paul graduate Wayne Carlisle. It is now known as the Manors of St. Vincent. (Courtesy of the *Messenger*, the Diocese of Covington newspaper.)

EMANUELA RANALLO ROMITO. Emanuela, at age 60, accompanied Giovanna Donatelli along with her brother Mario Donatelli to America for Giovanna's prearranged marriage to Antonio Romito Sr. They arrived at Ellis Island on December 30, 1920, aboard the ship *America*. The ship's manifest shows she was carrying $1,280 cash with her. (Courtesy of Vicki Davis Cook.)

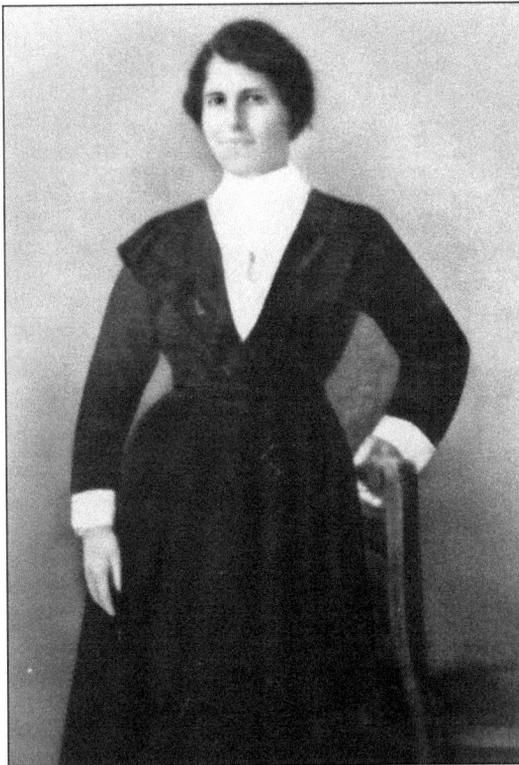

GIOVANNA "JENNY" DONATELLI. Giovanna was born on June 24, 1892, in Pescocostanzo, L'Aquila, Abruzzo, Italy, and arrived in America at the age of 28. She was skilled at weaving, tatting, and crocheting and donated much of her work to St. Vincent de Paul Church. She also loved gardening. (Courtesy of Vicki Davis Cook.)

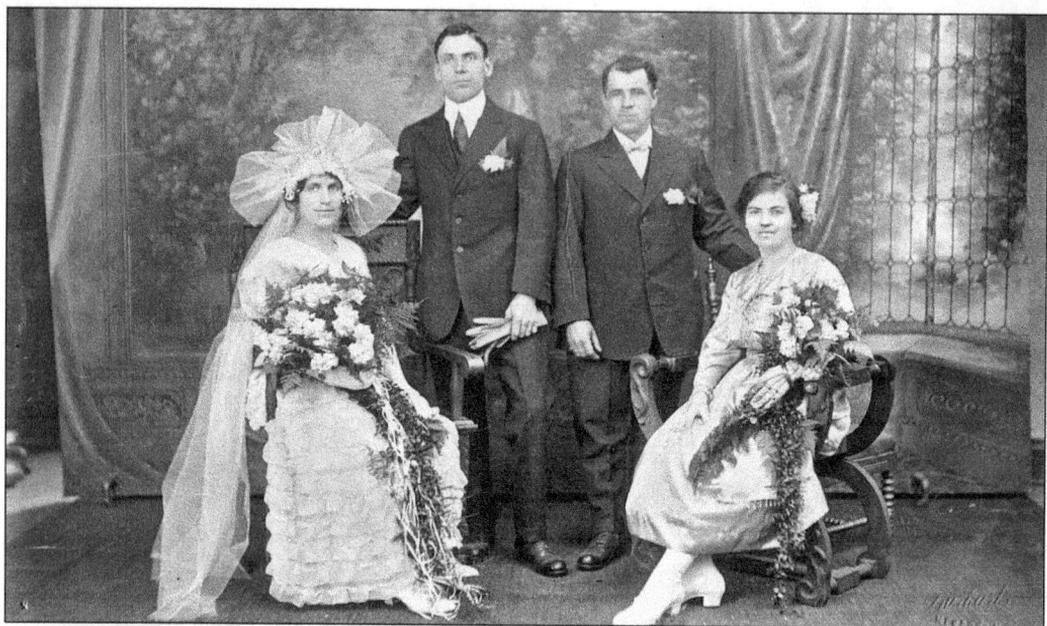

THE DONATELLI AND ROMITO WEDDING, 1921. Achillo Antonio Romito came to America in 1917 from the region of Abruzzo between the towns of Pescara and L'Aquila. After securing work as a stonemason, he sent for his bride-to-be. Antonio and Giovanna Donatelli were married at St. Vincent de Paul Church on January 15, 1921, witnessed by Luigi and Rose Larvo. The Romitos raised six boys: Leroy, Felix, Pasquale, Michael, Joe, and John. (Courtesy of Vicki Davis Cook.)

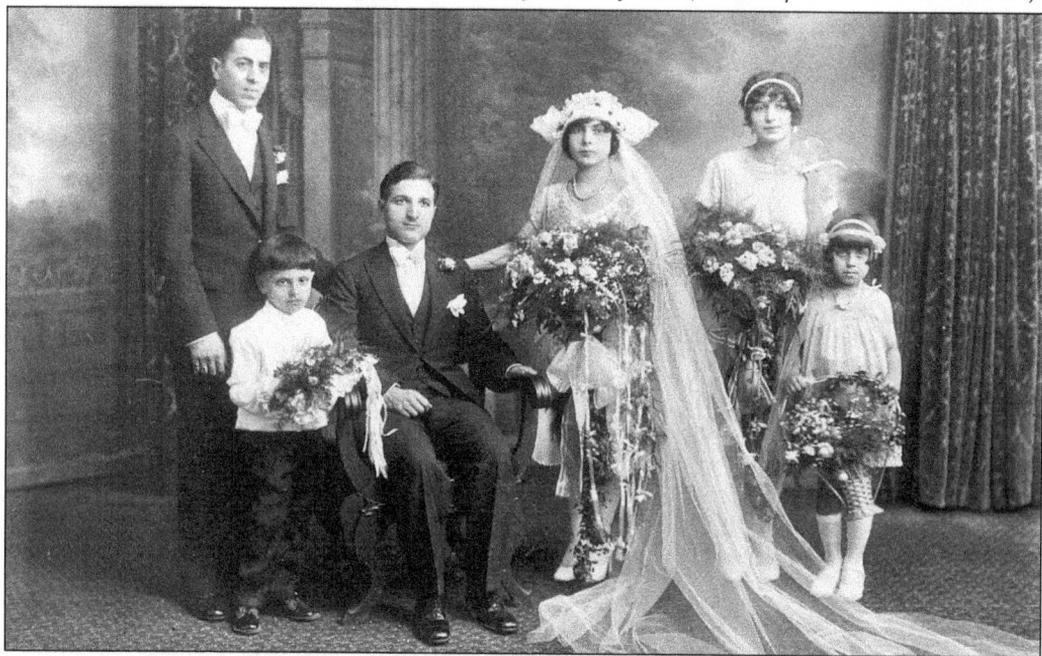

DONATELLI AND FERRARA WEDDING, 1927. Mario Donatelli married Angela Ferrara on July 9, 1927, at St. Vincent de Paul Church. Pasquale Greco and Caroline "Lena" Ciafardini witnessed the wedding. The little boy in the photograph is Lavario "Leroy" Romito. Mario was a tailor and lived at 28 Home Street in Clifton. They were married for 54 years. (Courtesy of Vicki Davis Cook.)

ANTONIO SENA AND MARY PICCIRILLO WEDDING, JUNE 30, 1928. The couple were married at St. Vincent de Paul Church and lived at 175 Main Avenue. Antonio worked for McGregor Goldsmith in Cincinnati from 1928 until he retired in 1967; he made baseballs and bats. During the Depression, he helped put food on the tables of his neighbors by bringing home baseballs and having them hand-sew the jackets onto the balls. (Courtesy of Sandy Piccirillo McFarland.)

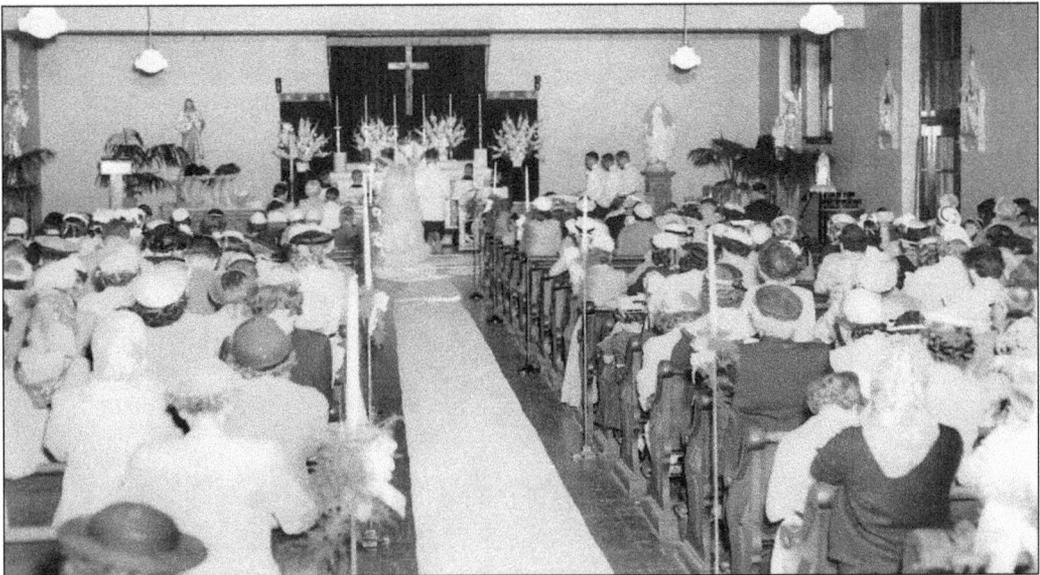

INSIDE ST. VINCENT DE PAUL BASEMENT CHURCH, JULY 30, 1955. The basement church was the place of worship for the parishioners from 1923 through 1959. This photograph was taken at the wedding of Owen Bennison and Dolores Lehr, daughter of Paul and Mildred Giancola Lehr and granddaughter of Maddalena and Edward Giancola. (Courtesy of Madelyn Lehr.)

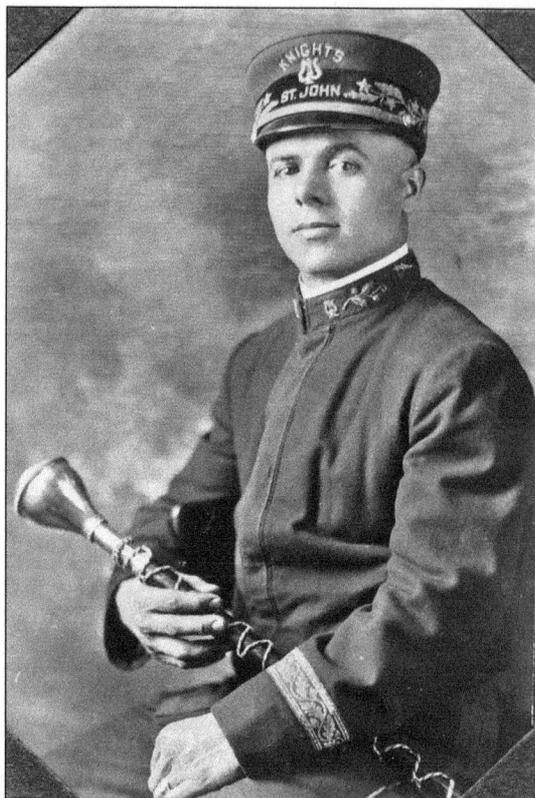

THE KNIGHTS OF ST. JOHN, C. 1920. Eugene "Gene" Giancola became a member of the Knights of St. John cadets on August 17, 1920. Fr. Herman J. Wetzels organized the group of cadets in Clifton. According to the Knights of St. John International, the order was officially incorporated in the state of New York on May 6, 1886. They sought to "care for the spiritual, social and physical needs of their members and neighbors." (Courtesy of R. Toni Bungenstock.)

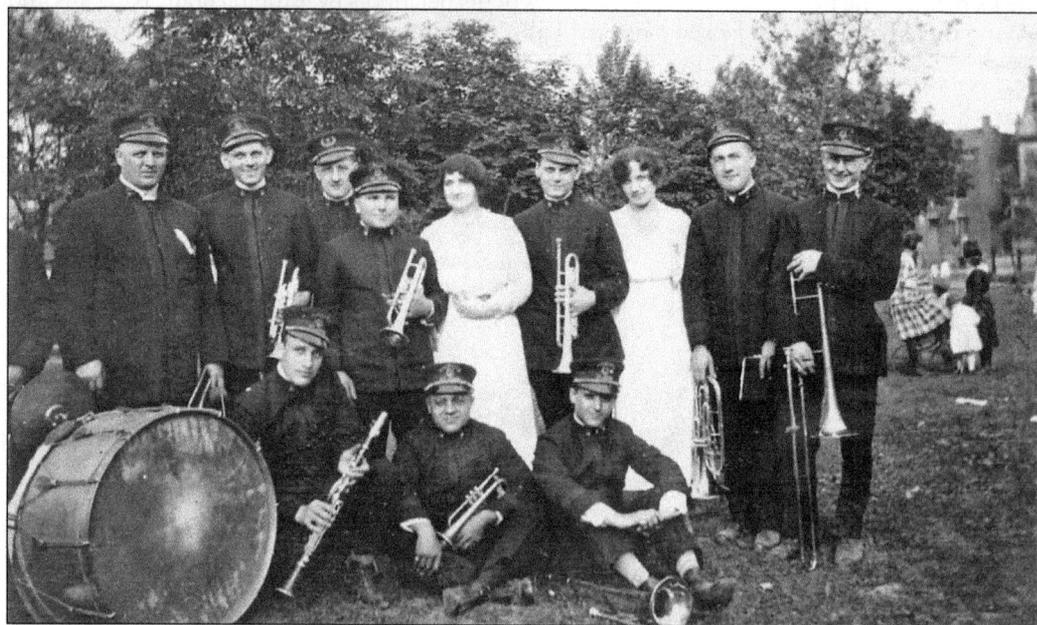

THE KNIGHTS OF ST. JOHN BAND. In addition to charitable works, the Knights of St. John cadets formed a band and performed concerts and marched in various parades throughout the area. Meetings would often be held at St. Stephen's auditorium at Ninth Street and Washington Avenue. (Courtesy of R. Toni Bungenstock.)

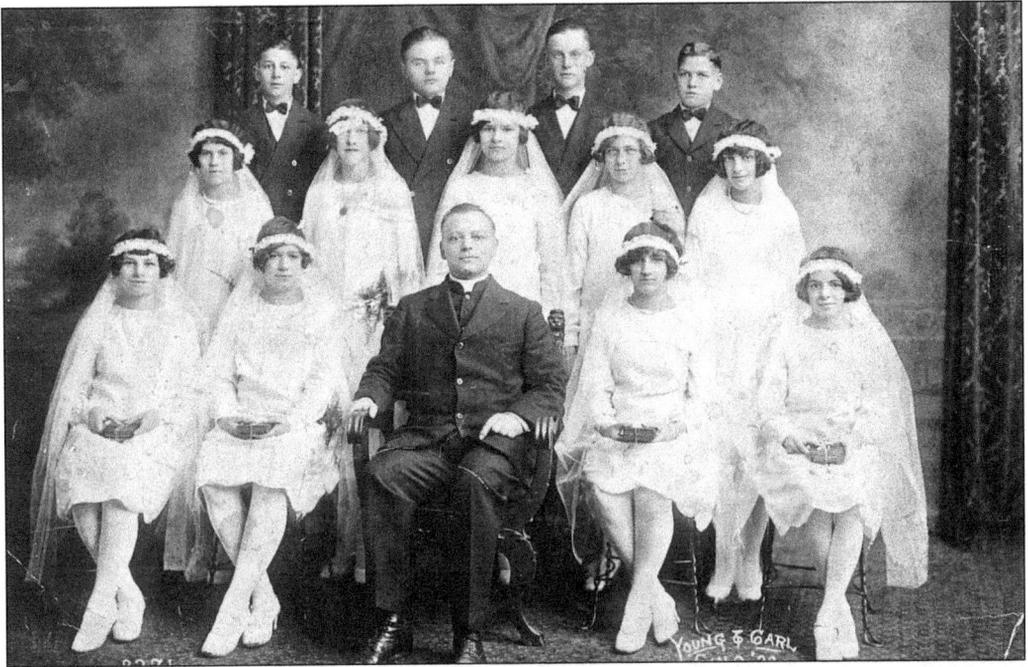

CONFIRMATION AND GRADUATION, 1928. This photograph features the confirmation and graduation class of 1928 from St. Vincent de Paul School. Class members are, from left to right, as follows: (first row) Stella Zappa, ? Meyers, Father Wetzels, ? D'Erminio, and Dolores Ledonne; (second row) ? Greco, ? Verax, ? Shoemaker, ? Brown, and Millie Pellillo; (third row) Carmen Sarge, Bob Sidell, Thaddeus Strief, and Jack Stephany. (Courtesy of Carmen Sarge.)

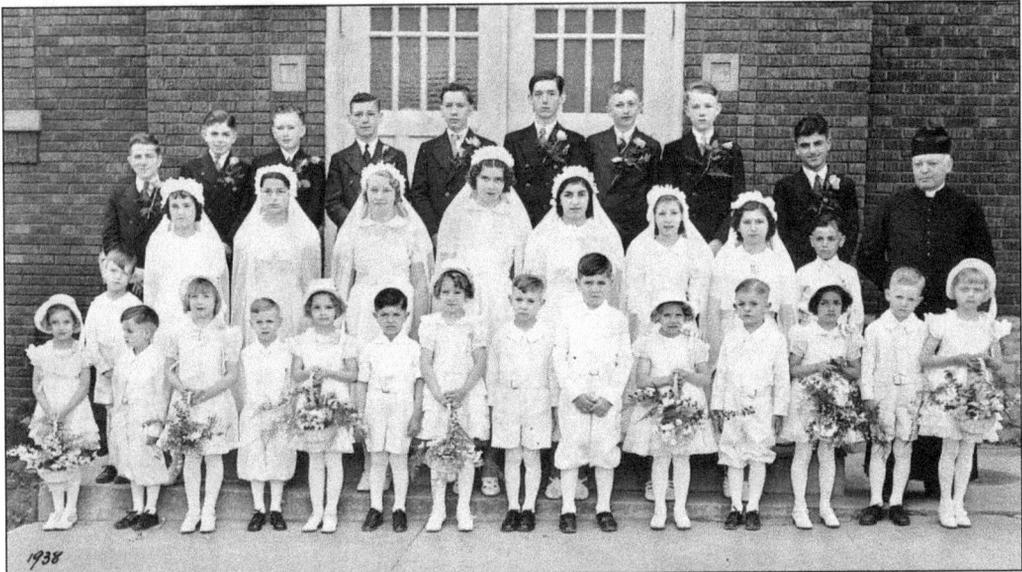

FIRST HOLY COMMUNION CLASS, 1938. Holy Communion (Eucharist) is one of the seven sacraments of the Catholic Church. Today it is typically administered to children at the age of seven or eight; however, in years past, it was offered at various ages. The faithful believe the Eucharist is the bread of life and is actually the body of Jesus Christ and essential for human salvation. (Courtesy of Vicki Davis Cook.)

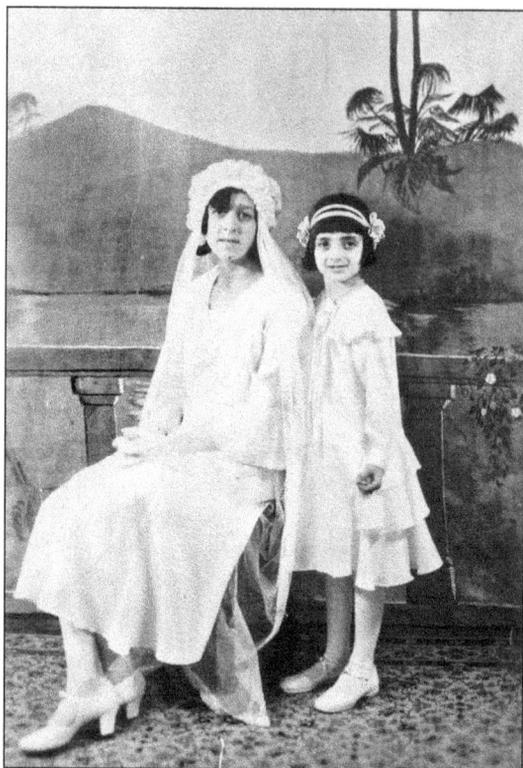

JENNIE MUSILLI, 1931. Jennie was the first child baptized in St. Vincent de Paul Church in September 1916. Here she is photographed for her eighth-grade graduation and solemn communion ceremony. The flower girl is unidentified. (Courtesy of Jennie Musilli Wogan Nadaud.)

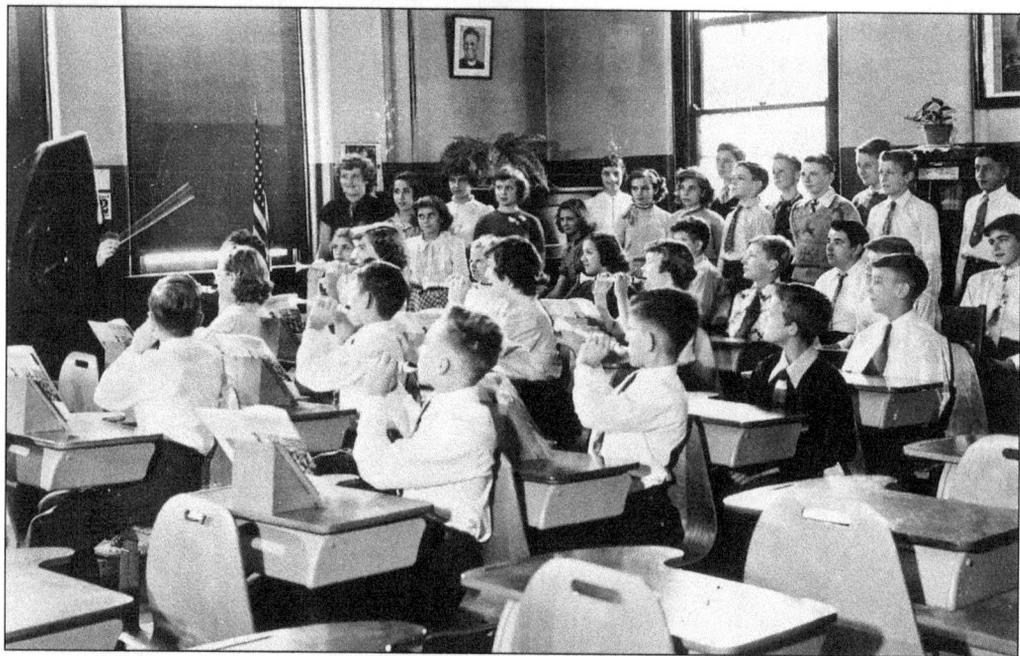

ST. VINCENT DE PAUL STUDENTS. The Sisters of Divine Providence provided overall educational opportunities to the children of Clifton from 1916 until the school's closing in 1984. The children are being taught music appreciation in this undated photograph. (Courtesy of the Sisters of Divine Providence.)

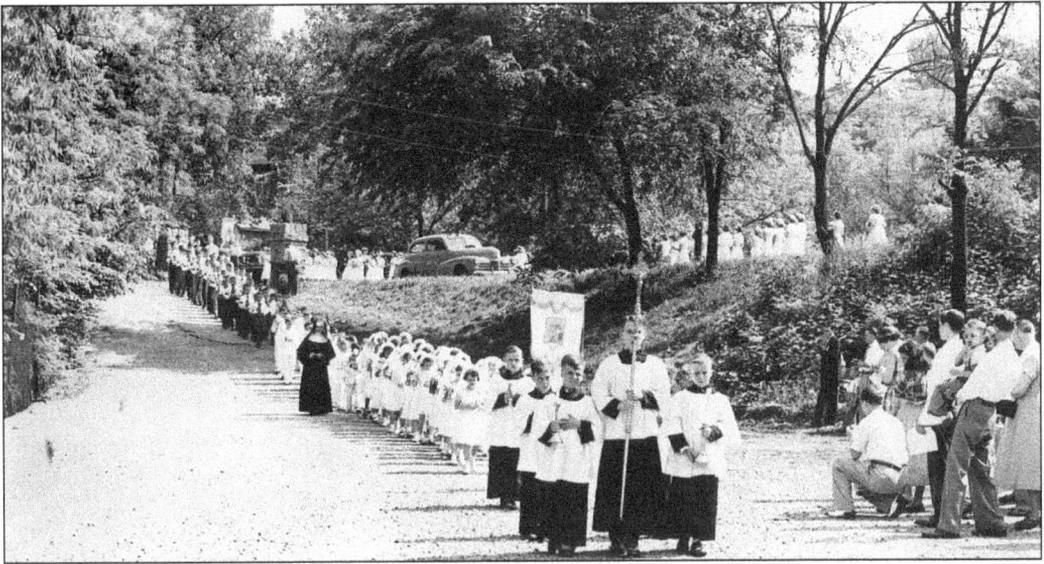

MAY CROWNING PROCESSION AND CEREMONY, C. 1951. The public display of monthly Marian devotions began in Italy in May 1784 and spread to Roman Catholics around the world by the 19th century. May is considered to be the season of the beginning of new life; therefore, the tradition began to honor the Blessed Virgin Mary, the Mother of the Son of God. The May crowning ceremony began with a procession with one small child carrying the crown of flowers on a cushion, and then another placed it on the statue of the Blessed Virgin Mary. The time-honored tradition is meant to remind the faithful of Mary's many virtues to be imitated by them throughout their lives and to show respect for Mary as Queen of Heaven. (Courtesy of the Sisters of Divine Providence.)

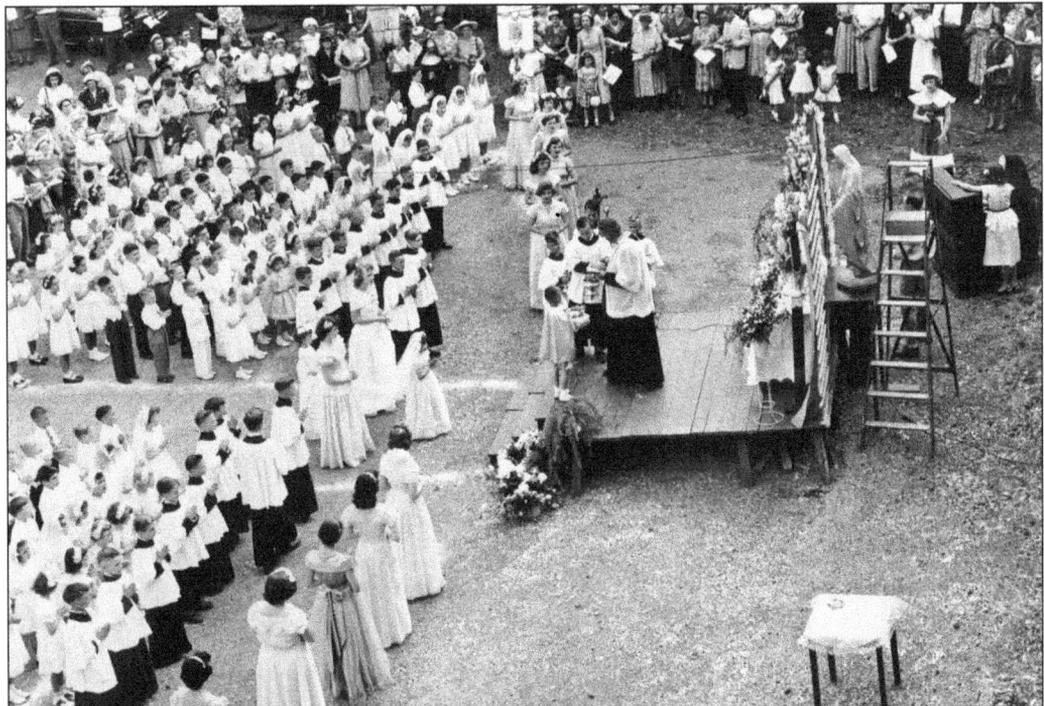

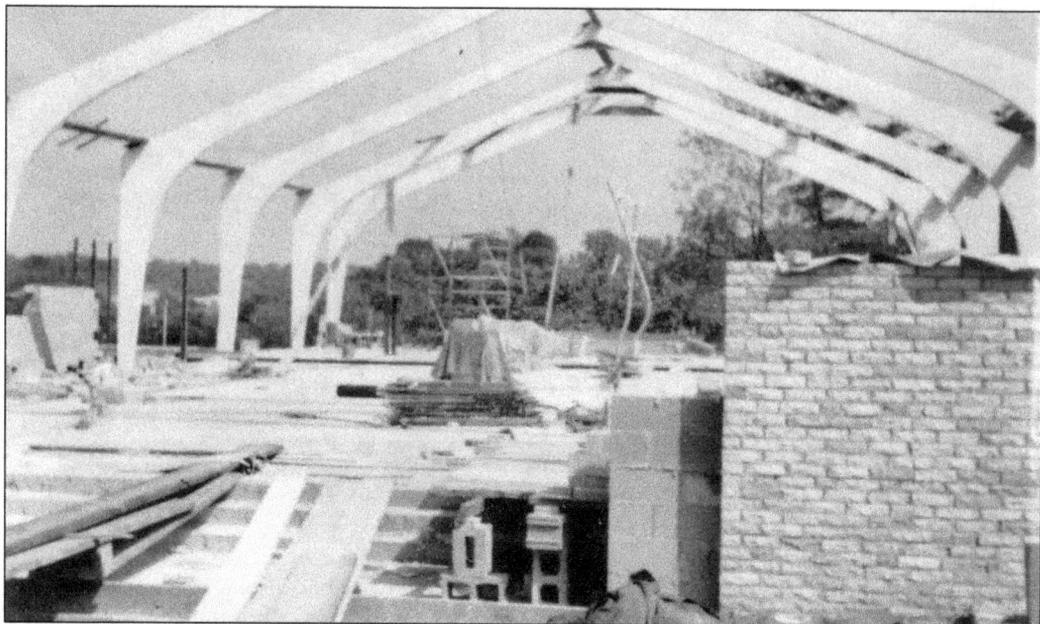

THE BUILDING OF ST. VINCENT DE PAUL CHURCH, 1958. The excavation for the new church began on the same site as the original basement church in the fall of 1958. For 35 years previously, the parishioners of St. Vincent de Paul worshipped in the basement, as funds were not available to finish the project due to the Great Depression. When construction halted, a roof was placed over the foundation, thus the name "basement church." (Courtesy of the Michelina Meconio Sharp family.)

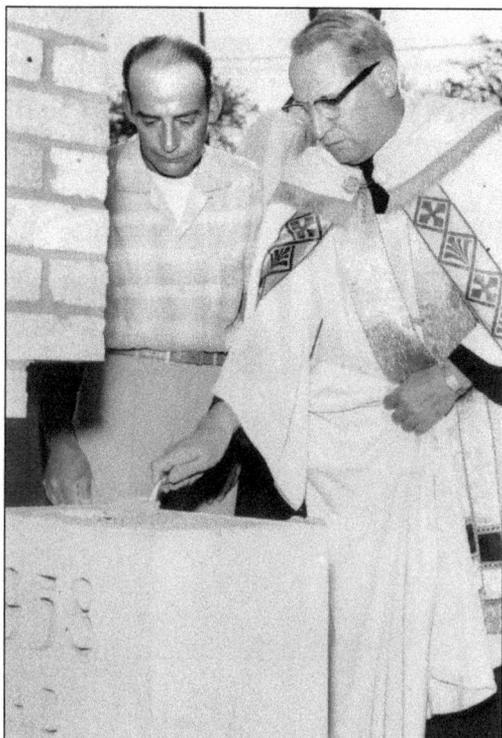

ST. VINCENT DE PAUL CHURCH CORNERSTONE, 1958. Fr. Ralph J. Stoeckle laid the cornerstone as witnessed by Al Fenhoff in the fall of 1958. Father Stoeckle served the parish as pastor for a 25-year period from 1954 to 1979. Father Stoeckle died on May 4, 1990. (Courtesy of the *Messenger*, the Diocese of Covington newspaper.)

ST. VINCENT DE PAUL CHURCH, 1959. The new church cost approximately $328,000 including all furnishings. The first mass in the new church was said on Christmas Eve 1959. The parishioners burned the mortgage on September 17, 1971. (Courtesy of the *Messenger,* the Diocese of Covington newspaper.)

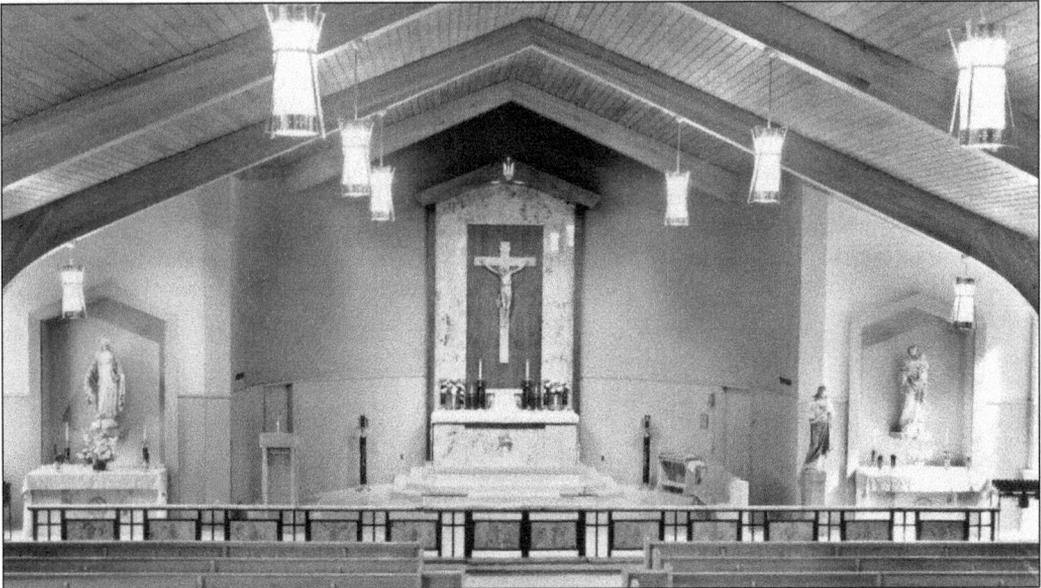

INSIDE THE NEW ST. VINCENT DE PAUL CHURCH. This simple church with its marble altars was truly a place of worship for the St. Vincent de Paul parishioners. After its closing in 2001, the items within the church were sold at auction or donated to area churches. The crucifix is now located above the altar at St. Therese Church in Southgate. (Courtesy of the *Messenger,* the Diocese of Covington newspaper.)

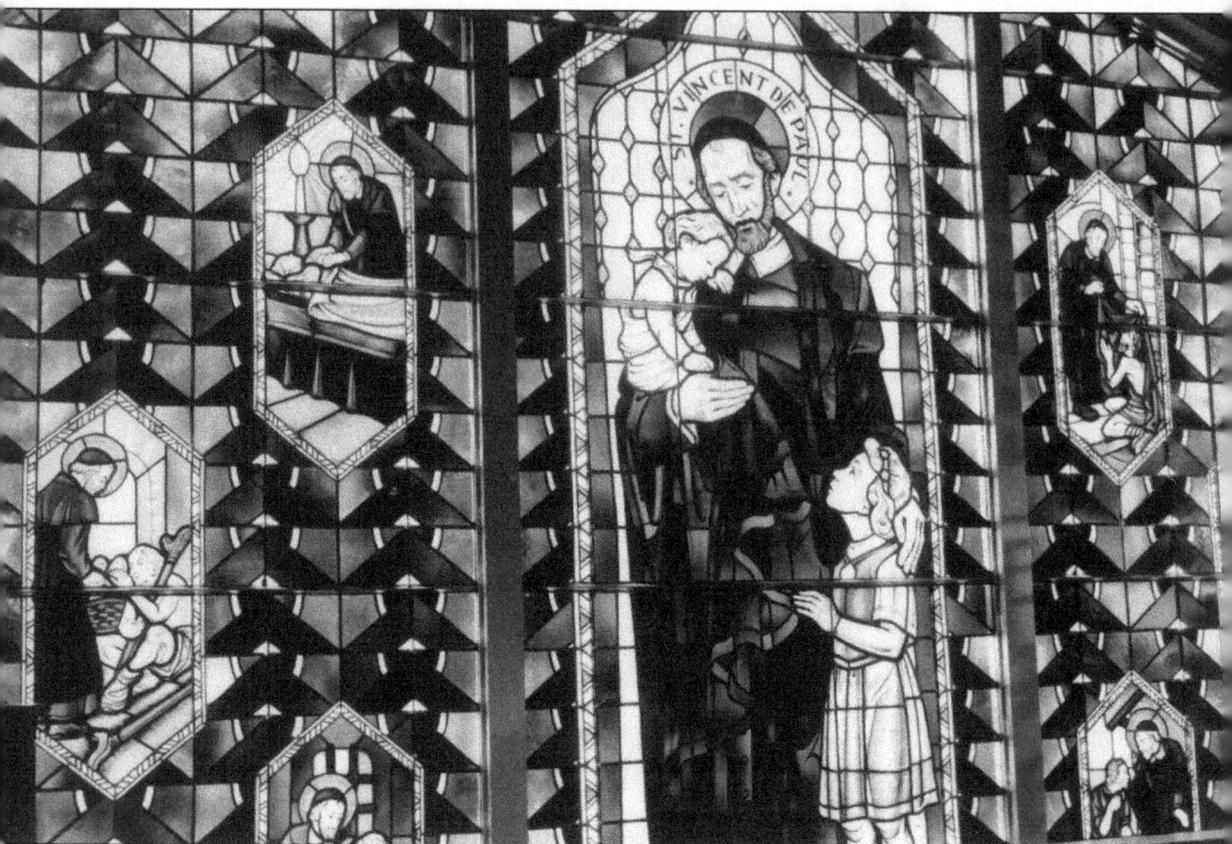

ST. VINCENT DE PAUL STAINED-GLASS WINDOW. It has been said that the stained-glass window of St. Vincent de Paul Church was the largest window for a small church in the Diocese of Covington of its time. The main window, made in Europe, depicts St. Vincent de Paul performing the corporal works of mercy: to feed the hungry, to give drink to the thirsty, to clothe the naked, to harbour the harbourless, to visit the sick, to ransom the captive, and to bury the dead. St. Vincent de Paul was born of poor parents in the village of Pouy in Gascony, France, in about 1580. The Franciscan fathers at Acqs, France, educated him. He was ordained a priest in 1600 after completing theological studies at the University of Toulouse. His feast day is September 27, and he is the patron saint of charitable societies. (Courtesy of the *Messenger*, the Diocese of Covington newspaper.)

Four

BUSINESSES

Newport Rolling Mill, now Newport Steel, provided unskilled jobs to many of the new immigrants upon their arrival in Northern Kentucky. The steel company was owned and operated on the west end of Newport by the Andrews family from 1891 to 1943. Italian immigrants also worked for the various railroad companies in Newport and Cincinnati. Immigrants held such unskilled positions as baggage handlers, mail handlers, and track repairman.

There were Italian immigrants who had learned skills that were utilized in the garment industry. There were tailors and seamstresses who worked for tailor shops in downtown Cincinnati. Other skilled positions included shoemakers who worked for the shoe factories in Cincinnati or opened their own stores. As early as 1908, Hyde Park Clothes, located at Sixth Street and Washington Avenue in Newport, employed Italian immigrants who would perform work as designers, tailors, cutters, seamstresses, and pressers.

A number of Italian immigrants, whether skilled or unskilled before migrating to the area, started their own businesses. These businesses included grocery stores, restaurants, ice cream shops, carpet cleaners, law offices, construction companies, and many others.

A strong work ethic kept the Italians working. Their entrepreneurial spirit helped them through the Depression and with learning new skills. Jobs within the community that others did not want they did willingly. And while there may have been some occasional showings of prejudices, it did not seem to affect their employment. The simple fact was that if they wanted to work, they could find work and earn a living in order to provide for their families.

BENJAMIN GRAZIANI. Born on November 16, 1858, Benjamin was one of the first-generation Italian Americans in the area. His father, Charles, was the son of the Count of Oneglia in Italy. Having been forced into exile by the European revolution of the 1840s, he came to America and settled in the Cold Spring area. Benjamin became an influential criminal attorney and state representative. (Courtesy of Kenton County Public Library.)

LAW OFFICE, 1884. Benjamin Graziani graduated from law school in 1884 and opened his law office at 508 Madison Avenue, Covington. He was a member of the Kenton County Bar Association and the Covington School Board, and he was an active member of his church. (Courtesy of Kenton County Public Library.)

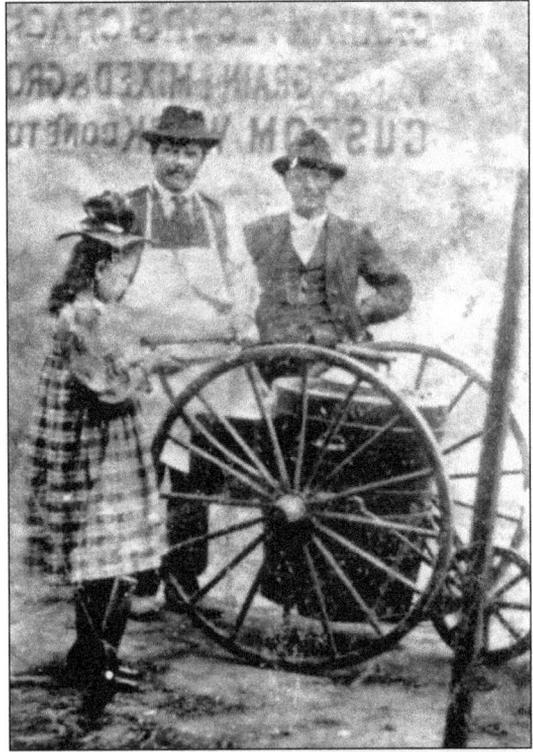

First Ice Cream Wagon, c. 1893. Palmerino Sabatino bought his first ice cream wagon for $10 and began selling his homemade ice cream on the streets of Newport. He eventually established an ice cream parlor at the northeast corner of West Eleventh Street in Newport, where he sold confections along with ice cream. (Courtesy of Mary Dilillo.)

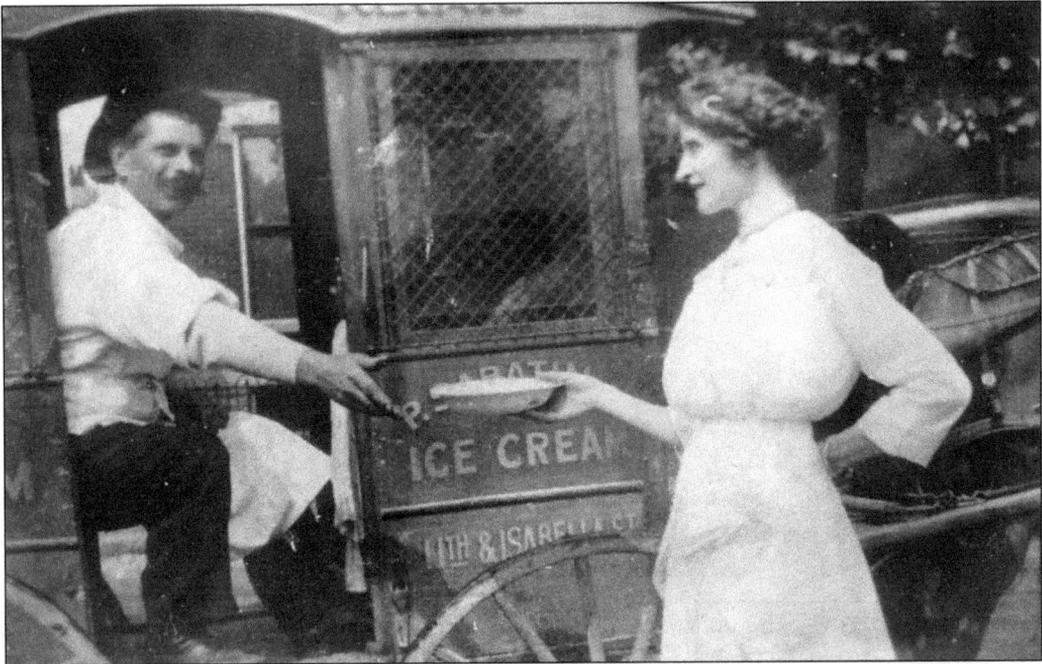

Sabatino Ice Cream Wagon, c. 1917. The Italians have always loved their *gelati* (ice cream). Even to this day, the streets of Southern Italy are full of ice cream parlors offering their abundantly flavorful homemade ice cream. It was a perfect fit for Palmerino to open his shop and offer his ice cream to the general public. (Courtesy of Mary Dilillo.)

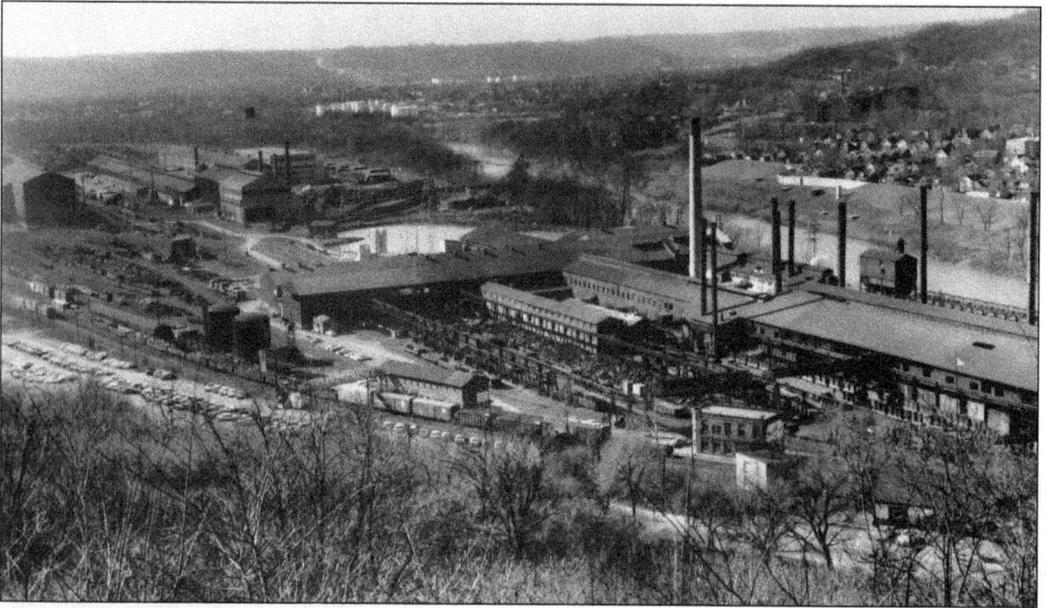

NEWPORT STEEL. This aerial view of Newport Steel shows what was known as Newport Rolling Mill, owned and operated by the Andrews family from 1891 to 1943. Most of the Italian immigrants worked at this location, at least in the beginning, until they could find better jobs. (Courtesy of Campbell County Historical and Genealogical Society.)

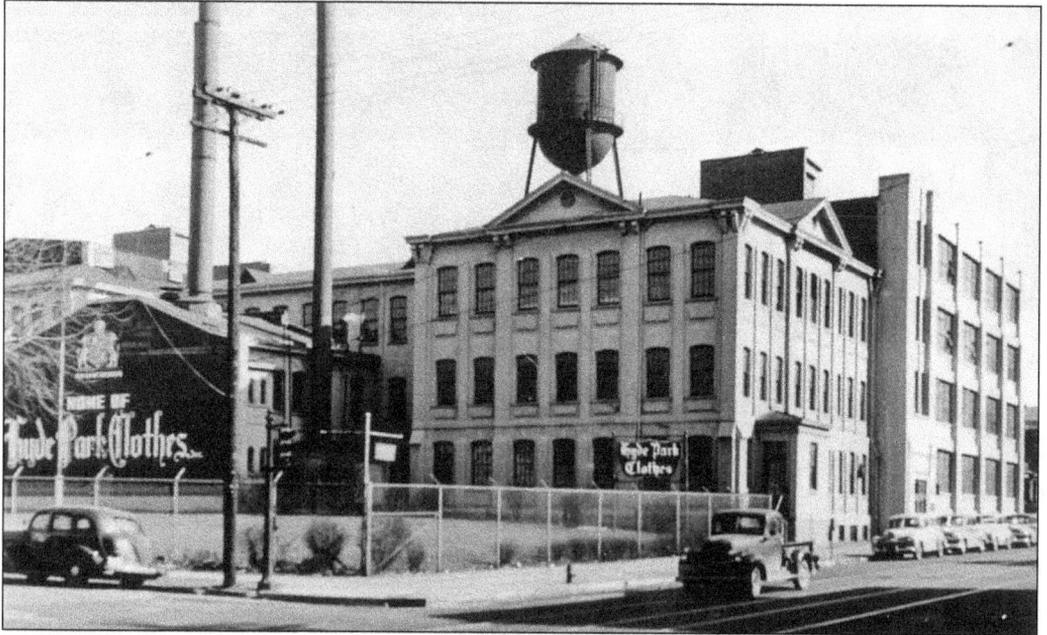

HYDE PARK CLOTHES. This undated photograph shows the original facade of Hyde Park Clothes. The company was organized in 1908 by Oscar Levine, and it became one of the major menswear manufacturers in the area throughout the 1950s. By 1954, Hyde Park Clothes had employed approximately 1,100 workers. It discontinued its manufacturing operation in the early 1970s and became a wholesale distributor and retailer. The business closed in 1979. The building is now called Water Tower Square. (Courtesy of Paul Hemmer Companies.)

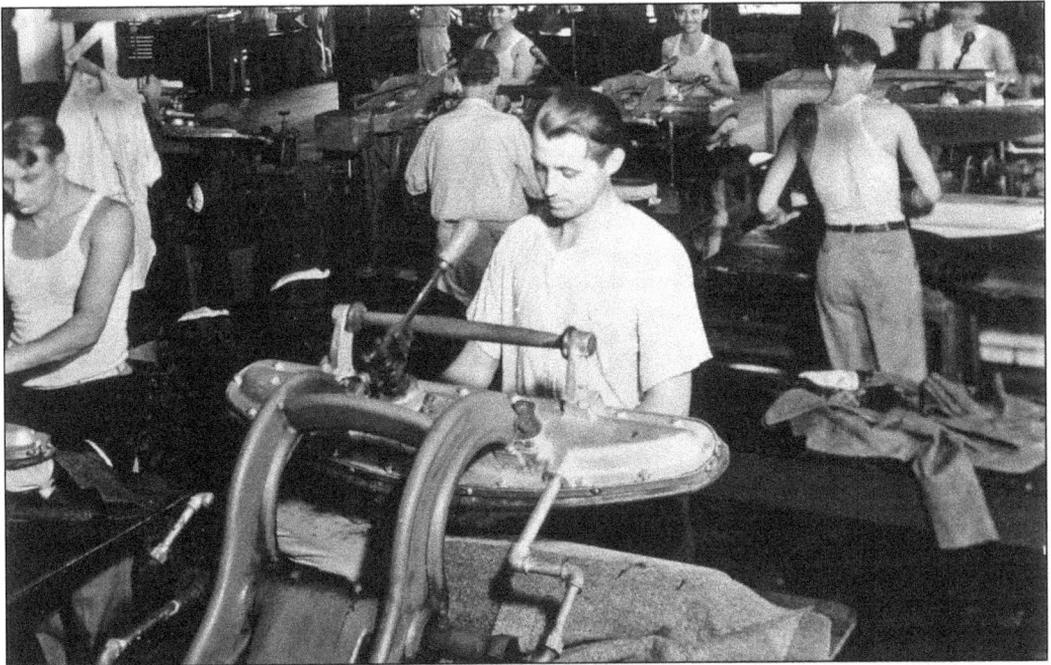

HYDE PARK CLOTHES COAT SHOP PRESSING DEPARTMENT. The pressers who worked in the manufacturing business were skilled at under pressing as well as the finished coat press. It was critical that the darts and seams were pressed flat for a clean look. The shop presser also would mold the front of each coat by hand as he used the hot press to give the coat front a pristine finish. (Courtesy of Paul Hemmer Companies.)

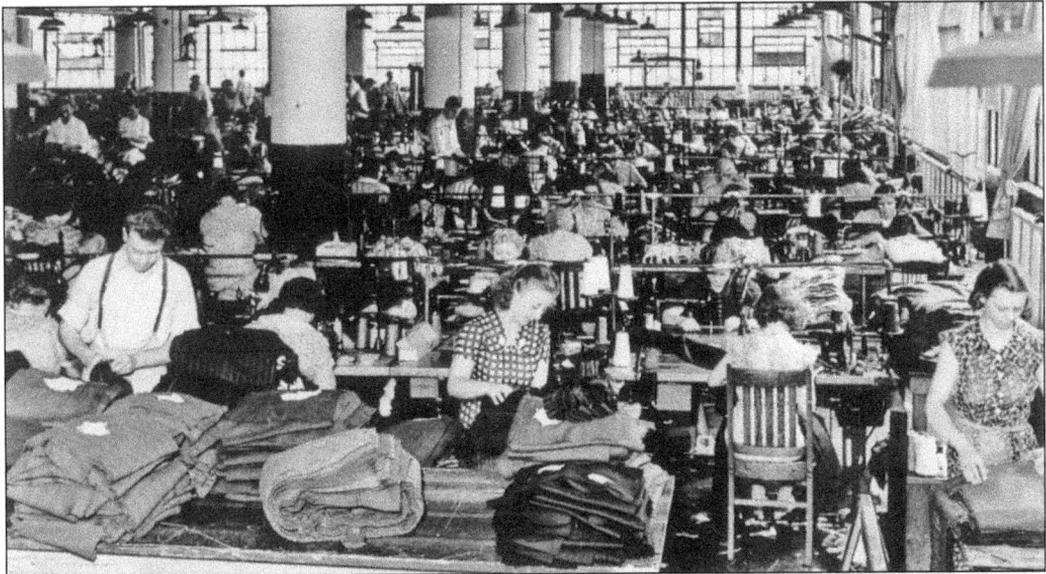

HYDE PARK CLOTHES PANTS SHOP. In the manufacturing business, the item being made was handled by many hands. It was more like piecework, whereby each worker did a different function and then passed it on to the next worker. Shown in this photograph are workers who are carefully checking the pants for quality in workmanship and folding and stacking the pants for shipping. (Courtesy of Paul Hemmer Companies.)

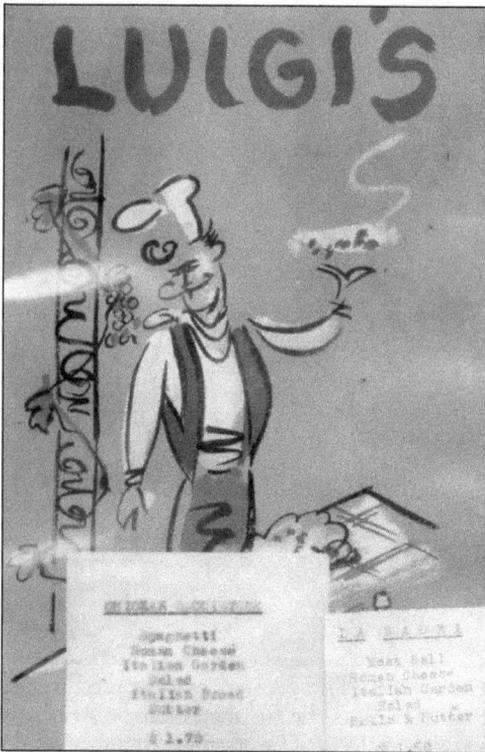

LUIGI'S MENU COVER. In 1955, patrons of Luigi's could order a T-bone steak complete with a salad and a choice of two side dishes with bread or rolls for $2. Pasta was an even better deal, with spaghetti dinners ranging from 75¢ to $1.60. A slice of pizza would set you back 20¢–30¢ per slice, and a large pizza would cost $1.50. (Courtesy of Linda Wagner.)

LOUIS "LUIGI" ZECHELLA. When Luigi first came to America at the age of 14, he dug ditches to earn money; he also worked as a water boy for a West Virginia coal mine. He later spent 30 years as a floral designer in Cincinnati. He retired to manage the family restaurant in 1947. "Pop" Zechella, as he was often called, is claimed to be the first to introduce pizza to Northern Kentucky. (Courtesy of Linda Wagner.)

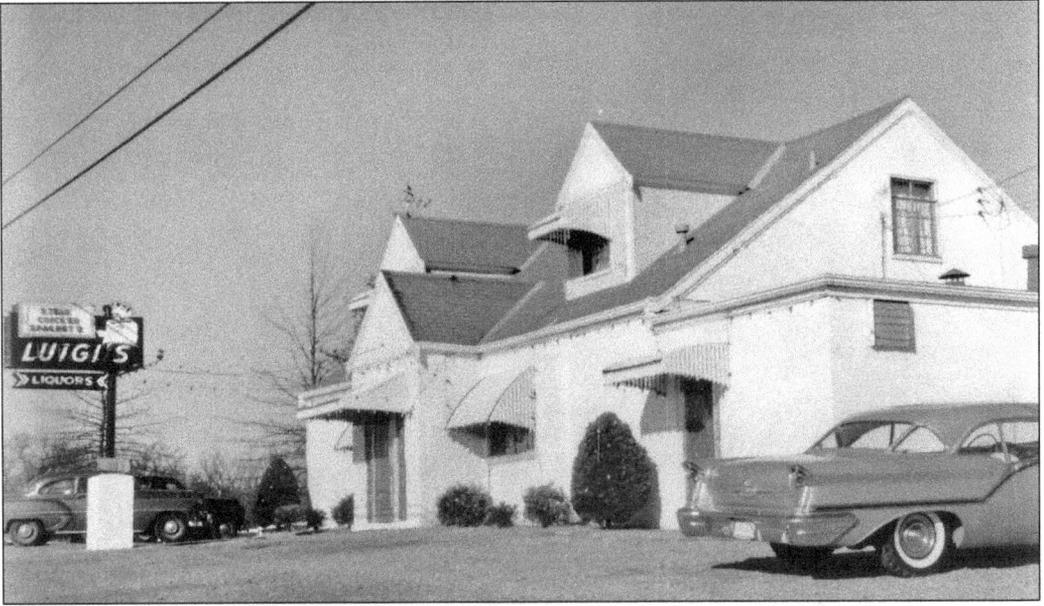

LUIGI'S RESTAURANT, HIGHLAND HEIGHTS. The Zechella family opened Luigi's restaurant on Bon Jan Lane in Highland Heights in 1951 and later moved to a new location on U.S. 27 in Cold Spring in 1954. Eventually the restaurant was forced to close with the expansion of U.S. 27 from two lanes to a four-lane highway. (Courtesy of Bertha Zappa Stahl.)

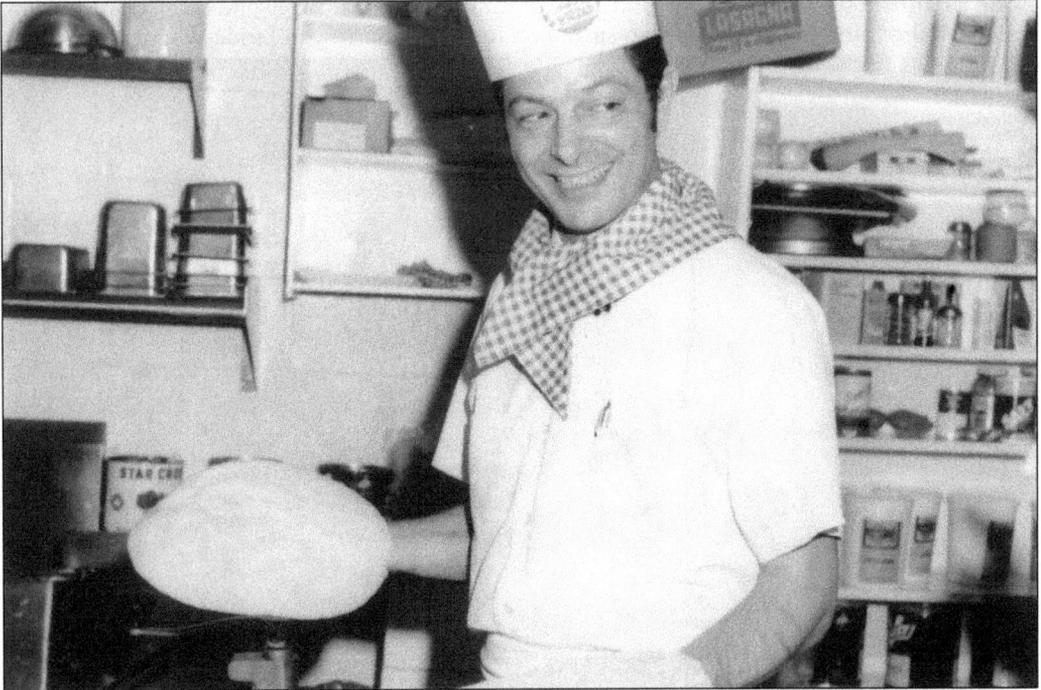

TONY ZECHELLA. Tony and his wife, Helen, operated the family restaurant until Tony was called to serve in the Korean War. During that time, Luigi managed the restaurant until Tony returned. In later years, Luigi would work part-time making and partially baking about 100 pizza crusts daily. (Courtesy of Linda Wagner.)

THE ZECHELLA FAMILY, C. 1951. Family members from left to right are (first row) Rosella holding Donna, Edith, Sotty holding Sandy, and Tony holding Jane; (second row) Jim, Luigi, Clara holding Carol, Mildred, and Lou with Marilyn sitting on his lap. (Courtesy of Linda Wagner.)

ANTHONY "DOC" ZECHELLA. "Doc" Zechella, a dentist in Northern Kentucky, is seated at the left with his wife, Ruth, and friends Dot and Mike Pompilio, enjoying a night out at Beverly Hills Supper Club. Doc practiced dentistry in his Newport office, located at Eighth and Monmouth Streets. Mike helped run the family restaurant, Pompilio's, with his father and brothers. They owned the restaurant from 1933 to 1982. (Courtesy of Donna Pompilio Lange.)

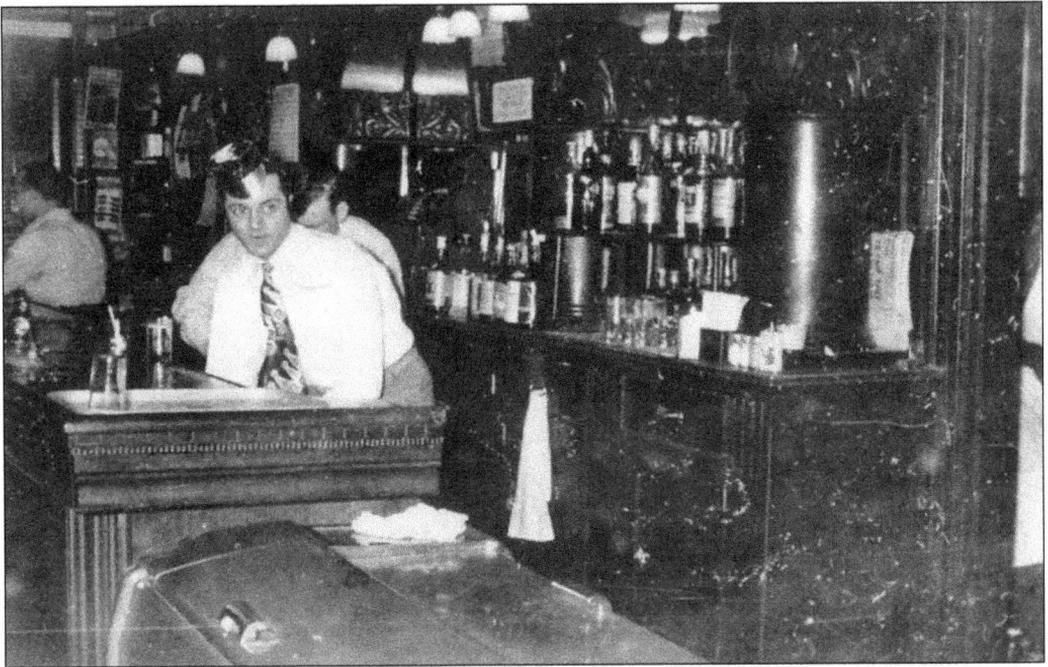

INSIDE POMPILIO'S RESTAURANT. Dan Pompilio Sr. is shown here tending bar on New Year's Eve at Pompilio's restaurant in Newport. For nearly 50 years, the Pompilio family offered delicious food, fun, and entertainment at its restaurant. It was one of the favorite spots in Newport to dine and to enjoy social gatherings. (Courtesy of the Pompilio family.)

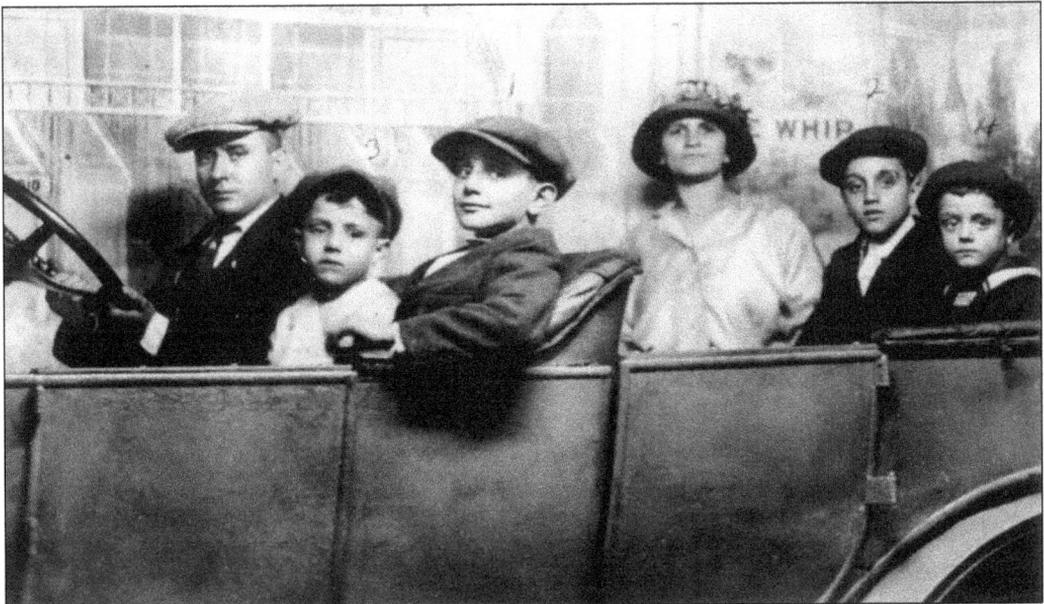

POMPILIO FAMILY ENJOYING A DAY AT CHESTER PARK, OHIO, C. 1920. The Pompilio family had this photograph taken while having fun at Chester Park, a favorite amusement park located at Spring Grove Avenue and Platt Avenue near Winton Place, Ohio. The park was established in 1875 and closed in 1932. Family members from left to right are John, Mike, Tony, Johanna, Matt, and Dan. (Courtesy of the Pompilio family.)

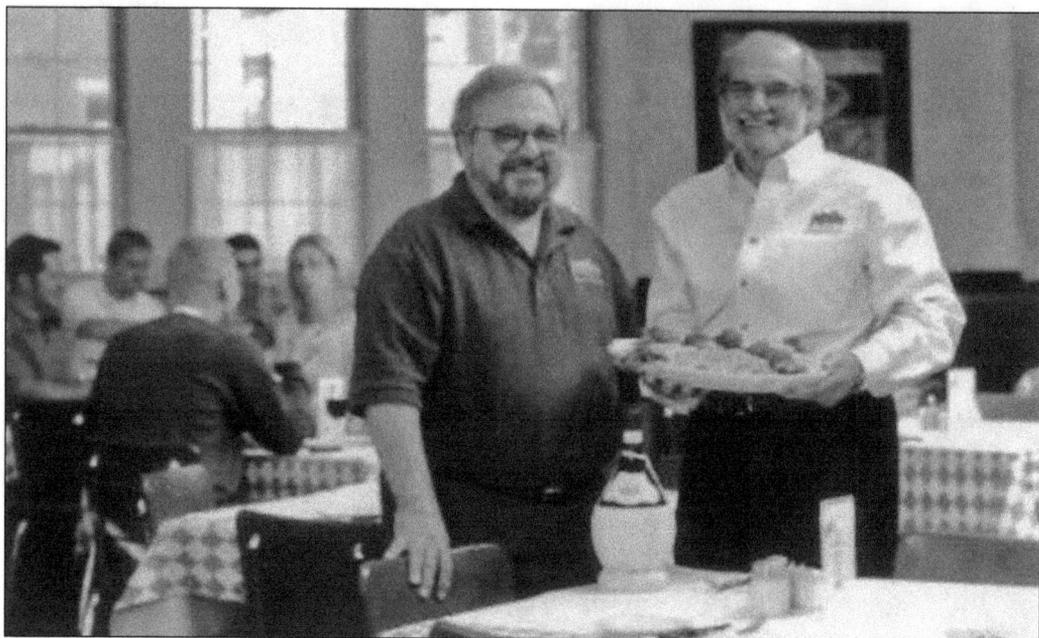

CURRENT OWNERS OF POMPILIO'S RESTAURANT. Peter F. (left) and Frank C. Mazzei (right), along with Carmen A. Argento, bought the establishment in 1982. It still operates under the name of Pompilio's, offering casual Italian dining for the whole family. The restaurant was featured in the famous toothpick scene in the 1988 movie *Rain Man*. (Courtesy of Kenton County Public Library.)

TAILOR CUTTING TABLE. This photograph was taken in the basement of Pat Greco's home in Southgate. Most tailors, even if they worked in tailoring shops, would often do work at home. Here he skillfully turned fabric as he cut it for suits and pants that he made for family and friends after he retired. His patterns are lined against the wall and were destroyed (the usual procedure) after his death in 1996. (Courtesy of the Pat Greco family.)

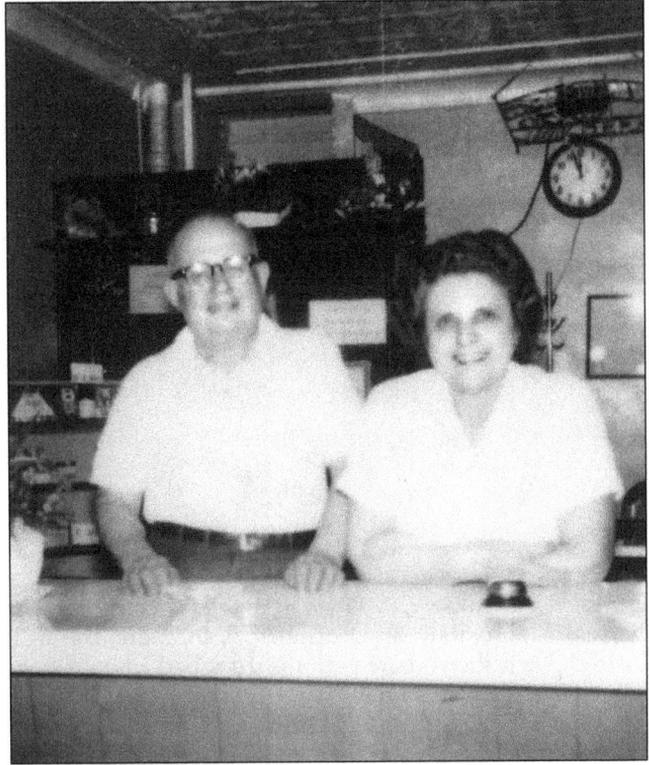

MICHAEL AND BERNADETTE TESTA FORDE, C. 1946. Michael Forde, along with his brother Charles, emigrated from Italy around 1917. Both men served in World War I. While serving, they were repeatedly annoyed by the mispronunciation of their name, so they changed the spelling of their surname from Forte to Forde. Bernadette Testa Forde was born in England of Italian parents and emigrated in 1919. They were married for 50 years until Michael's death in 1974. (Courtesy of Tom Forde.)

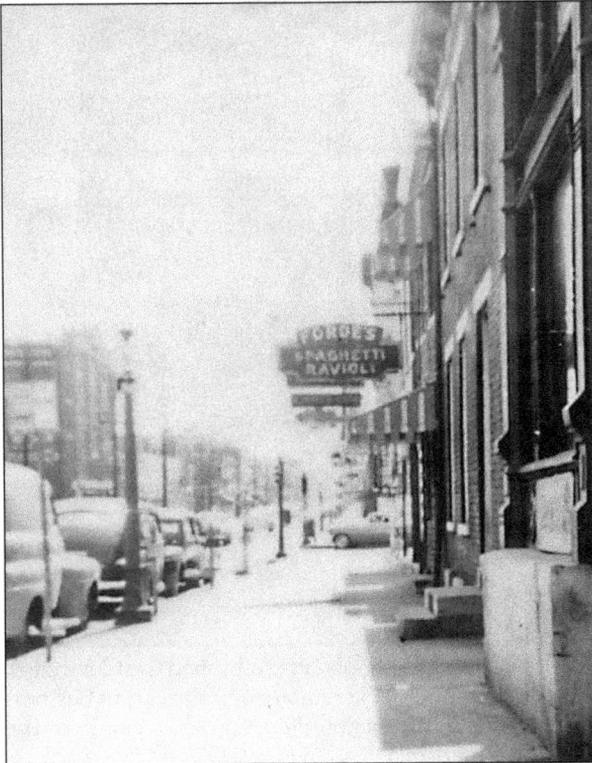

FORDE'S RESTAURANT, C. 1946. The final location for Forde's Restaurant was 414 Monmouth Street. Michael and Bernadette Forde opened the original restaurant in their home at 1132 Putnam Street in Newport in 1924. In 1930, they relocated their business to Ninth and Saratoga Streets in Newport. After 50 years in business, the restaurant closed in 1974. The Forde family was famous for their ravioli. (Courtesy of Tom Forde.)

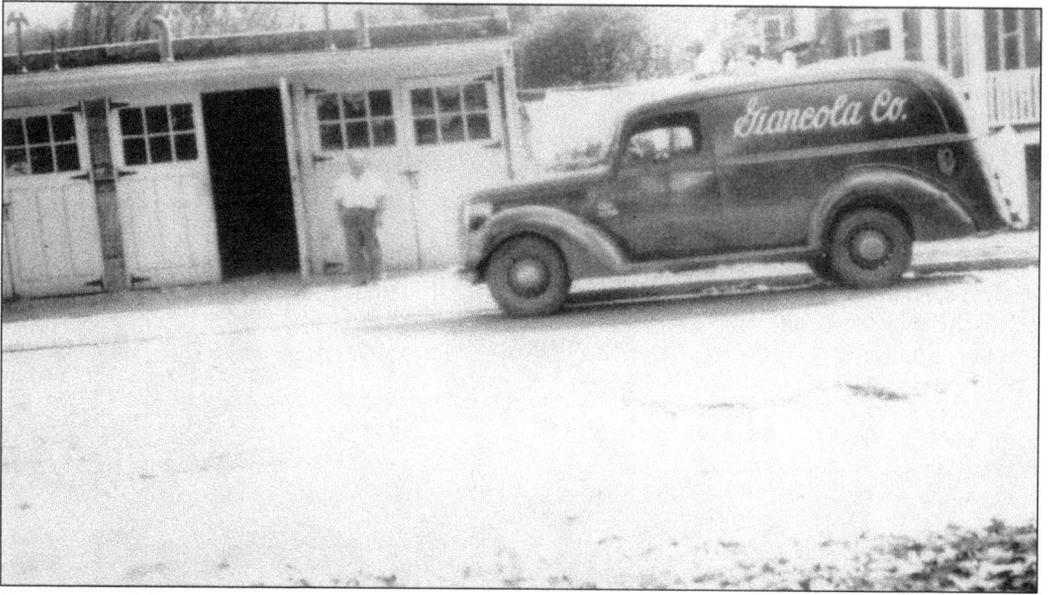

GIANCOLA COMPANY, C. 1949. John Giancola Sr. was born in Castelpetroso, Campobasso (now Isernia), Molise, Italy, on December 29, 1885, and traveled with his mother, Rufina, to America in 1893. He is shown here with his truck parked on Ash Street in South Newport. (Courtesy of Tina Giancola Pferrman.)

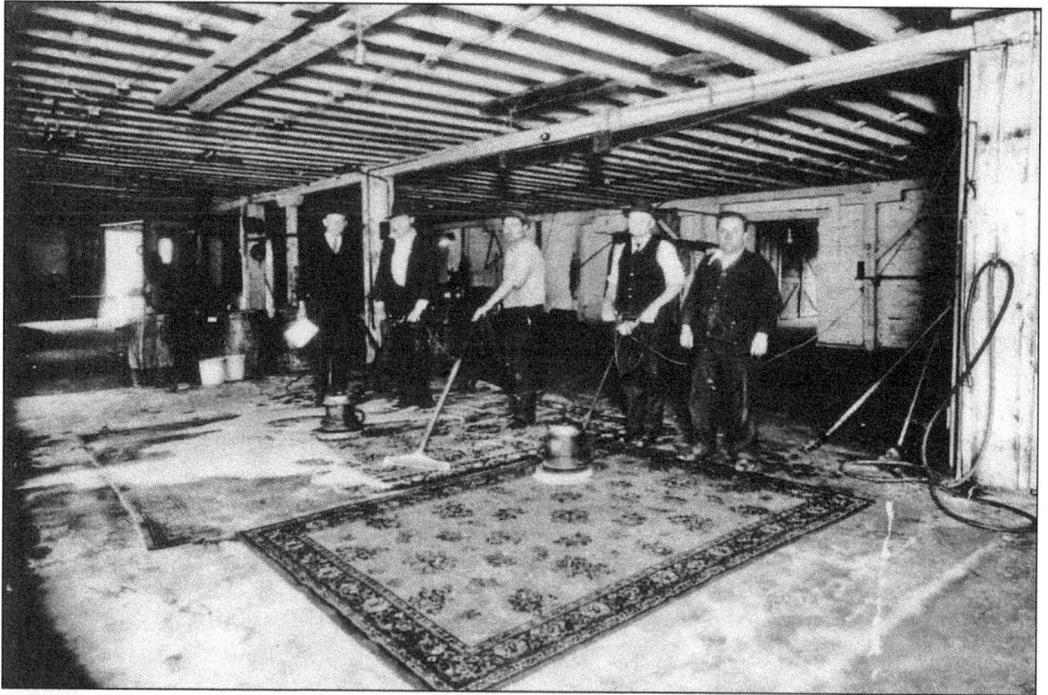

GIANCOLA RUG CLEANING BUSINESS. In the 1930s, John Giancola Sr. established the Covington Carpet Cleaning Company on Fifteenth Street in Covington. He remained in the carpet business for over 50 years. Today second- and third-generation Giancola and Pferrman sons remain in the flooring business. (Courtesy of Tina Giancola Pferrman.)

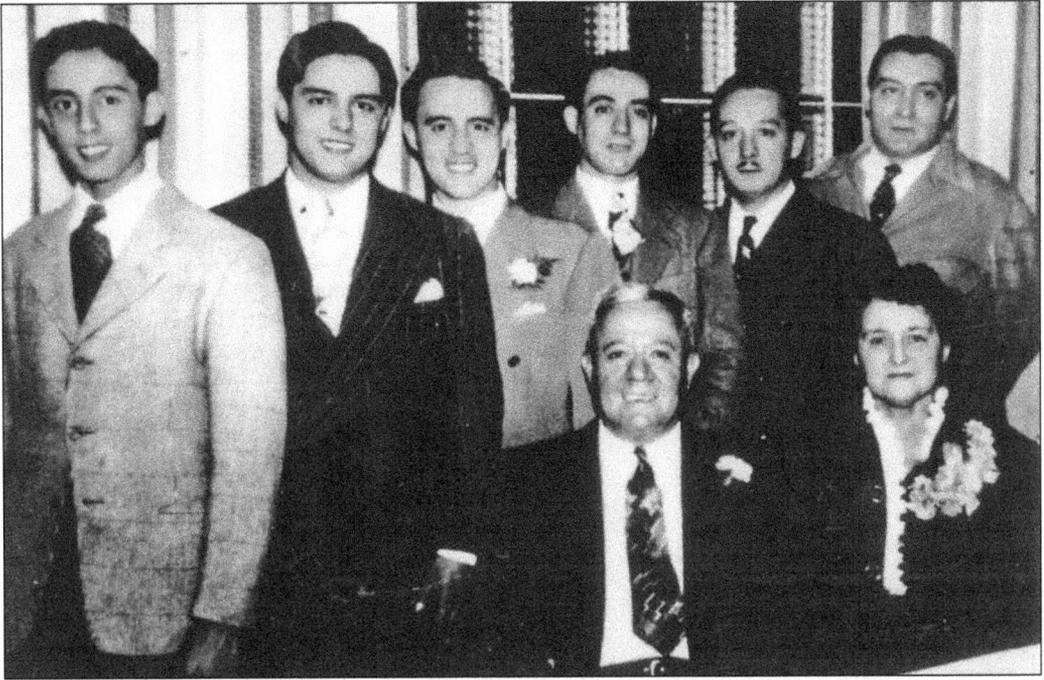

GIANCOLA FAMILY—SONS AND DAUGHTERS. In the above photograph, John Sr. and Bertina Zappa Giancola are shown with their sons—from left to right are Larry, Francis, John Jr., Eugene, Carl, and Jule. The Giancola daughters pose with their mother below: from left to right are Antoinetta Dinger, Bertina "Tina" Pferrman, Bertina Zappa Giancola, Delores Gobel, and Viola Barone. Bertina Zappa Giancola, the daughter of Julius and Juvini Zappa, was born in Newport in the house her father, Julius, built at 43 Grandview Avenue in Clifton. (Courtesy of Tina Giancola Pferrman.)

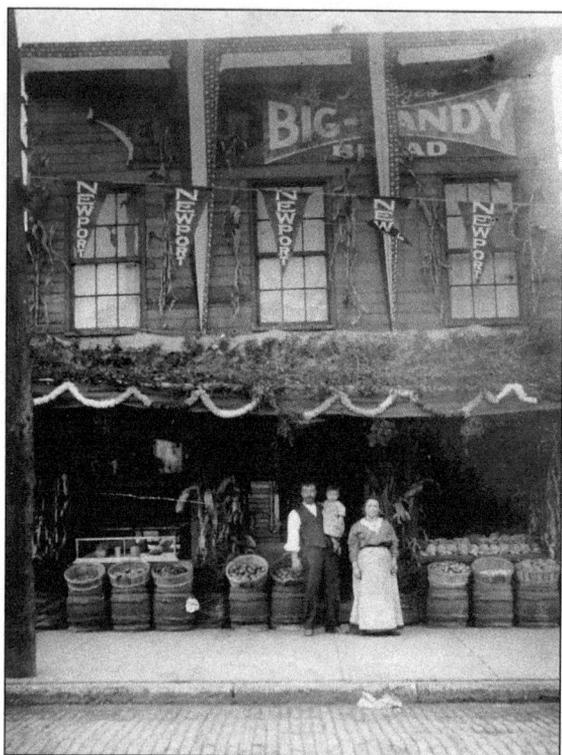

CRIMELLA'S GROCERY STORE, C. 1913.
Mario and Maria Bernero Crimella
owned and operated this store at 506
York Street in Newport. They also
operated another store at 525 York
Street. No one who ever entered the
store without money was turned away.
The Crimella family would offer credit
to their customers even if there were no
hope for repayment. They are holding
their daughter Antoinette "Ann" in this
picture. (Courtesy of Sr. Virginia Ann
Wolfzorn, CDP.)

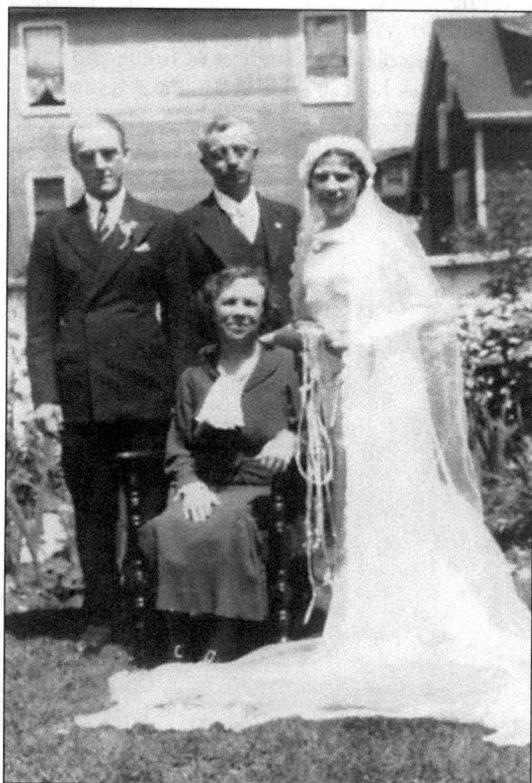

ERVIN WOLFZORN AND ANN CRIMELLA
WEDDING, MAY 29, 1935. Ervin and
Ann were married at the Immaculate
Conception Catholic Church in Newport.
They lived in town until about 1940, when
they moved to 27 Ash Street. There they
raised their two children, Carol Ann, who
would join the Congregation of Divine
Providence and become known as Sr.
Virginia Ann Wolfzorn, CDP; and a son,
Ervin "John" Wolfzorn. (Courtesy of Sr.
Virginia Ann Wolfzorn, CDP.)

Five

FAMILIES

Italian families were for the most part the union of a father and mother and often an elderly parent living within the same household, at least for a period of time. The father usually controlled discipline, and the mother took care of the physical and emotional needs of the family. Since most of the Italian families knew how to sew, they often made clothes for the children to wear. Toys to play with were either handmade or were everyday items used along with the imagination.

Cooking and meal preparation were the tasks of the women in the family. Young daughters helped as needed with meal preparation, household chores, or helping to care for the younger children. Traditional foods were the norm; making homemade bread and pasta were everyday occurrences. Pasta was laid to dry on any flat surface; even sheets laid across the top of the bed would do when the crowd was going to be larger than normal. Certain foods were reserved for the holidays, such as baccala (salted cod fish) for Christmas Eve or Italian Easter bread (sweet bread with whole eggs wrapped within the braided bread).

Winemaking and tending to the garden were usually left to the men in the household. An occasional trip to the basement, late at night while no one was looking, to taste the wine would definitely get the young sons in trouble. Neighborhood baseball games, street ball, and sleigh riding in the winter were how the older children passed the time.

Sadness and death would also impact the family in much the same way as today, only more frequently due to the lack of antibiotics. Men and women would often lose their spouses, and the family unit would have to be cared for by the surviving spouse, or in many cases, the widowed spouse would marry a brother or sister from the same family.

Most Italian families were private about family matters and outwardly affectionate, talking loudly and arguing over almost anything. While using hand gestures, communication would be understood with minimal effort. Italians for the most part were peace-loving, law-abiding citizens.

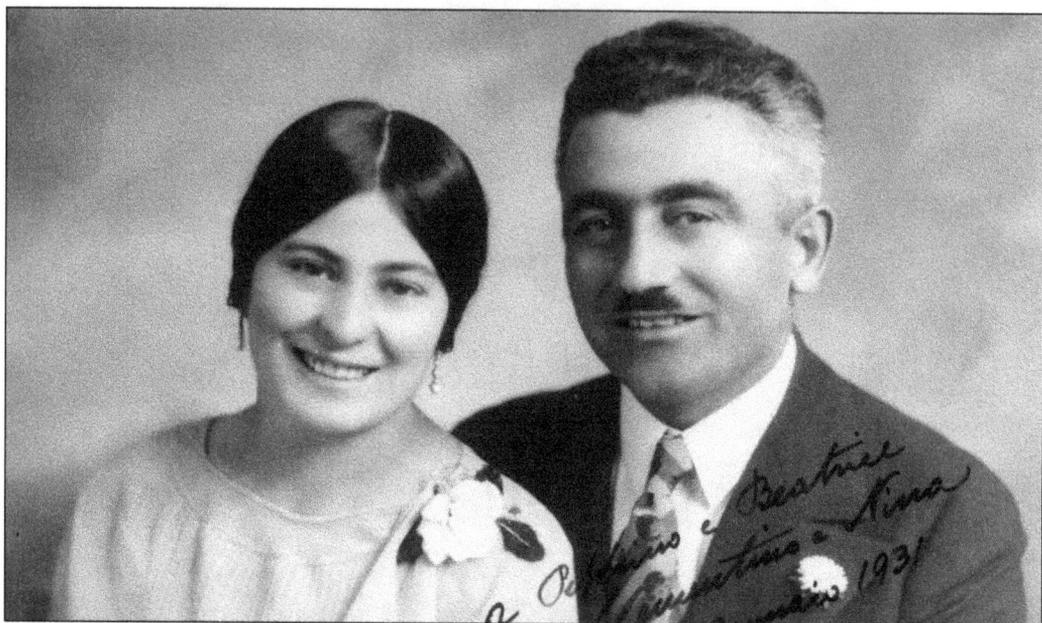

CLEMENTE AND ANNA MOCCIA SAULINO, C. 1931. Clemente "Clement" was born and raised in the town of Civitanova del Sannio, Isernia (formerly Campobasso), Molise, Italy. After World War I, Clement came to America on the *France*, arriving at Ellis Island on July 17, 1920. A tailor by trade, he stayed with his cousin in Cincinnati until he was able to find work. He was 28 years old when he arrived. (Courtesy of Bernice Saulino Roll.)

SAULINO FAMILY, C. 1949. Clement and Anna settled in Cumberland, Harlan County, Kentucky, where Clement owned and managed a dry-cleaning business. Anna helped with the alterations. They moved to Fort Thomas, Kentucky, in 1957. The family from left to right are (first row) Joe and Tom; (second row) Anna "Nina," Michela "Mickey," Joanne, Bernice, and Clement. (Courtesy of Bernice Saulino Roll.)

ENRICO AND MADELENA FARRO FORTE
FAMILY, C. 1932. Pictured from left to
right are Henry Jr., Madelena, Ed, Enrico
"Henry," and Philomena; Joseph is standing
behind them. After working the coal
mines of Pittsburgh, Enrico worked for the
Pennsylvania Railroad, where he repaired
track and handled mail and baggage.
After 40 years, he ended his career at the
Cincinnati Union Terminal. Madelena was
a seamstress and did piece work at home.
(Courtesy of the Forte family.)

LUCIA FORTE PUGLIESE AND BROTHER
ENRICO FORTE, 1955. During the Italian
immigration to America, families' lives
would change forever. Enrico said good-bye
to his sister in Italy in 1906, and after 49
years, they were able to reunite. Lucia Forte
Pugliese was reunited with her brother
Enrico "Henry" Forte on August 25, 1955,
while she was visiting her daughter in New
York. (Courtesy of the Forte family.)

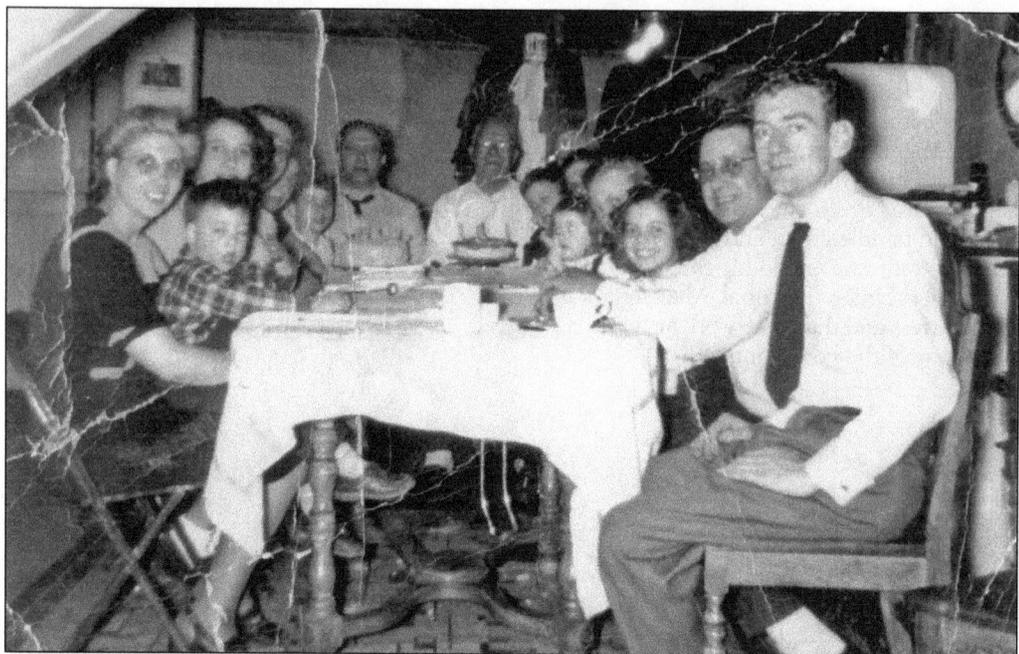

FAMILY GATHERINGS IN THE BASEMENT. It was common for large Italian families to gather and celebrate events in the coolness of their basements. Children would run and play, and the family would set up a table for all to eat together. The basement was often dug by hand in the homes where none existed. It was considered a necessity in order to store jarred foods from the garden and to age the wine. (Courtesy of the Michelina Meconio Sharp family.)

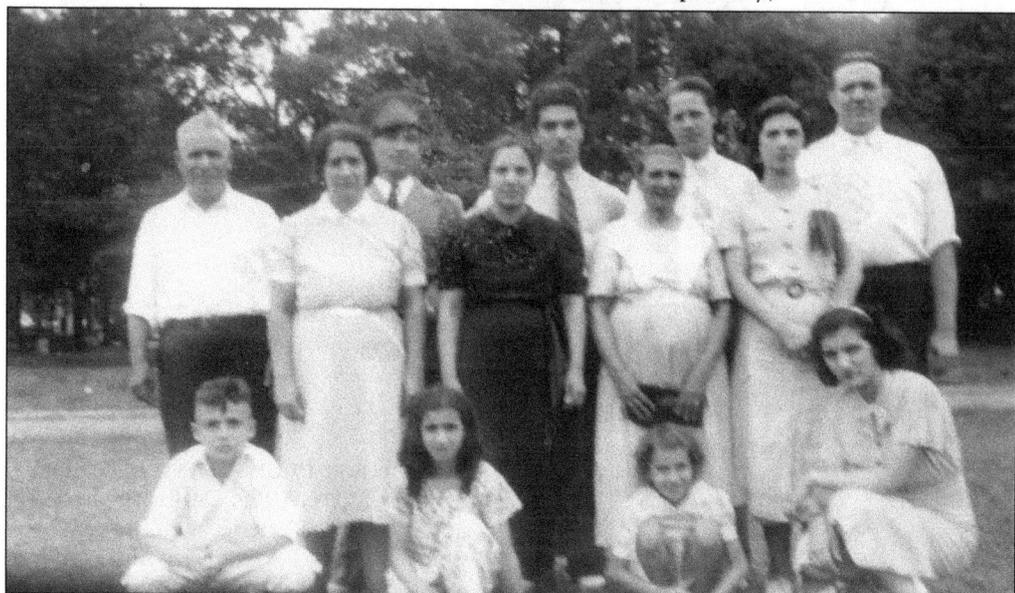

THE MECONIO FAMILY. Members of the Meconio family from left to right are (first row) four unidentified; (second row) Marco Meconio, Carmel Greco Meconio, Philomenia Meconio Miglio, Caterina Litrenta Meconio, and Mickey Meconio Sharp; (third row) John Meconio, John Miglio, Vincent Sharp, and Morris Kravitz. Bertha Meconio Kravitz is not shown. (Courtesy of the Michelina Meconio Sharp family.)

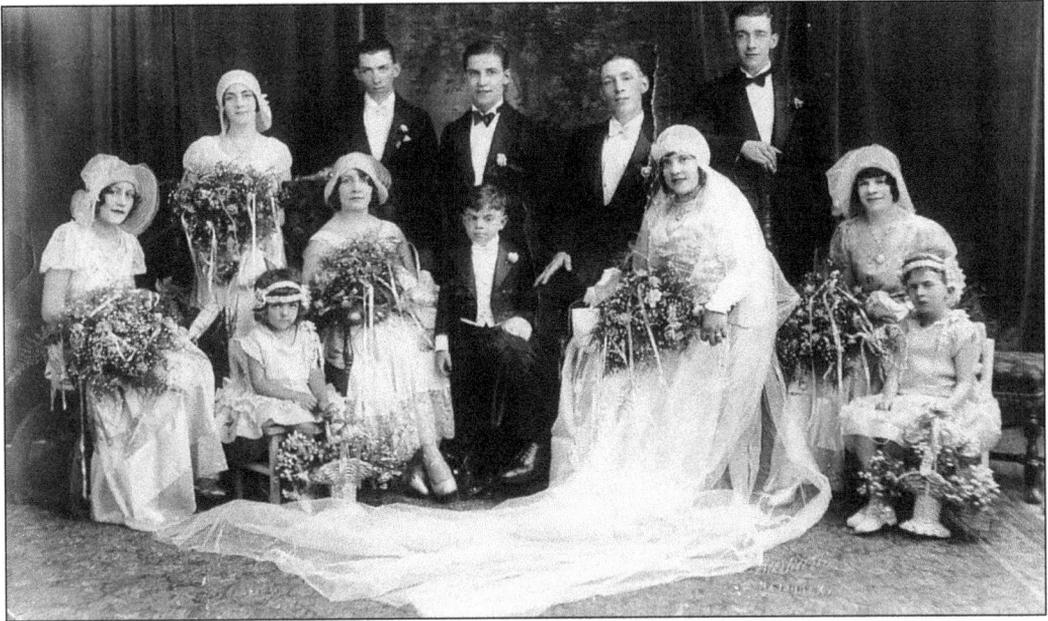

THE WEDDING OF MILDRED GIANCOLA AND PAUL LEHR, JULY 5, 1930. As shown on the cover, the wedding party is, from left to right, (first row) two unidentified, Josephine Giancola Arcaro, Pete Ledonne, Mildred, Ida Ledonne, and Lillian Lehr (seated in the chair); (second row) Esther Larvo, Charles Lehr, Frank Giancola (bride's brother), Paul, and unidentified. (Courtesy of Madelyn Lehr.)

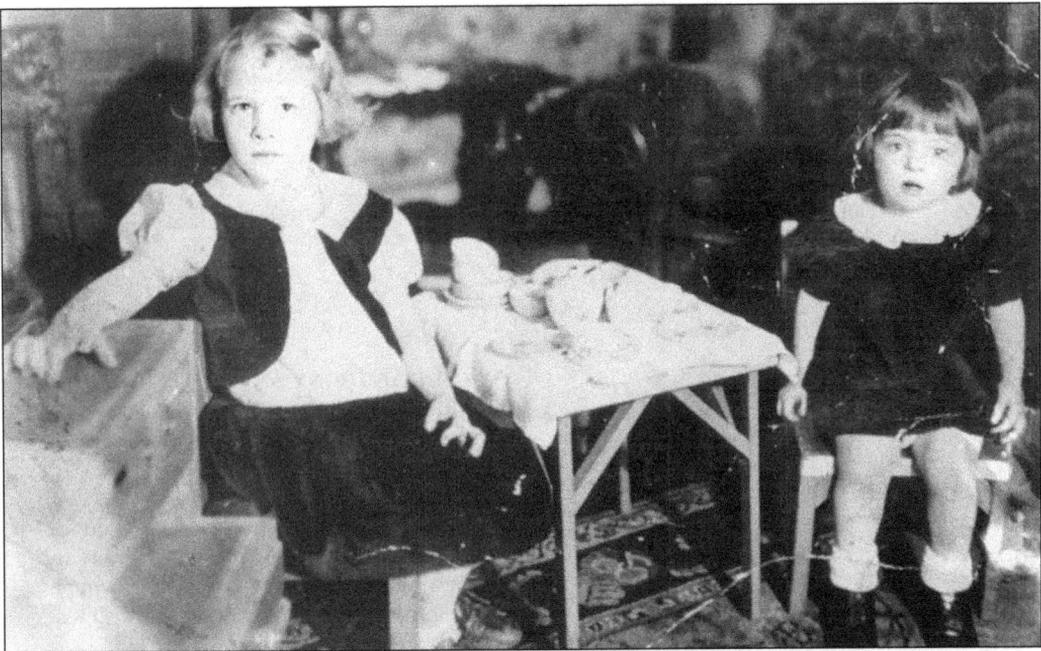

MADELYN AND DOLORES LEHR, C. 1934. These children at play are dressed in clothes made by their mother, Mildred Giancola Lehr. Their father, Paul, made the furniture. From left to right are Madelyn, who was a Sister of Divine Providence for 19 years, and Dolores "Dee," who served as an administrative assistant with the Newport Police Department. (Courtesy of Madelyn Lehr.)

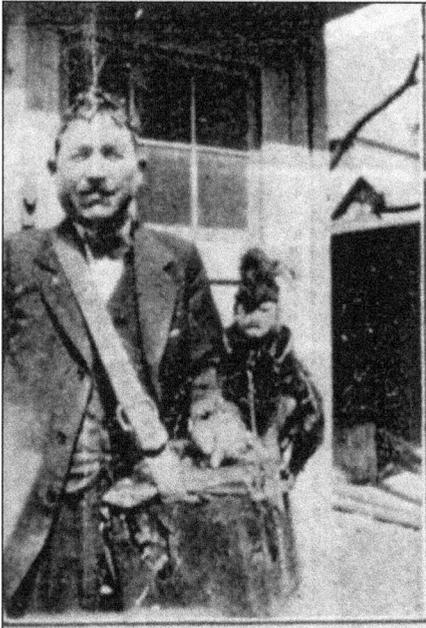

CARMINE ARMENTI

Monkey and Organ Furnished
for Parties and other Occasions

1918 EAST 123rd STREET
CLEVELAND

Telephone: GArfield 0842

CARMINE ARMENTI AND HIS MONKEY. Carmine Armenti from Cleveland would visit his family and the Forte family in Newport every November. He came to work at Rollman and Sons Department Store. He and his monkey would entertain the children in the toy department while their parents shopped for Christmas gifts. (Courtesy of Gayle Forte Groeschen.)

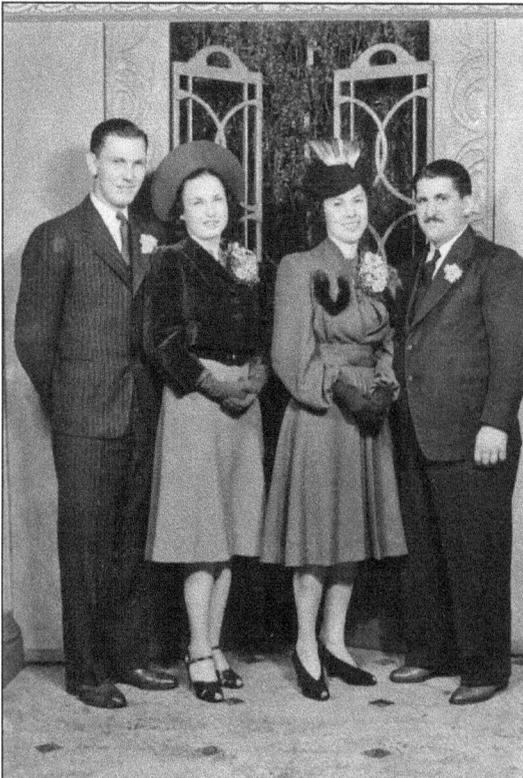

JOHN ANTHONY AND HELEN MENCH ARMENTI WEDDING, NOVEMBER 23, 1940. John (far right) was the son of Joseph and Caterina Armenti, who came to America at the beginning of the 20th century. The Armenti family settled for a short period in Erie, Pennsylvania, and then moved to Cleveland, Ohio, where they raised their family. John found work with the American Tool Works. He and Helen (shown next to him) lived in Newport, where they raised three daughters, Catherine, Judy, and Rosie. (Courtesy of Gayle Forte Groeschen.)

DOMINICK FORTE SR. AND OLIVE "OLLIE" WAITS WEDDING, JUNE 22, 1929. This photograph was taken on Tenth Street in Newport, where they blocked off the street and held their reception. Dominick was a machinist, and Ollie was a homemaker who also worked as a waitress at Forde's Restaurant. They had four children, Dominick Jr., Robert, James, and Gayle. (Courtesy of Gayle Forte Groeschen.)

DOMINICK FORTE JR. Dominick died on August 2, 1937, at the age of seven, the first in the area to die from polio. From the mid-1940s through 1950s, the Northern Kentucky area was faced with a polio epidemic. Dominick's mother, Ollie, was active in raising funds to find a cure for the dreaded disease. A vaccine was developed in 1953, and area children were vaccinated in April 1955. (Courtesy of Gayle Forte Groeschen.)

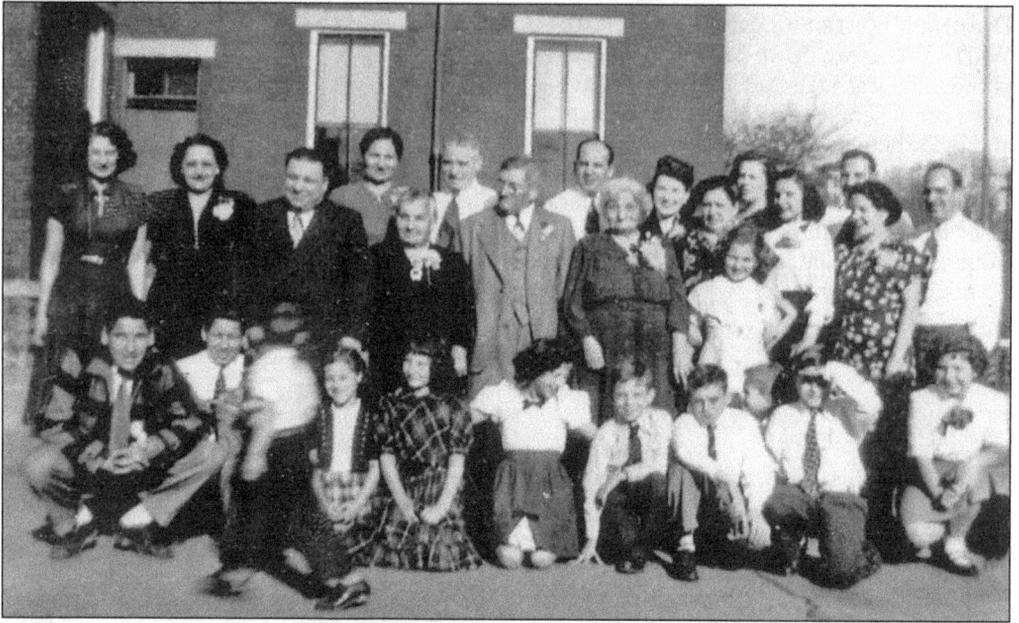

PAOLUCCI FAMILY, 1948. This family photograph was taken at the 50th wedding anniversary of Peter and Mary Illiano Paolucci at York Street School in Newport. Celebrating the event are members of the Dilillo, Paolucci, Plucci, and Purcell families. (Courtesy of Bob Paolucci.)

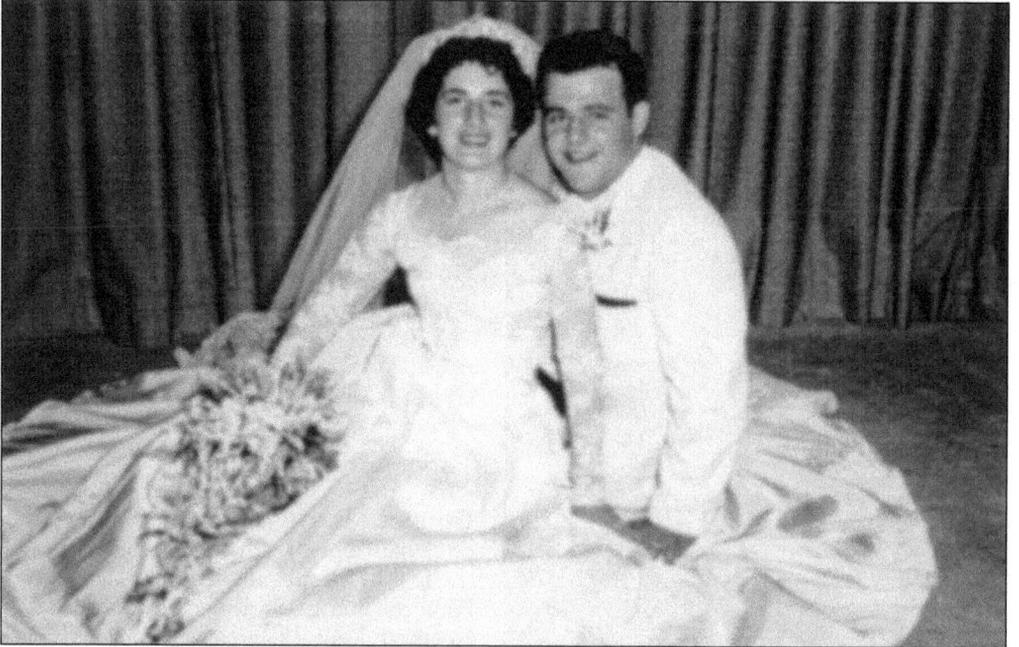

JAMES AND IDA DI PAOLO FINKE, AUGUST 30, 1958. Escaping the rule of Benito Mussolini, Ida emigrated from Cansano, L'Aquila, Abruzzi, Italy, at three years of age along with her family in April 1939 and settled in New York. After marrying Jim Finke, a Northern Kentuckian, they moved to Kentucky. Ida took an active role in the community, serving as an officer in the Women's Guild of St. Elizabeth Hospital and the Covington–Kenton County Jaycee Wives. They raised two children, Lisa and Michael. (Courtesy of Ida Di Paolo Finke.)

CARMELLA STELLITANO PANGALLO. At the end of the day, Carmella would spend hours crocheting baby gifts and blankets for the family. A kind-hearted, loving person who always made anyone she talked with feel special, Carmella was considered by those who knew her as everyone's mother and everyone's grandmother. (Courtesy of Pangallo family.)

MADDALENA MONTI GUIDUGLI. Maddalena loved to garden and especially cared for her roses at the family home located at 1112 Burnet Avenue in Woodlawn. Perhaps her secret was that under those 150 rose bushes, she planted her herbs to perfectly season the food she prepared for her family. (Courtesy of Sr. Maddalena Guidugli, CDP.)

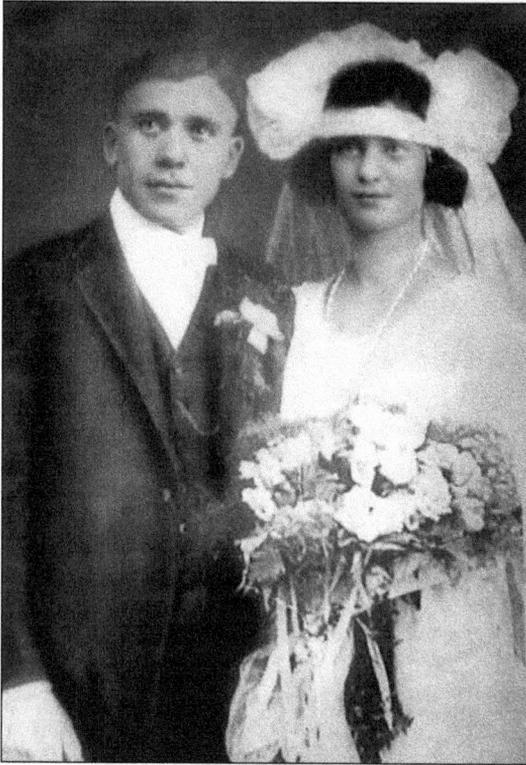

POTITO "PETE" PETROZE AND MARY ZAPPA WEDDING, OCTOBER 19, 1921. Pete, the son of Donato and Carmella Zechella Petrozzi, left his home in Ascili Satriano, Foggia, Puglia, on April 10, 1913. While at Ellis Island, his last name was changed from Petrozzi to Petroze. Pete arrived in Newport on July 3, 1913. He served and was severely injured in France during World War I. When he returned from the war, he married Mary Zappa. (Courtesy of Nick Petroze.)

PETROZE CHILDREN, 1944. Beatrice "Bea Ann" and Nicholas "Nick" were all dressed up for the wedding of Rosella Zechella and Bill Kathman. In addition to Nick and Bea Ann Lang, the other Petroze children are Dolores Kramer, Rosemary Fuchs, Donald, Henry, William "Bangs," and Thomas. (Courtesy of Nick Petroze.)

PELUSO FAMILY. Giovanni "John" J. Peluso Sr. emigrated with his wife, Antoinette Shavio Peluso, from Italy in 1901 and originally settled in Bellefonte, Pennsylvania. After moving to Kentucky, he operated a grocery store at 623 Monmouth Street in Newport. He is shown here with his son Joe and his son Johnny's wife and children; shown from left to right are Antoinette, Joseph Peluso, John J. Sr., and daughter-in-law Margaret Holloran Peluso with sons Frank Sr. and John Martin. (Courtesy of Frank Peluso Sr.)

GRANDMA PELUSO WITH GRANDDAUGHTER. Immigrant Antoinette Shavio Peluso, a homemaker, is shown here with her granddaughter and namesake Antoinette Peluso Kunkel. Her granddaughter's love of children and concern for their education brought her to work as an administrative assistant in the superintendent's office for Newport Public Schools, where she worked for 15 years before her death in 1997. (Courtesy of Frank Peluso Sr.)

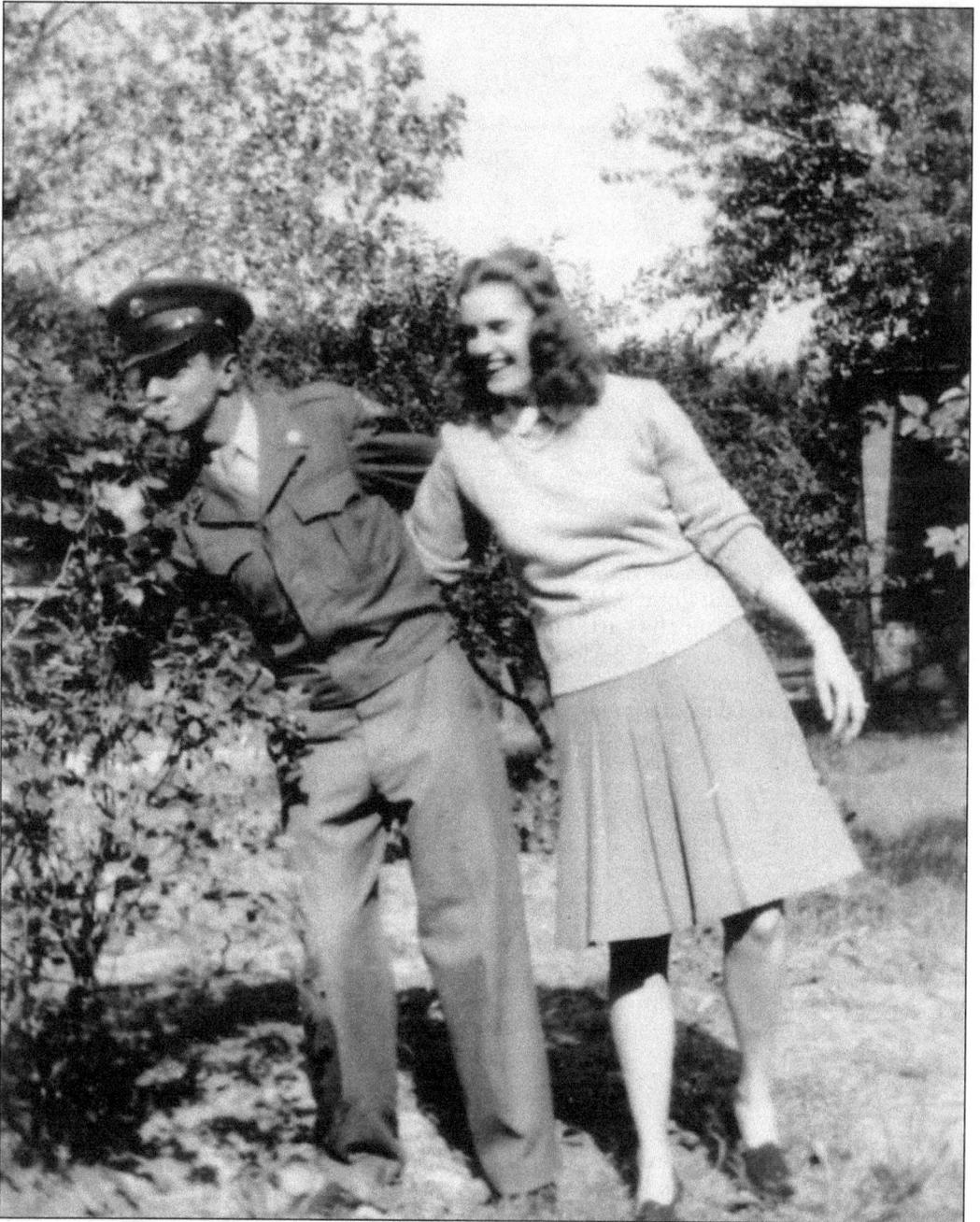

JOHNNY J. PELUSO JR. AND MARGARET HOLLORAN PELUSO. Johnny, the son of Italian immigrants Giovanni "John" Sr. and Antoinette Shavio Peluso, was born in Bellefonte, Pennsylvania, on June 1, 1923. He is one of 19 children. Johnny married Margaret Holloran in 1942. He fulfilled his military obligation with the 69th Army Infantry Division during World War II, during which time he became a prisoner of war. After the war, he started his own television repair shop and received the nickname of Johnny "TV" Peluso. Johnny served the citizens of Newport as mayor for two terms beginning in 1964 and 1976. He also served four terms as a Newport city commissioner. (Courtesy of Frank Peluso Sr.)

Six

WAR

Italian Americans have participated in every major confrontation facing America since the American Revolution. While war is difficult for everyone, and it seems no one ever really wins, it changes everything. The early immigrants, while still trying to build a future in America, found themselves faced with the United States' entry into World War I (1914–1918). The American Expeditionary Force, or AEF, was the United States military during the war. Instead of the war being "the war to end all wars" as President Wilson had hoped, it became the training ground for what was to follow in World War II.

The United States' entry into World War II (1939–1945) would find first-generation Italian Americans fighting for freedom on all fronts. The impact was felt in both Italy and America, as family members realized that they could be fighting their brothers and extended family in Italy. Perhaps due to the small communities in Northern Kentucky, there was no apparent mistrust of the Italians; therefore, the internment of Italian Americans or the labeling of them as "enemy aliens," as was demonstrated in the larger United States cities, did not apply here. Italian Americans who held jobs with the railroads, for example, continued to work without any discrimination.

The brave men and women covered in this chapter were proud to have served in the United States military during World War I, World War II, and the Korean War (1950–1953). No one could ever question their patriotism. The families at home, and the communities at large, did what they could to stay in touch with all of those who served and to show their appreciation for their sacrifices.

During and after the war, training and higher educational opportunities were available to those who served, and cheaper housing loans were made available under the G.I. Bill. This was a great advantage, particularly to the Italian families who were trying to get a better education in order to achieve their American dream.

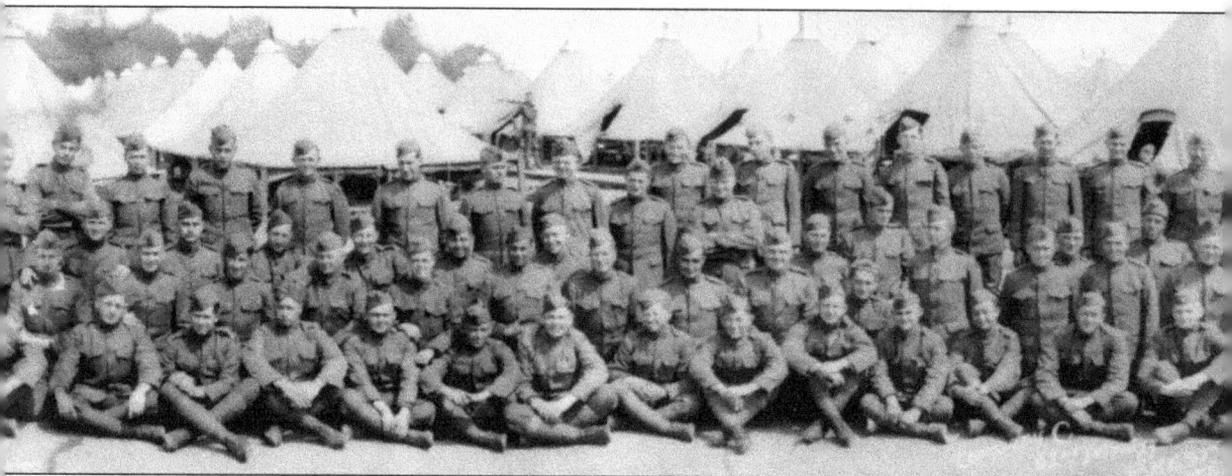

COMPANY C, 52ND INFANTRY, WORLD WAR I AMERICAN EXPEDITIONARY FORCE. America remained neutral during the first two and a half years of World War I. The United States lacked a large army, had no plans for mass mobilization, and had poorly trained soldiers. Once Congress declared war in April 1917 and the Selective Service Act was passed, local draft boards registered

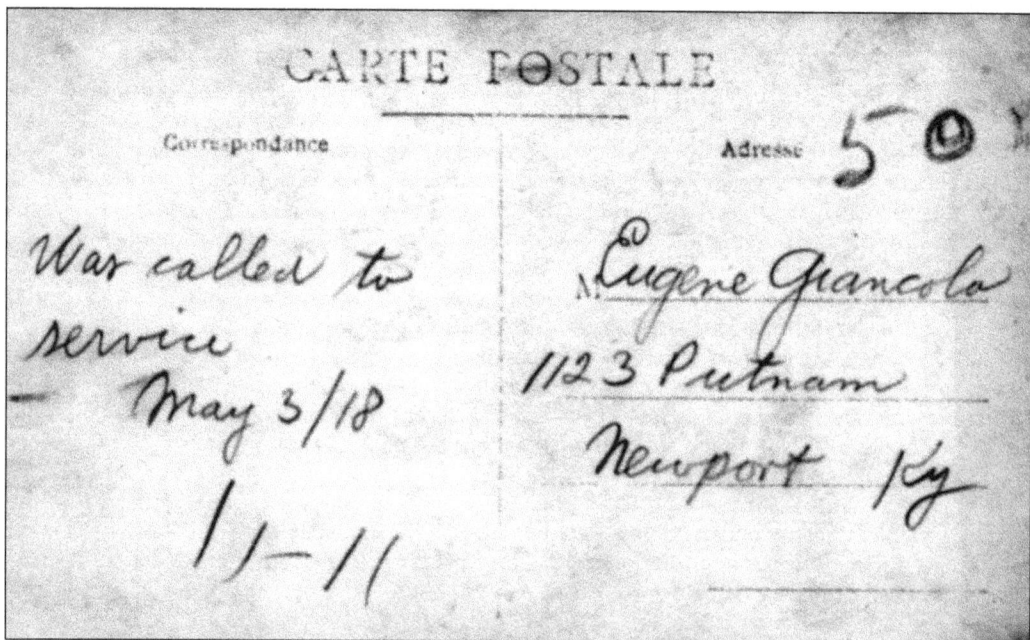

PASCHAL GIANCOLA WORLD WAR I POSTCARD TO HIS BROTHER EUGENE, 1918. Paschal sent this postcard and announced to his brother his pending deployment. Paschal served from July 6, 1918, to June 12, 1919, overseas in the infantry of the American Expeditionary Forces (AEF). (Courtesy of R. Toni Bungenstock.)

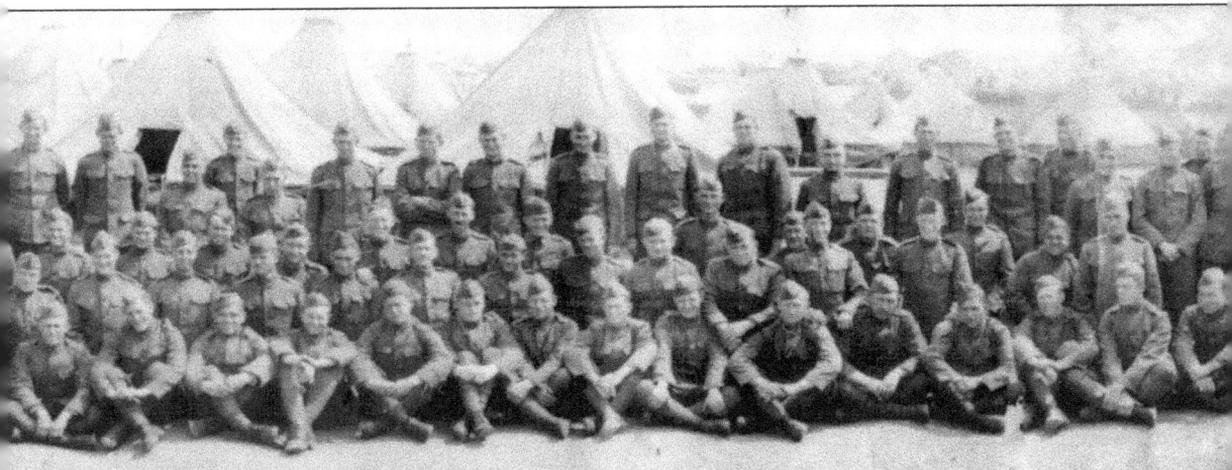

24 million men between the ages of 18 and 45 to serve. Paschal Giancola, a first-generation Italian American, is shown in the second row, second from the right end. (Courtesy of R. Toni Bungenstock.)

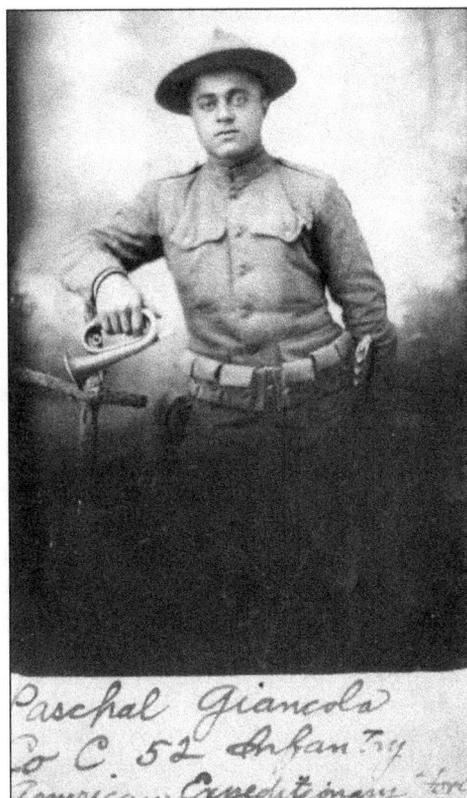

PASCHAL GIANCOLA. Paschal served under the command of Gen. John J. "Black Jack" Pershing. The AEF, for the most part, fought as a separate American force, with most battles fought in the Meuse Valley, Belgium, which bordered France. (Courtesy of R. Toni Bungenstock.)

Paschal Giancola
o C. 52 Infantry
American Expeditionary force

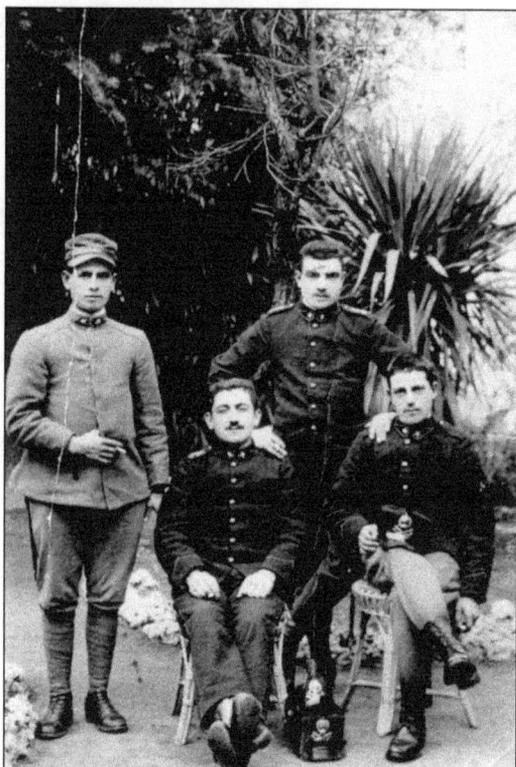

CLEMENTE "CLEMENT" SAULINO IN WORLD WAR I, C. 1918. Clement fought in the Italian Army during World War I. The Italian participation during the war consisted of mounting 11 offensives from June 1915 through November 1917 in the Battles of Isonzo as well as the Battle of Caporetto. Clement is sitting in the center of the photograph. The other men in the photograph are unidentified. (Courtesy of Bernice Saulino Roll.)

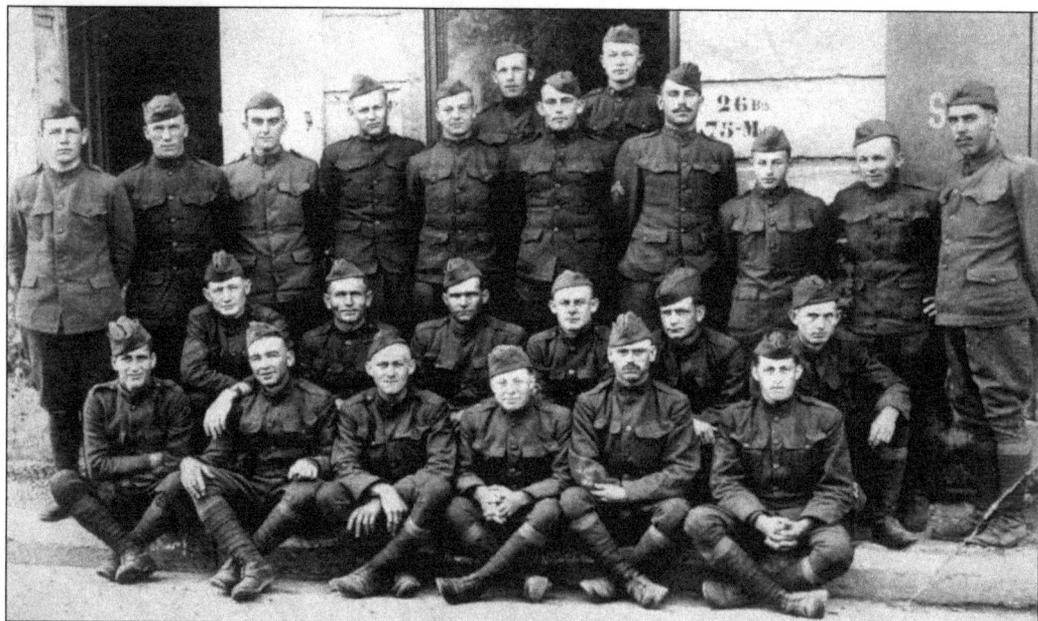

PFC. MICHAEL GALLICCHIO IN WORLD WAR I, JULY 12, 1918. Michael (third row, third from the right) received his citizenship papers by volunteering to serve in World War I. He was inducted into the American Expeditionary Force on December 24, 1917. He served with Battery E, 61st Artillery, C.A.C. (Coast Artillery Corps), from January 21, 1918, until February 18, 1919. The regiment landed in St. Nazarre, France, on July 30, 1918. (Courtesy of Bob Bramel.)

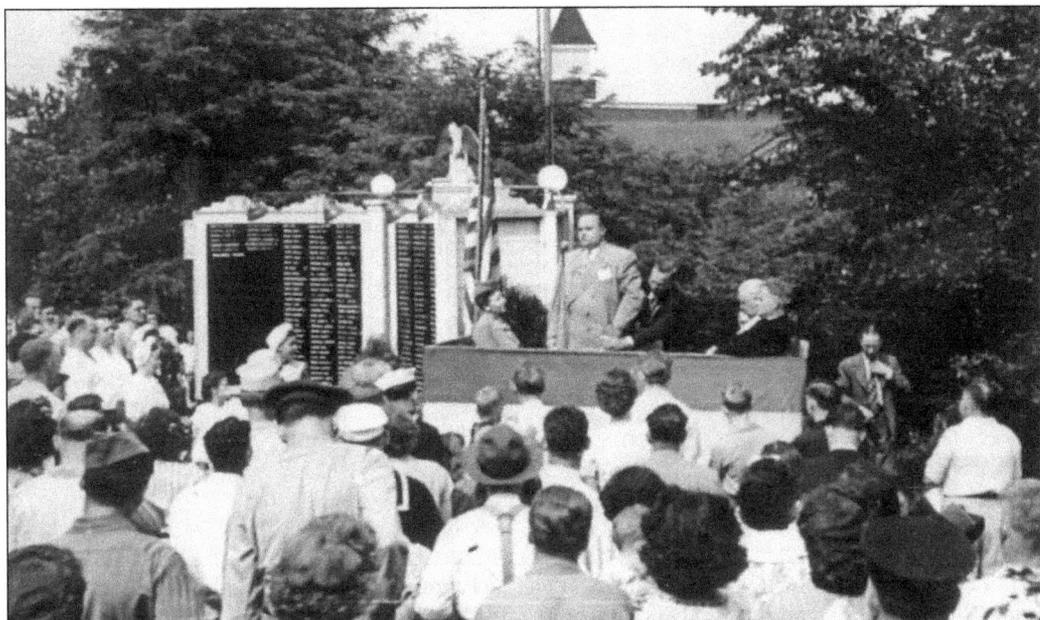

DEDICATION OF THE SOUTH NEWPORT HONOR ROLL. William J. Busam Sr. of 202 Kentucky Drive designed the South Newport Honor Roll, and a committee was established to raise funds in order to update and maintain it. The names of South Newport servicemen were painted on the board, and as of January 1946, it listed 485 names. Bob Sidell is shown here dedicating the honor roll. (Courtesy of Mary Dilillo.)

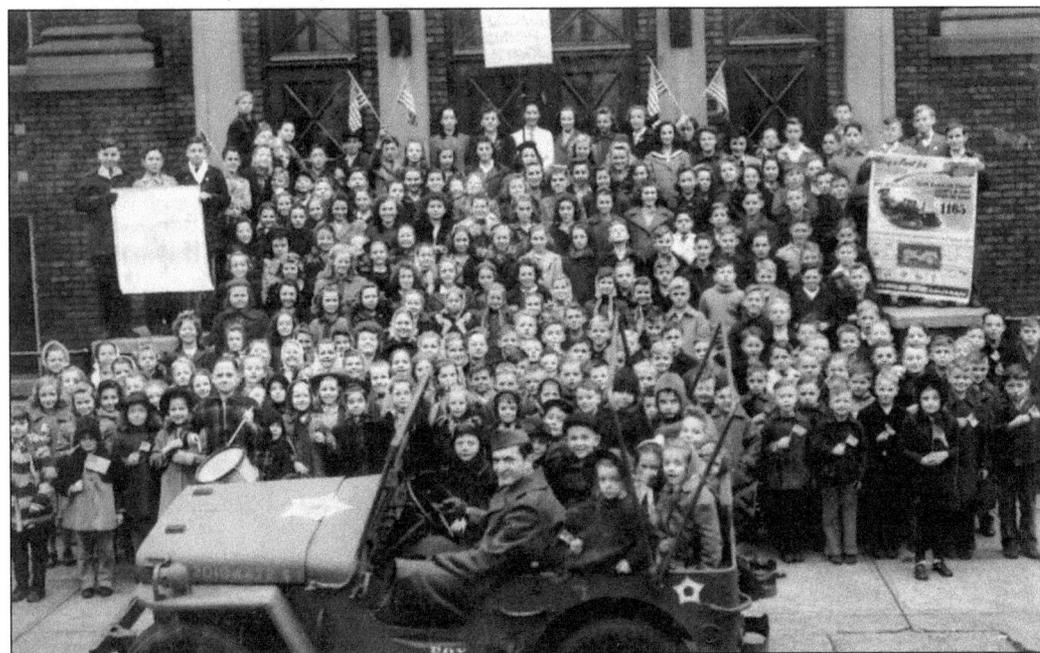

CORPUS CHRISTI SCHOOL SCRAP DRIVE, C. 1943. The schoolchildren at Corpus Christi School in Newport held a scrap drive to purchase a Jeep for the U.S. Army during World War II. After the jeep was purchased, a soldier delivered the Jeep to the school for the children to see and to officially thank them. (Courtesy of Bob Paolucci.)

THE LOMBARDO FAMILY IN COTE BRILLIANTE. The Lombardo family resided at 15 Ohio Avenue from 1918 until 1943. Family members from left to right are (first row) Antoinette "Dean," Andrew, and Angelina (née Greco); (second row) Dominic, Mary Anne, Sylvester, and Ernest. Four out of five of the Lombardo sons would serve during World War II. Ernie was drafted into the army in July 1944 and received a medical discharge in November 1944 for a bad knee. Dominic, being a sole surviving son, was exempt from serving. (Courtesy of the Lombardo family.)

ST. FRANCIS DE SALES CHURCH, COTE BRILLIANTE. Andrew Lombardo was a stonemason who helped build St. Francis de Sales Catholic Church in 1911. With sadness, the members remembered parishioners who died in World War II during a memorial service held there on August 4, 1946. Those remembered were Frank Benning Jr., David Guidugli, Robert Huskisson, John Schmitz, Vincent Steil, and Harry Vaal. (Courtesy of Sr. Maddalena Guidugli, CDP.)

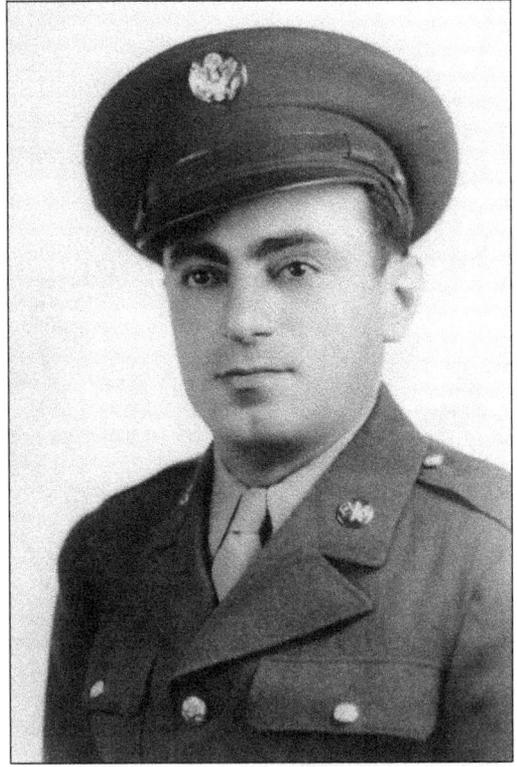

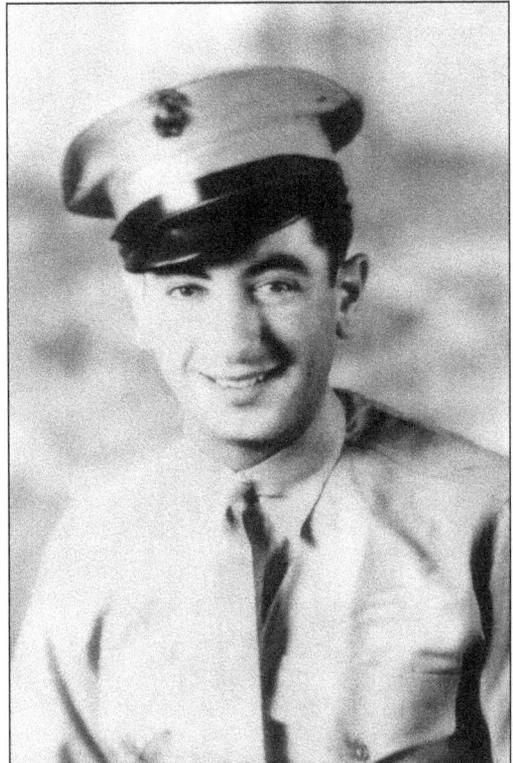

CPL. JOHN, CPL. ADOLPH "AL," AND SGT. SYLVESTER LOMBARDO. In September 1941, John (above left) was one of the first 50 to be drafted into the army from Campbell County. He was assigned to the Army Combat Engineers and participated in the invasion of Africa. His unit built airstrips, roads, and bridges. Al (above right) was drafted in November 1942 and sent to the University of Kentucky for radar and radio school prior to being shipped out. He was assigned to the Army Signal Corps in the European theater, where he worked in army intelligence. His tour of duty took him to England, France, Germany, Belgium, and Holland. Sylvester (shown at right) served in the U.S. Marine Corps from March 1942 through February 1945. Assigned to the infantry, he participated in the invasion of Wake Island and was a drill sergeant. (Courtesy of the Lombardo family.)

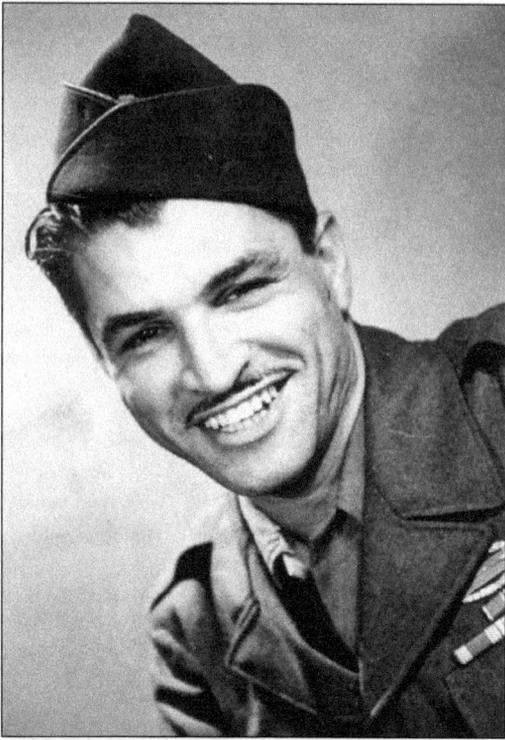

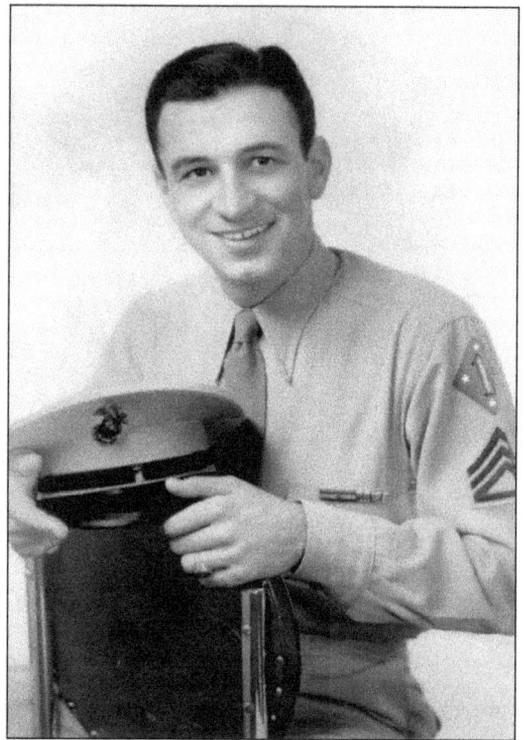

S.Sgt. Nicholas J. Ciafardini and S.Sgt. Patrick J. Ciafardini in World War II. Nick (above left) served with the U.S. Army cavalry detachment and regular army with tours in Belgium and France. While in Belgium, he fought in the Battle of the Bulge. His brother Pat (above right) enlisted in the U.S. Marine Corps on February 2, 1942. He fought in the invasion of Guadalcanal Island on August 7, 1942. (Courtesy of the Ciafardini family.)

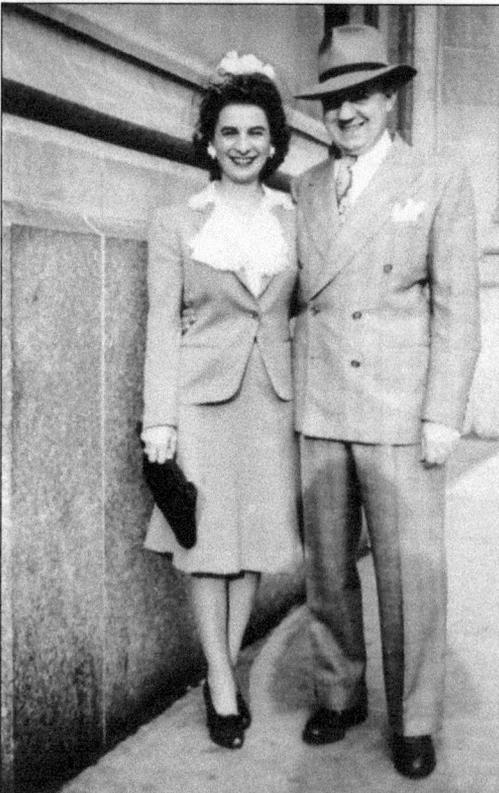

Albert and Rosa Ciafardini Di Pilla in New York City, 1943. Rosa went to New York City to visit her husband, Albert, a tailor, who was there making uniforms for the military during World War II. After the war, Albert and his brothers opened a tailoring business in downtown Cincinnati called Di Pilla Custom Tailors Shop. Rosa was a homemaker and volunteered at Sacred Heart Church. (Courtesy of the Ciafardini family.)

ALBERT "BUDDY" AND ROSALIE GRECO.
Pat Greco, the head designer and cutter
at Leonard Tailoring in Cincinnati, was
making officers' uniforms for the military
during World War II. He made this uniform
for his son from the actual fabric used for
the officers' uniforms. The brass ornaments
needed to complete it were obtained from
a supply officer. Buddy's sister, Rosalie, is
all dressed up to celebrate her uncle Bill
Greco's homecoming furlough party held
in November 1944. (Courtesy of the Pat
Greco family.)

LENA CIAFARDINI GRECO. During the
war, Lena prepared a scrapbook to record
what was happening with her brother Pat
while serving overseas. Newspaper articles
were clipped and pasted in the book along
with his letters. She would keep up with
her brother Nick, too, and relay family and
community information to them. (Courtesy
of the Ciafardini family.)

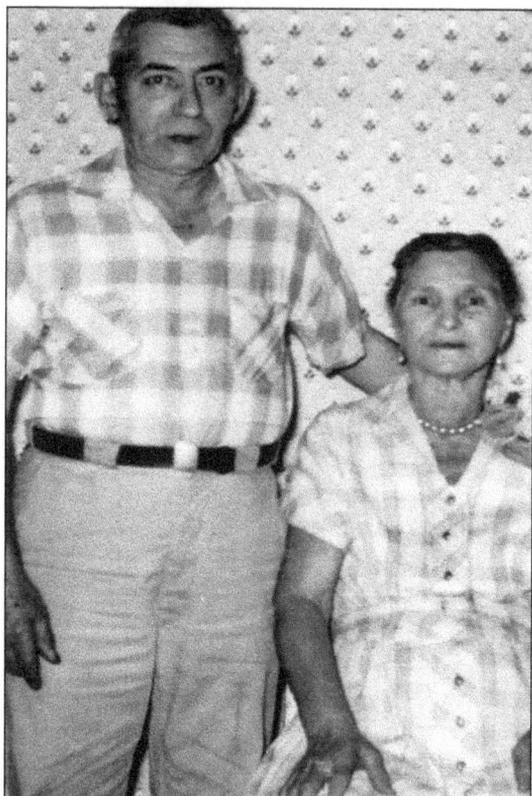

GIOVANNI AND CAROLINA ZAPPA PICCIRILLO 50TH WEDDING ANNIVERSARY, APRIL 1957. Giovanni "John" came to America on August 9, 1902, and Carolina arrived on July 3, 1905, for her prearranged marriage to Giovanni. They raised 11 children. They also sent the greatest number of family members from Campbell County, Kentucky—five of their sons—to serve in World War II. (Courtesy of Sandy Piccirillo McFarland.)

MIKE, ALFRED "FREDDIE," LOUIE, AND SEVERIN "PETE" PICCIRILLO (FROM LEFT TO RIGHT). Pfc. Alfred J. Piccirillo was injured while training for the infantry. He later served in England and was granted a medical discharge. Pvt. Severin "Pete" Piccirillo was inducted in July 1944 and served overseas. (Courtesy of Sandy Piccirillo McFarland.)

JOHN AND JOSEPH "JOE" PICCIRILLO. Sgt. John Piccirillo Jr. (above left) served in the Pacific and received the Arrow Head Award for spearheading landing troops. He also did occupational duty in Japan. Pfc. Joseph A. Piccirillo (above right) served in the infantry. He was wounded on D-Day and received the Purple Heart in addition to the Arrow Head Award for spearheading troops. (Courtesy of Sandy Piccirillo McFarland.)

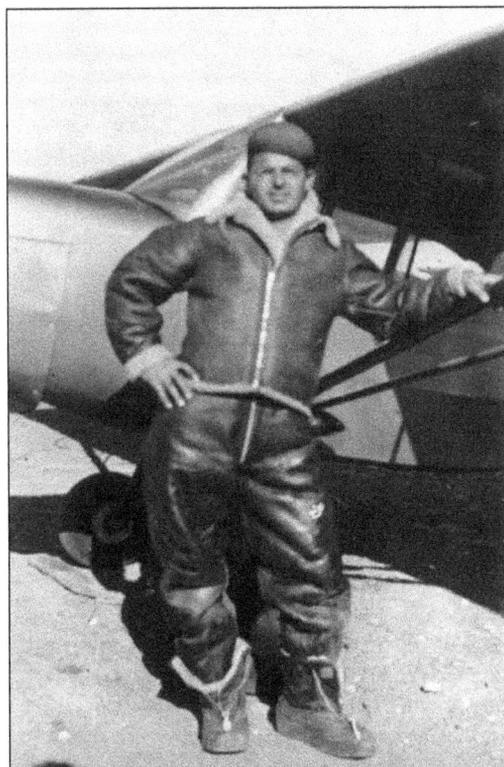

GEORGE PICCIRILLO. Sgt. George Piccirillo served in the Air Corps Ground Service during the war. He met his brother Pfc. Joe Piccirillo on January 17, 1945, for the first time in three years while on duty in France. According to their parents, it was the greatest surprise of their lives. (Courtesy of Sandy Piccirillo McFarland.)

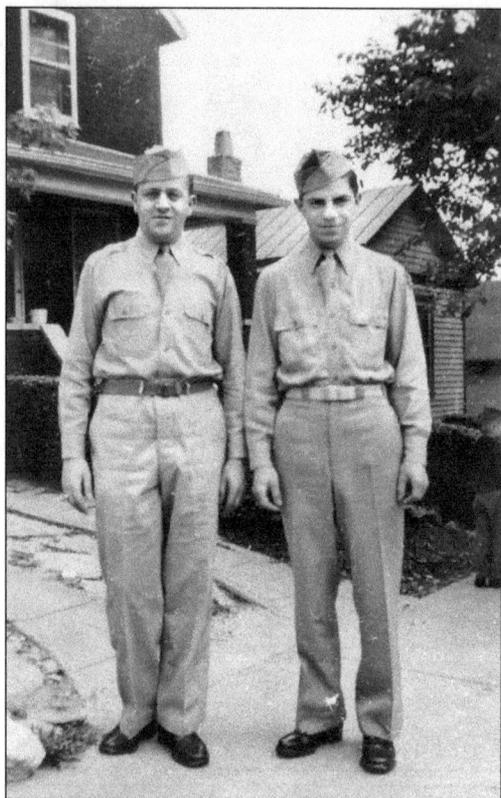

PALMER AND PETE LEDONNE, 1948. Palmer (at the left) was drafted to serve in the army during World War II. He participated in the Battle of Ardennes, commonly called the Battle of the Bulge, which was the largest land battle in the history of the U.S. Army. It began on December 16, 1944, and continued until January 25, 1945. Pete entered the army after the war and served stateside and in Germany. (Courtesy of Mary Dilillo.)

TEC5 HENRY "JOHN" LEDONNE. John served with a port battalion in the army for two and a half years at the Port of Khorramshahr, Iran. He was killed on April 2, 1945, by a lift machine while checking vital cargo at the port. His body was laid to rest at the American Cemetery at Tehran, Iran, and later returned home. (Courtesy of Mary Dilillo.)

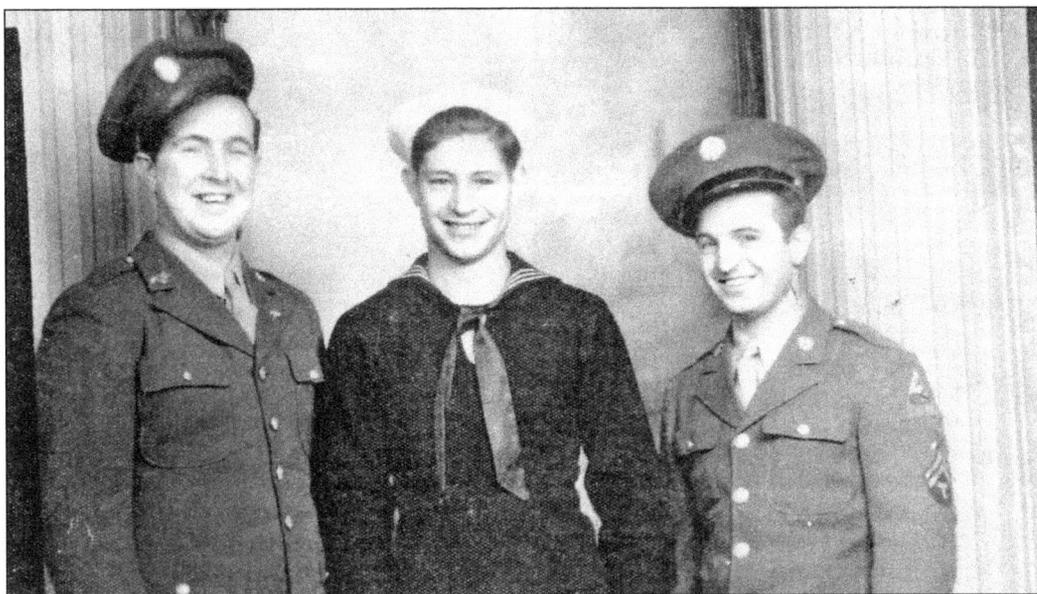

GUIDUGLI BROTHERS IN WORLD WAR II. The Guidugli brothers, shown from left to right, are Gino, Joe, and Mike. Gino served in the U.S. Army as a guard at a prisoner of war camp located in Camp Boric, Texas. Joe, while serving in the U.S. Navy, was a cook for the Air Corps and stationed at Elizabeth, North Carolina, and Norfolk, Virginia. Mike served with the U.S. Army Signal Corps with both the 45th and 36th Infantry Divisions. He was stationed in Luxembourg. (Courtesy of Sr. Maddalena Guidugli, CDP.)

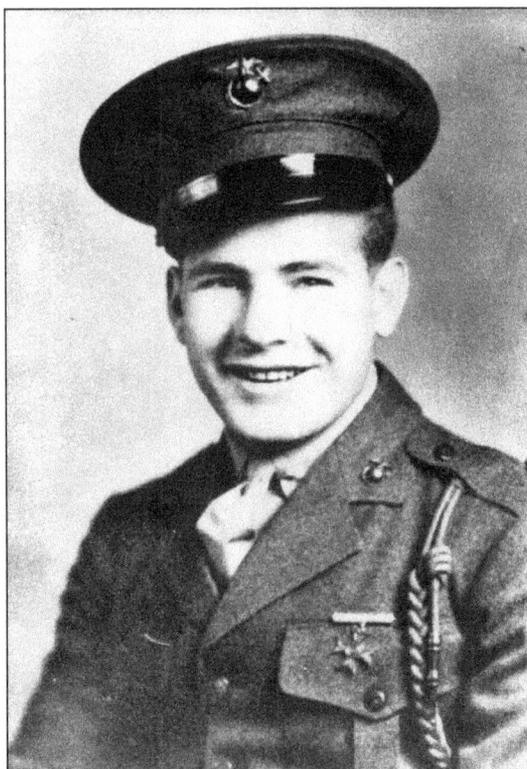

PFC. DAVID ANTHONY GUIDUGLI, U.S. MARINE CORPS, C. 1941. Pfc. David Guidugli fought with honor with the 22nd Marine Regiment in the Battle of Eniwetok under the command of Col. John T. Walker, a campaign that lasted from February 17 through February 23, 1944. He was killed in action on February 22, 1944. David was brought home and buried on March 5, 1948. (Courtesy of Sr. Maddalena Guidugli, CDP.)

THE GIGLIA FAMILY IN WORLD WAR II.
Army captain Anthony "Tony" R. Giglia, M.D., (above left) met 1st Lt. Pearl A. LaViolette, R.N., (pictured) while stationed in Manila. They were married on October 12, 1946. Cpl. Rose Giglia (above right), a former teacher, enlisted in the Women's Army Corps (WAC) and was one of over 150,000 women who were not nurses to serve in the army during World War II. While attending Xavier University, Jim Giglia (next to Rose) was drafted and sent to dental school at the University of Louisville. Cmdr. Jim Giglia then served stateside in the navy. After the war, Jim set up his dental practice in Fort Thomas. An experienced mining engineer, Sgt. Frank Giglia (left) was drafted and stationed in Amarillo, Texas, from 1943 to 1944 to teach field system training classes. After the war, Frank attended Xavier University under the G.I. Bill then went on to the University of Louisville for dentistry. Upon graduation, he established his practice in Bellevue. (Courtesy of Terri Giglia Babey and Fay Giglia.)

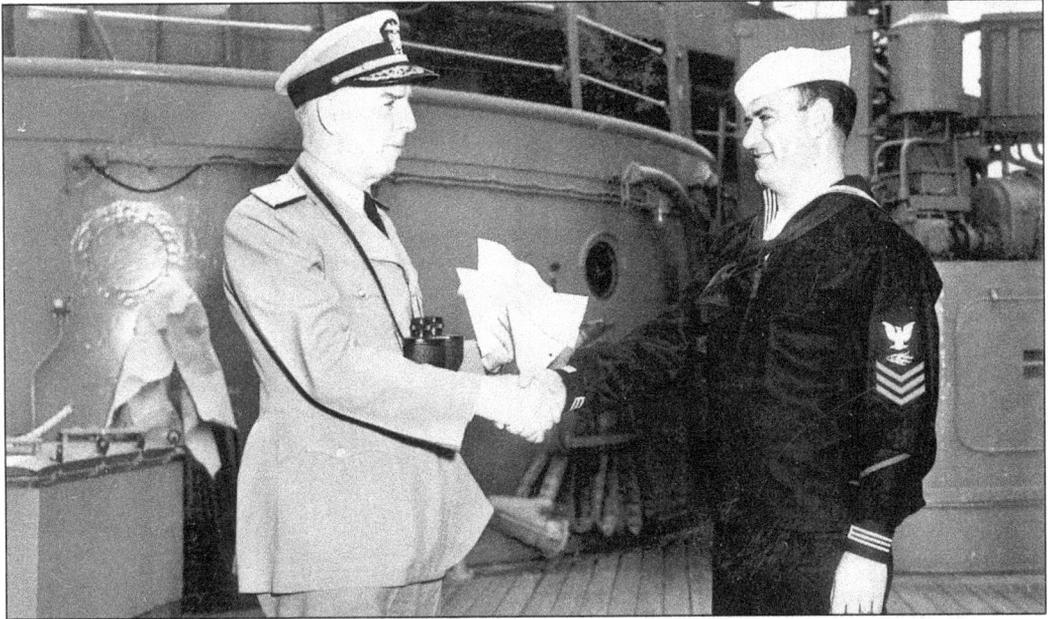

HENRY N. FORTE JR. IN KOREA, 1951. Radioman Henry Forte Jr. (right) was recalled to serve during the Korean War aboard the ship USS *Manchester* with the Pacific Fleet. On May 14, 1951, he was presented with a letter of commendation from Rear Adm. Allen E. Smith for exceptional performance of duty and a commendation medal for bravery in action. The ceremony was held aboard the flagship USS *Prairie*. (Courtesy of the Forte family.)

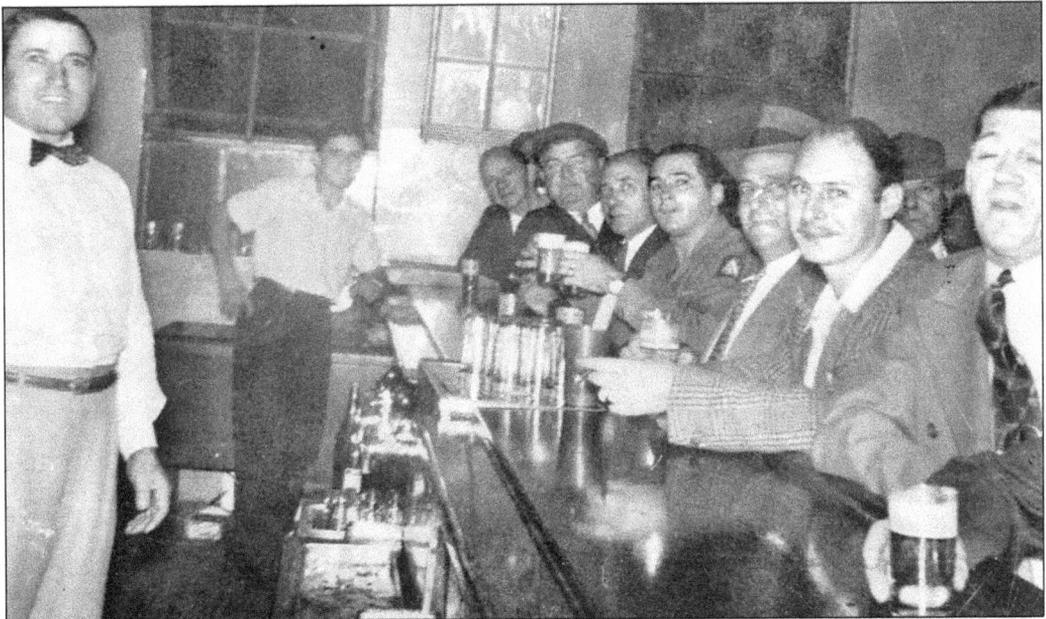

SAM SANTINI'S BAR AND RESTAURANT, NOVEMBER 27, 1945. Having a drink with the boys is Joe Raniero while home on leave from the army. Shown in the photograph from left to right are owner Pasquale "Sam" Santini, his son Anthony (both behind the bar), Carl Huck (across from Anthony), Clifford Scheid, Pete Petroze, Joe Raniero, Anthony Digiacomo, Michael Piccirillo, Chris Weber (in the background), and Wilber Schoo. (Courtesy of Sandy Piccirillo McFarland.)

Pfc. Pete Petracco in World War II. Pete was born to Enrico "Henry" and Antoinette Gallo Petracco at 108 Fifteenth Street in Clifton in 1923. He was 19 years old when he served in the U.S. Air Force Ground Crew. Pete's unit would follow Gen. George S. Patton across Europe, taking over the operations of captured airfields. In 1951, Pete established his home remodeling business in Fort Thomas. (Courtesy of Pete Petracco.)

Pfc. Nick Forte Jr. While in Kure, Japan, on October 26, 1945, Nick wrote to the *Hill Top Herald* of his experience viewing the devastation of Hiroshima after the atomic bombing of the city: He was one of a hundred soldiers who got to go that day by convoy, and upon entering the city, the hollering and talking by the guys in the trucks previously "made a silence that was hard to hear." (Courtesy of Gayle Forte Groeschen.)

THE HILL TOP HERALD
THE SERVICEMEN'S PAPER
SOUTH NEWPORT, KY.

Eugene Giancola, Editor

Miss Lillian Gilb
Associate Editor

Volume 2 Issue 5 March 11, 1945 Published Monthly

THE INFANTRY

THE INFANTRY, TERMED THE BACKBONE OF THE ARMY, IS THE MAIN FIGHT-
ING PART OF ANY ARMY. IT FIGHTS ON FOOT AND IN TANKS. IN BATTLE
INFANTRY USUALLY HAS THE MAIN TASK. AN INFANTRY DIVISION IS A
LARGE COMBAT UNIT MADE UP OF A NUMBER OF DIFFERENT ARMS AND SERVICES,
BUT THE LARGEST AND THE FUNDAMENTAL PART OF ITS FIGHTING STRENGTH
CONSISTS OF INFANTRY. THE TRIANGULAR (STREAMLINED) INFANTRY DIVISION
CONTAINS THREE INFANTRY REGIMENTS, TWO REGIMENTS OF SUPPORTING FIELD
ARTILLERY, ONE BATTALION EACH OF ENGINEER, MEDICAL, AND QUARTER-
MASTER TROOPS, AND A COMPANY OF SIGNAL CORPS TROOPS. THE SQUARE
DIVISION CONTAINS TWO INFANTRY BRIGADES, EACH OF TWO REGIMENTS, A
BRIGADE OF THREE REGIMENTS OF SUPPORTING FIELD ARTILLERY, QUARTER-
MASTER, AND MEDICAL TROOPS, AND SMALLER UNITS OF ORDNANCE AND
SIGNAL CORPS SPECIALISTS. CAVALRY, AIR CORPS, AND CHEMICAL WARFARE
UNITS, AND ADDITIONAL TANKS, FIELD ARTILLERY, AND ENGINEERS, ARE
OFTEN ADDED TEMPORARILY. ALL OF THESE OPERATE TO SUPPORT THE
INFANTRY FIGHTING EFFORT. THE CHIEF WEAPONS OF INFANTRY ARE THE
SHOULDER-RIFLE WITH ITS BAYONETS, THE TANK, AND THE MACHINE GUN.
OTHER INFANTRY WEAPONS, ALL OF THEM IMPORTANT IN WARFARE, ARE THE
HAND GRENADE, THE CALIBER .30 AUTOMATIC RIFLE, THE PISTOL, THE
CALIBER .50 AND THE 37-mm. (ANTITANK) GUNS, AND THE 60 - AND 81-mm.
MORTARS.

CIVIC ASSOCIATION ELECTS OFFICERS

The newly elected officers of the Ky. Drive Civic Association are:
President, Edw. Graf; Vice President, Wm. Nueslein; Financial
Secretary and Treasurer, Harry Kessel; Recording Secretary, C. A.
Hirmer; Sgt. at Arms, Chris Gehlker; and, Trustees, Adolph Graf,
Henry Swope, and Norb. Godfried. The installation of officers will
be held at their meeting, March 29, 1945.

THE HILL TOP HERALD, 1945. The *Hill Top Herald* was Eugene Giancola's idea of a way to keep area servicemen informed of what was going on at home and abroad during World War II. With a mimeograph machine located in the basement of his home, he created and mailed 350 newspapers overseas, and they distributed many more within the community, sharing all sorts of news. The paper grew from two pages to six during the three years of its existence. (Courtesy of Vickie and Gerry Greco.)

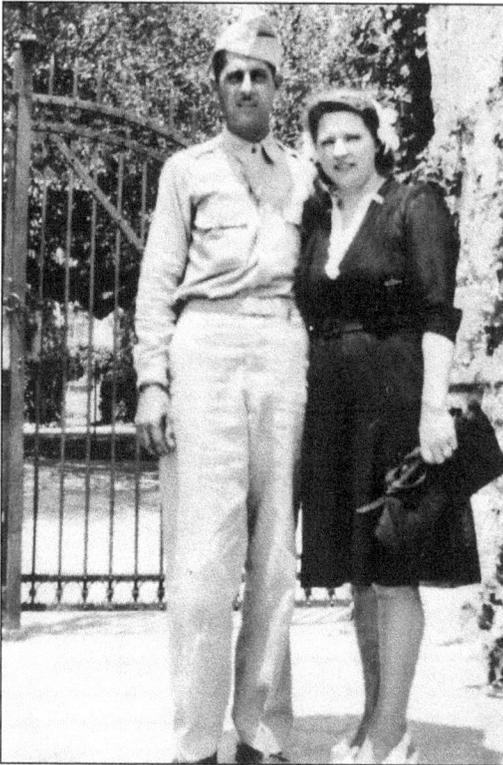

PFC. VICTOR "TODDY" GRECO AND DOROTHY MUEHLENHARD WEDDING, 1945. Toddy and Dorothy were married at Camp Clairebourne, Louisiana, by the camp chaplain. Toddy was stationed there for advance basic training in preparation for foreign service. He was in the army's military police and had been serving since May 11, 1942. The newlyweds spent a 21-day furlough in South Newport. They lived at 221 Main Avenue in South Newport. (Courtesy of Vickie and Gerry Greco.)

JOHN AND TONY GALLICCHIO IN WORLD WAR II. John (at the left) served with the Army Corps of Engineers, and Tony was a baker in the navy. During the war, it became known that Tony's ship was transporting his brother John. The navy had a policy not to have family members on the same ship; therefore, Tony was given the responsibility of seeing that nothing happened to his brother. (Courtesy of Bob Bramel.)

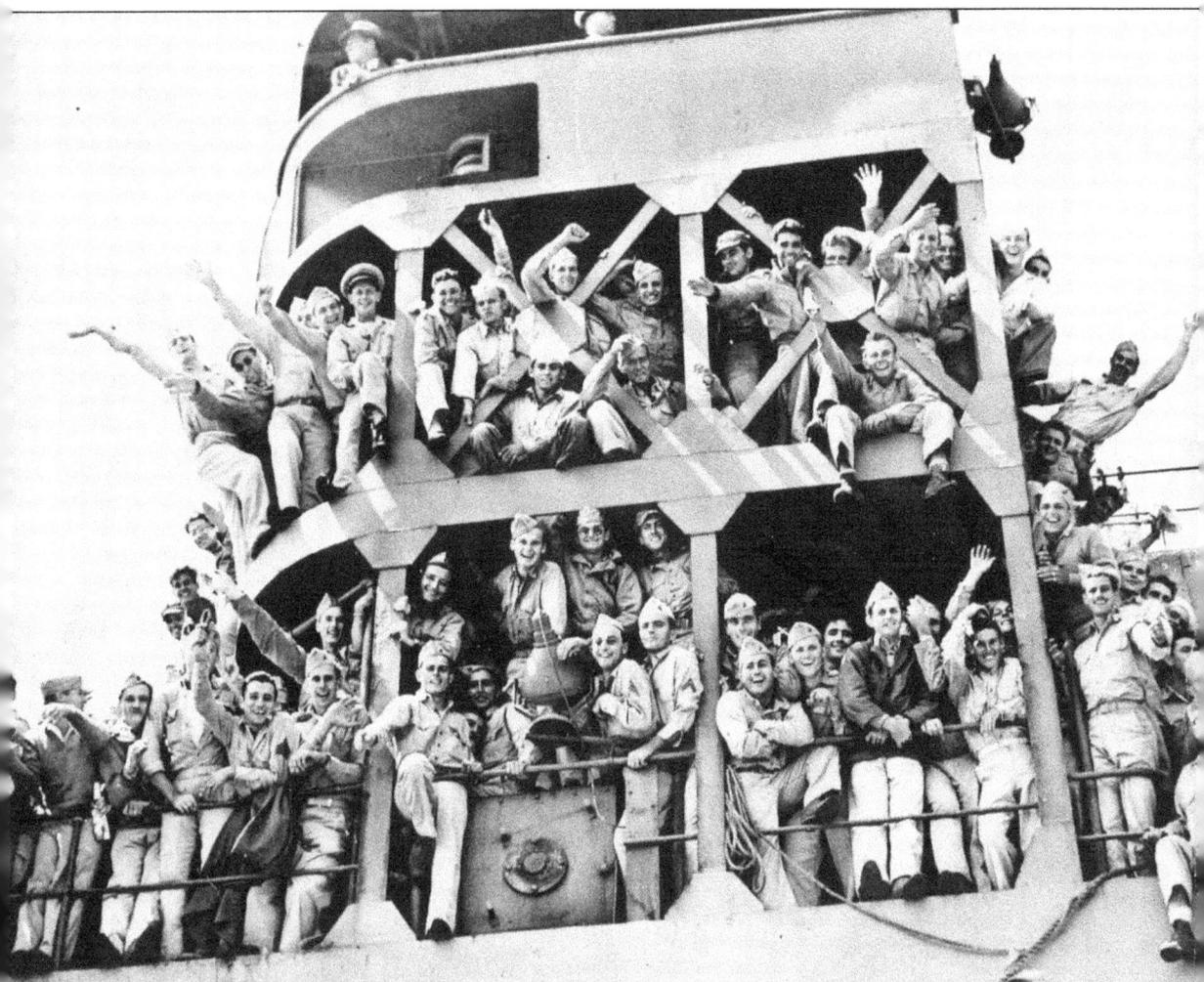

COMING HOME, 1944. The 1st Marine Division, Reinforced, under the command of Maj. Gen. Alexander A. Vandergrift, arrived in San Diego Harbor after completing 26 months of fighting in the South Pacific during World War II. S.Sgt. Patrick J. Ciafardini fought at Guadalcanal and the British Solomon Islands. His family first learned of his return when this photograph appeared in the *Sunday Enquirer* newspaper. Pat is located at the bottom left, fifth from the end, waving with his hat in hand. Pat finished his active duty on February 14, 1946. After the war, Pat went to work for the City of Newport Police Department, retiring in 1972 as chief of detectives. (Courtesy of AP/Wide World Photos.)

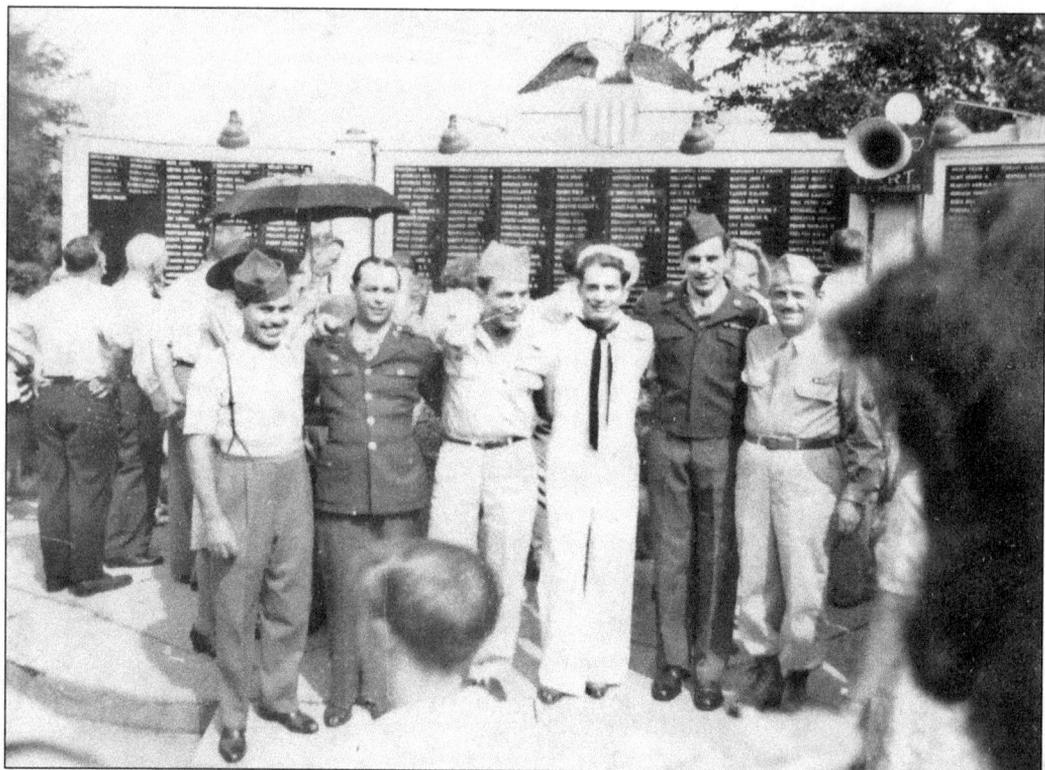

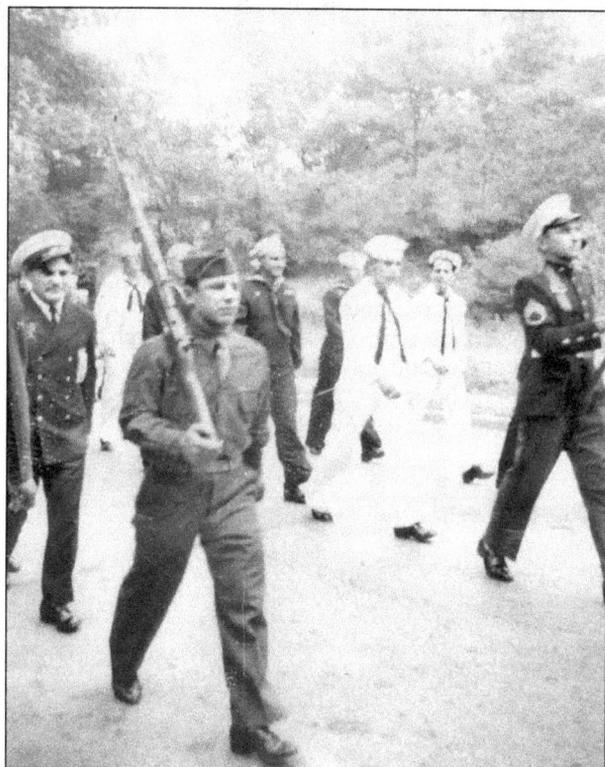

WELCOME HOME PARADE. The World War II veterans from South Newport participated in a parade celebrating the end of the war and their arrival home. In front of the South Newport Honor Roll are, from left to right, Albert Barone, Ervin Wedmore, Mike Barone, Bill Barone, Pete Petracco, and Frank Sidari. At left, the veterans identified are Louis Raniero Sr. holding the rifle, Frank Guerrea marching behind him (far left), and Pat Ciafardini (far right). After the war, Albert worked for Hyde Park Clothes, and Mike and Pete returned to State Floor Covering. Bill worked in heating and air conditioning, and Frank Sidari made cabinets in Cincinnati. Frank Guerrea, also known by his professional boxing name of "Midge Guery," sold insurance; Louis Sr. served on the City of Newport Fire Department, retiring in 1975 as assistant fire chief. (Courtesy of Mike Barone.)

Seven

LEGACY

In the course of a lifetime, a legacy is left behind for the following generation. As Americans, we tend to think that a legacy has to be something tangible in the form of a building, or monument, or an institute of learning. While those things are important and often accomplished, the legacy of the Italian immigrants was that through hard work and perseverance they could experience a better life. The example set forth by them, from the sheer courage shown as they journeyed to America, to insisting on a formal education for their children, enabled them to see achievements they never would have thought possible.

Ordinary people doing ordinary things built the communities in Northern Kentucky. The Italians who settled in Newport and Northern Kentucky achieved the American dream. From the time they set foot on American soil, they wanted to fit in and to be Americans. It was worth the time and sacrifices it took to make America their home. But while wanting to be Americans, they never wanted to lose their Italian heritage, so it was important to preserve the core of what it meant to be Italian.

The area's Italian heritage has been publicly celebrated, from Columbus Day in the late 1800s to Italian Day at Coney Island in the mid-1950s, and for the past 15 years, through the City of Newport's Italianfest, a four-day festival. Families from all over the tri-state area come to celebrate the music and food and to enjoy the camaraderie of meeting with family, friends, and neighbors of years gone by. The legacy of life—of understanding how one life touches another—creates a legacy that far outlasts anything material, because in the end, it is not what we have accomplished but who we really are and what we stand for.

MADDALENA GIANCOLA WITH HER DAUGHTERS AND ARCARO GRANDCHILDREN. The humble beginnings of the legendary jockey George Edward "Eddie" Arcaro are shown in this photograph. Pictured are from left to right are Maddalena Giancola (Eddie's grandmother), Eddie's sister Evelyn on her lap, Maddalena's daughter Mildred behind her, Eddie, and his mother, Josephine. (Courtesy of Madelyn Lehr.)

EDDIE ARCARO FAMILY PHOTOGRAPH, C. 1948. For many years, Eddie visited his family the day after the Kentucky Derby. His mother and grandmother would prepare an Italian feast, especially chicken cacciatore, Eddie's favorite. Family members from left to right are Charles Wehry, Josephine Giancola Arcaro Wehry (Eddie's mother), Ruth Arcaro (Eddie's wife of 50 years), Joanne Mospins (daughter of Evelyn and Johnny Maggio), Maddalena Giancola (Eddie's grandmother), Eddie Arcaro, Mildred Giancola Lehr, Madelyn Lehr, Johnny Maggio, Evelyn Arcaro Maggio (Johnny's wife), Helen Arcaro (Eddie's sister), and Pat Arcaro (Eddie's father). (Courtesy of Madelyn Lehr.)

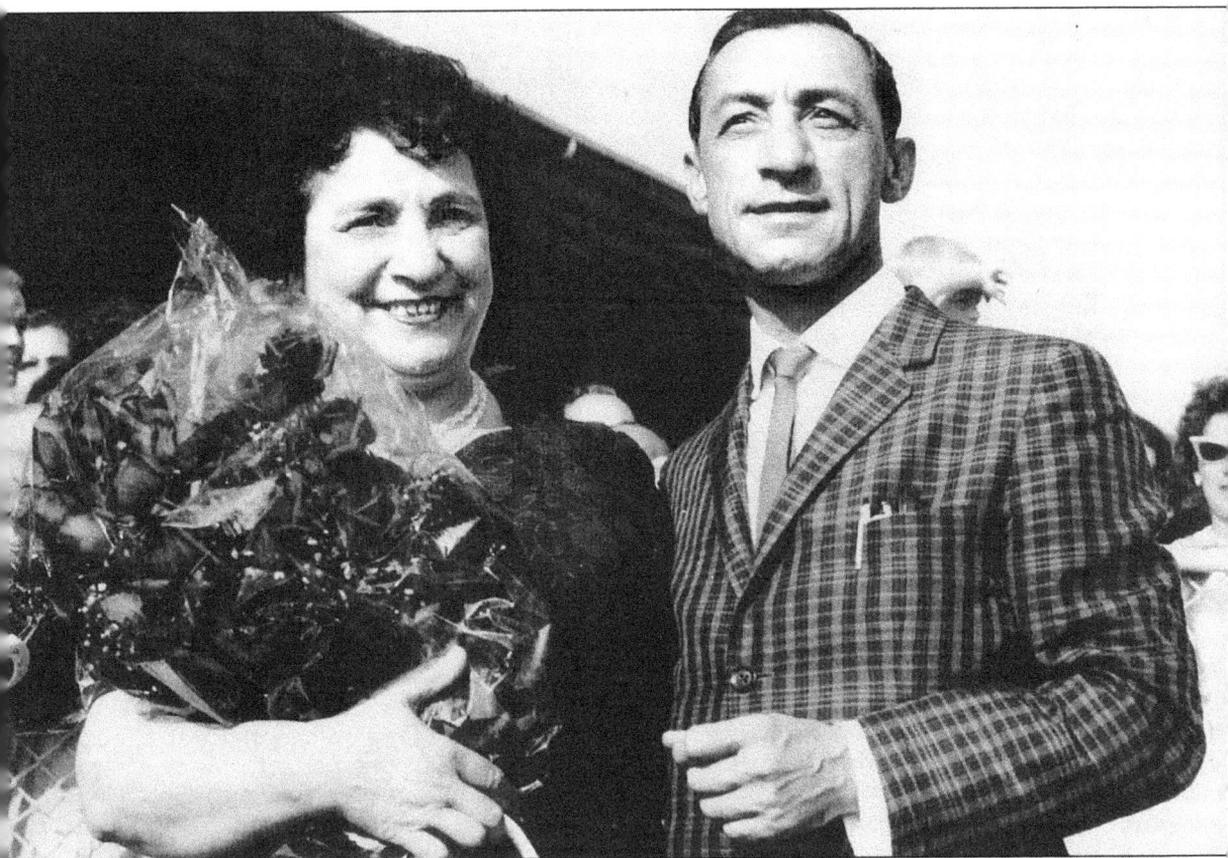

River Downs Race Track in Cincinnati, Ohio, 1962. This time the roses were for Josephine Giancola Arcaro Wehry and not her famous son, Eddie Arcaro. Eddie was born on February 19, 1916. He quit school when he was 14 years old to pursue his love of horses. During his career, he won five Kentucky Derbies, six Preakness Stakes, and six Belmont races. He made history as the only jockey to ride two Triple Crown champions, Whirlaway in 1941 and Citation in 1948, both from Calumet Farm in Lexington. His Kentucky Derby win in May 1948 landed him on the cover of *Time* magazine that month. Eddie, often called the "Master," rode the last Triple Crown winner (Citation) until Secretariat in 1973. He was inducted into horse racing's hall of fame in 1958. Eddie retired from horse racing in the spring 1962 at the age of 46. His total purse winnings were over $30 million. He remains one of the most famous athletes from the Northern Kentucky area. (Courtesy of Madelyn Lehr.)

ANUZZA "NUZZA" GAMMERI AND ANTONIO SILLA GIGLIA, C. 1946. Nuzza and Antonio met while Nuzza was harvesting olives from the trees and Antonio was working on the road in the town of Sinagra, Sicily. They married on November 15, 1906, and shortly thereafter came to America. Antonio settled in West Virginia and worked in the coal mines of Glen Jean. Nuzza met him there, and together they operated a general store from 1914 through 1945. They are pictured in front of an unused coal house. (Courtesy Fay Giglia.)

OSWALD, WEST VIRGINIA, JULY 16, 1942. Antonio Giglia is the first man from the left in the second row. This photograph was taken just as the miners were entering the mines. Antonio came to Kentucky for one year after he retired from mining. Unable to adjust to the area, he and Nuzza returned to West Virginia until his death in 1947. Nuzza moved to Kentucky in 1950 to live with her daughter Rose, who owned the White House Delicatessen in Bellevue. (Courtesy of Fay Giglia.)

116

GIGLIA FAMILY, C. 1950. Family members from left to right are (first row) Mary Ann, Nancy, Nuzza, Yons, and Rose; (second row) Frank, Jim, Tony, and Charlie. Although Antonio never learned to read or write, he knew the value of an education and insisted that his children complete their education at least through high school. Encouraged to pursue their dreams, five of the Giglia children went to college; all but Charles and Nancy lived out their adult lives in Kentucky. (Courtesy of Fay Giglia.)

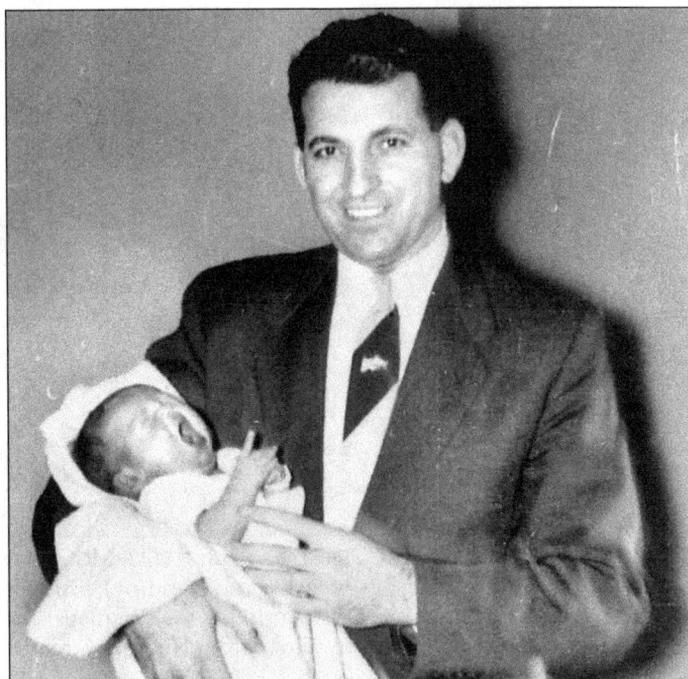

DR. ANTHONY ROBERT GIGLIA II, M.D. After World War II, Dr. Anthony Giglia served as the first board-certified OB/GYN in Northern Kentucky. He was on the founding staff of St. Luke Hospital. Dr. Giglia delivered three out of his four children and loved bringing life into the world. Dr. Giglia delivered his last baby on June 18, 1979. (Courtesy of Terri Giglia Babey.)

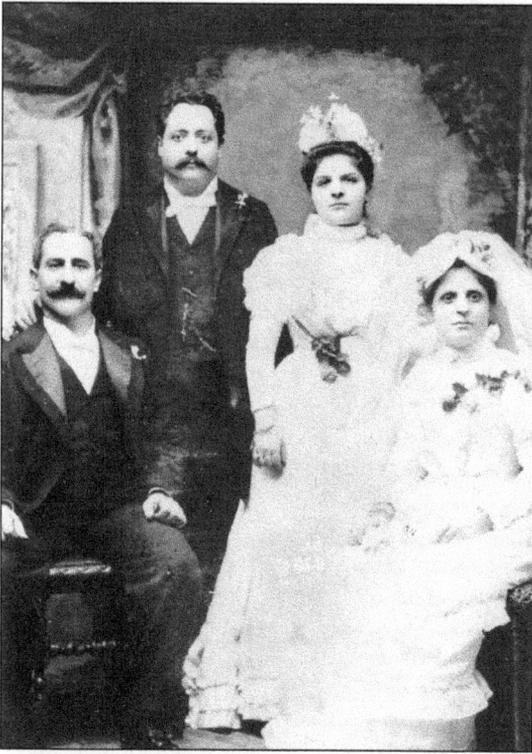

WEDDING OF PIETRO "PETER" CETRULO AND STELLA GAGLIARDI, MAY 7, 1899. Seated are the bride and groom with their witnesses, Antonio Delvecchio and Maria Passafiume. Peter Cetrulo emigrated from Caposele, Italy, a small mountain village near the city of Avellino, Avellino, Campania. He became a naturalized citizen in 1889. After marrying, Stella and Peter settled in Covington, where Peter operated the Covington Barbershop on Court Street. They raised three children, Frank, Camillo, and Rose. (Courtesy of Robert C. Cetrulo, J.D.)

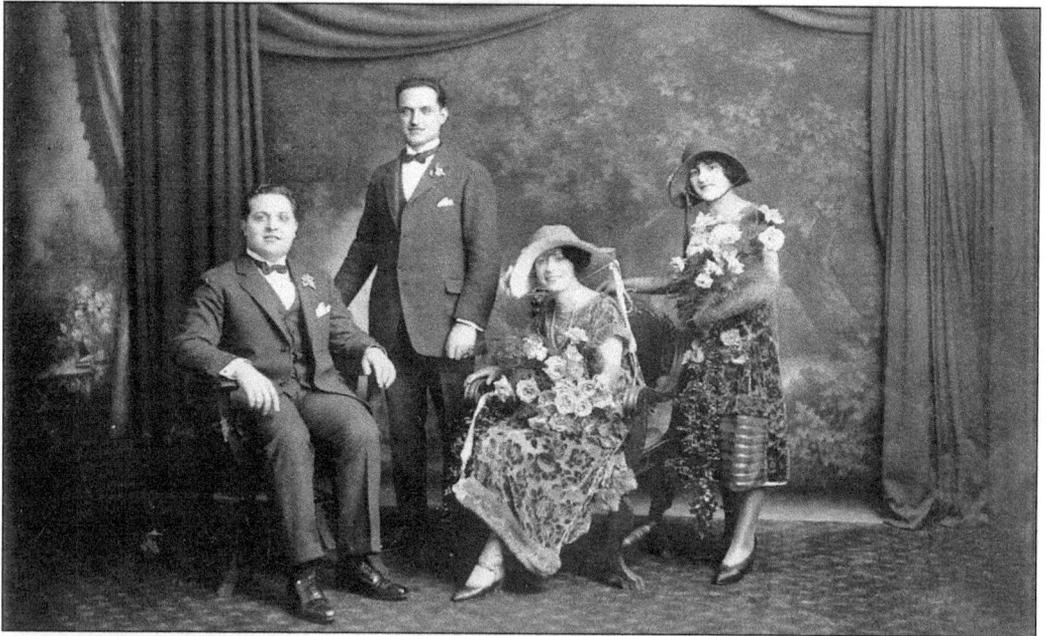

MARRIAGE OF CAMILLO A. CETRULO AND ESTELLE MCGRATH, DECEMBER 27, 1924. Angelo Laruso and Camillo's sister Rose Mary (both standing) witnessed the Cetrulo wedding. Camillo was in the retail furniture business, serving as sales manager for the Ostrow Furniture Company at Eighth and Madison Streets in Covington, Kentucky, for over 40 years. (Courtesy of Robert C. Cetrulo, J.D.)

ATTORNEY ROBERT C. CETRULO, J.D., OF KENTON COUNTY. Robert, the son of Camillo and Estelle Cetrulo, has served 47 years in a legal career in which he has served as president of the Kenton County Bar Association, and for a period of 15 years, he was a United States Magistrate Judge for the Eastern Judicial District of Kentucky at Covington. He founded the Northern Kentucky Right to Life Committee, serving as its president. He wrote the book *That Reminds Me of a Story . . . Reflections of Pro-Life Warrior.* (Courtesy of Robert C. Cetrulo, J.D.)

SANCTUARY OF ST. GERARD MAJELLA CAPOSELE, AVELLINO, CAMPANIA, ITALY, JULY 8, 2006. St. Gerard is the Roman Catholic patron saint of mothers and unborn children. It is believed that prayers by the faithful asking for his intercession before God to grant motherhood or a safe delivery are often answered. Such was the case of Philip Gerard and his mother, Alma Ciafardini. Phil served the citizens of Newport for 22 years, ending his career as city manager of Newport in November 2005. (Courtesy of the Ciafardini family.)

SR. MADDALENA GUIDUGLI, CDP. Sister Maddalena was born on January 14, 1929, to Giuseppe and Maddalena Monti Guidugli. Sister Maddalena entered the Congregation of Divine Providence (CDP) on September 8, 1953, and made her final profession of vows on August 29, 1960. She received a bachelor of arts degree from Villa Madonna College in 1961 (now Thomas More College) and a master of education degree from Xavier University in 1966. Through her ministries, she has served the needs of others within the community. (Courtesy of Sr. Maddalena Guidugli, CDP.)

SR. MADDALENA GUIDUGLI AND POPE JOHN PAUL II. Sister Maddalena, on a five-month sabbatical in 1988, had the opportunity to meet Pope John Paul II along with visiting her relatives in the area. Sister Maddalena brought her love of genealogy to the City of Newport Italianfest by establishing a photograph exhibit with family histories that showcased some of the original Italian families who settled in Newport. She continues to encourage Italian Americans to research their Italian genealogy and roots. (Courtesy of Sr. Maddalena Guidugli, CDP.)

ITALIAN DAY AT CONEY ISLAND, 1955. Italian Day was an annual event held at the pavilion area of Coney Island beginning in the 1950s. Members of the Italian societies from Northern Kentucky and Cincinnati met and planned for the day's activities. Pictured here from left to right are the Ciafardini children, Pam, Pat, and Tony, with Eugene Giancola. (Courtesy of the Ciafardini family.)

CONEY ISLAND FERRY. Although this photograph is undated, it is believed it was taken in the late 1940s or 1950s. Northern Kentuckians would board the ferry and be transported to the Rivergate at Coney Island. On Italian Day, laundry baskets full of food would also be transported along with families to the gate and then on to the pavilion for the day's festivities. (Courtesy of the Carlisle family.)

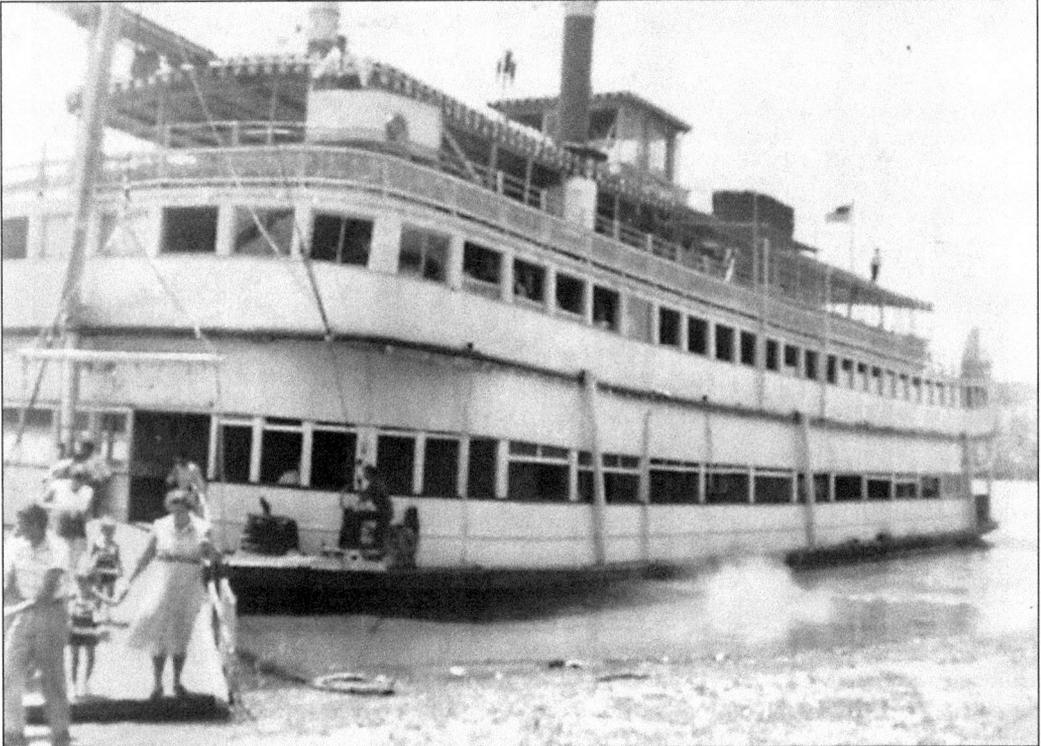

ITALIANFEST POSTER, 2002. The City of Newport Italianfest was the idea of Mayor Thomas L. Guidugli and Vice Mayor Jerry Peluso. The first event was held in June 1992 and has continued for the past 15 years. The posters for the past several years have been the creation of Newport resident Rick Mariani. (Courtesy of Rick Mariani.)

PAMELA CIAFARDINI CASEBOLT WITH GRANDCHILDREN, 2004. Italianfest is a family event with weekend activities for everyone. Pam, who served on the 2004 City of Newport Italianfest Committee, is shown offering candy to her grandsons Patrick Joseph Collins (left) and Micah J. McGrath. (Courtesy of the Ciafardini family.)

IN MEMORY OF ANNA CARLISLE. Anna Carlisle was born to Italian immigrants Virginia Vaspasian and Nicholas Funaro in Youngstown, Ohio. After her father was killed in a steel mill accident there, her mother married Italian immigrant James Chilelli and later moved to Newport. Anna was devoted to St. Vincent de Paul Parish and proud of her Italian heritage. She is lovingly remembered every year at the City of Newport Italianfest. (Courtesy of City of Newport Italianfest.)

In Memory of Anna Carlisle

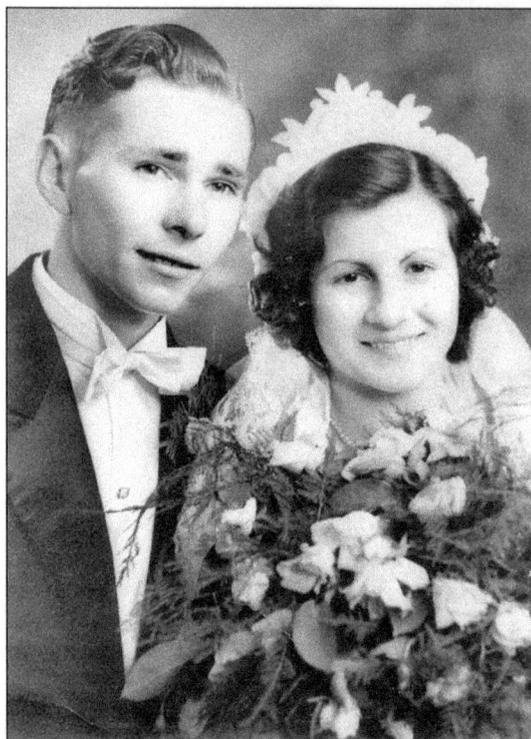

GRIFFIN AND ANNA CHILELLI CARLISLE WEDDING, JULY 4, 1936. Griffin and Anna were married at St. Vincent de Paul Church. Their first home was at 429 West Thirteenth Street in Newport. In 1964, the family moved to Highland Heights. In the early years, Anna worked for a tailoring shop in Cincinnati. Griffin, of English descent, established a hauling business. (Courtesy of the Carlisle family.)

CARLISLE HAULING. Griffin Carlisle owned two dump trucks in the early 1930s and hauled dirt as a sideline. The business grew, and under the leadership of his son Wayne (sitting on the truck), it became a multimillion-dollar business. Wayne is a very prominent and active leader in the Northern Kentucky community and played a major role in the revitalization of Newport. (Courtesy of the Carlisle family.)

THE CARLISLE FAMILY. Wayne Carlisle, recognizing that peace begins at home and in our schools, financed the World Peace Bell and brought it to Newport for everyone to enjoy. Shown from left to right are Griffin, his daughter Beverly, and his son Wayne. (Courtesy of the Millennium Monument Company.)

WORLD PEACE BELL ARRIVAL, C. 1999. The World Peace Bell is the largest swinging bell in the world. Located in Newport, the bell weighs 73,381 pounds and is 12 feet in diameter; it is made of 80 percent copper and 20 percent tin. The bell was cast by Paccard, a foundry near Nantes, France. Cast-Fab Technologies, Inc., made the striker and swinger used to ring the bell. The IT Verdin Company oversaw the project. (Courtesy of the Millennium Monument Company.)

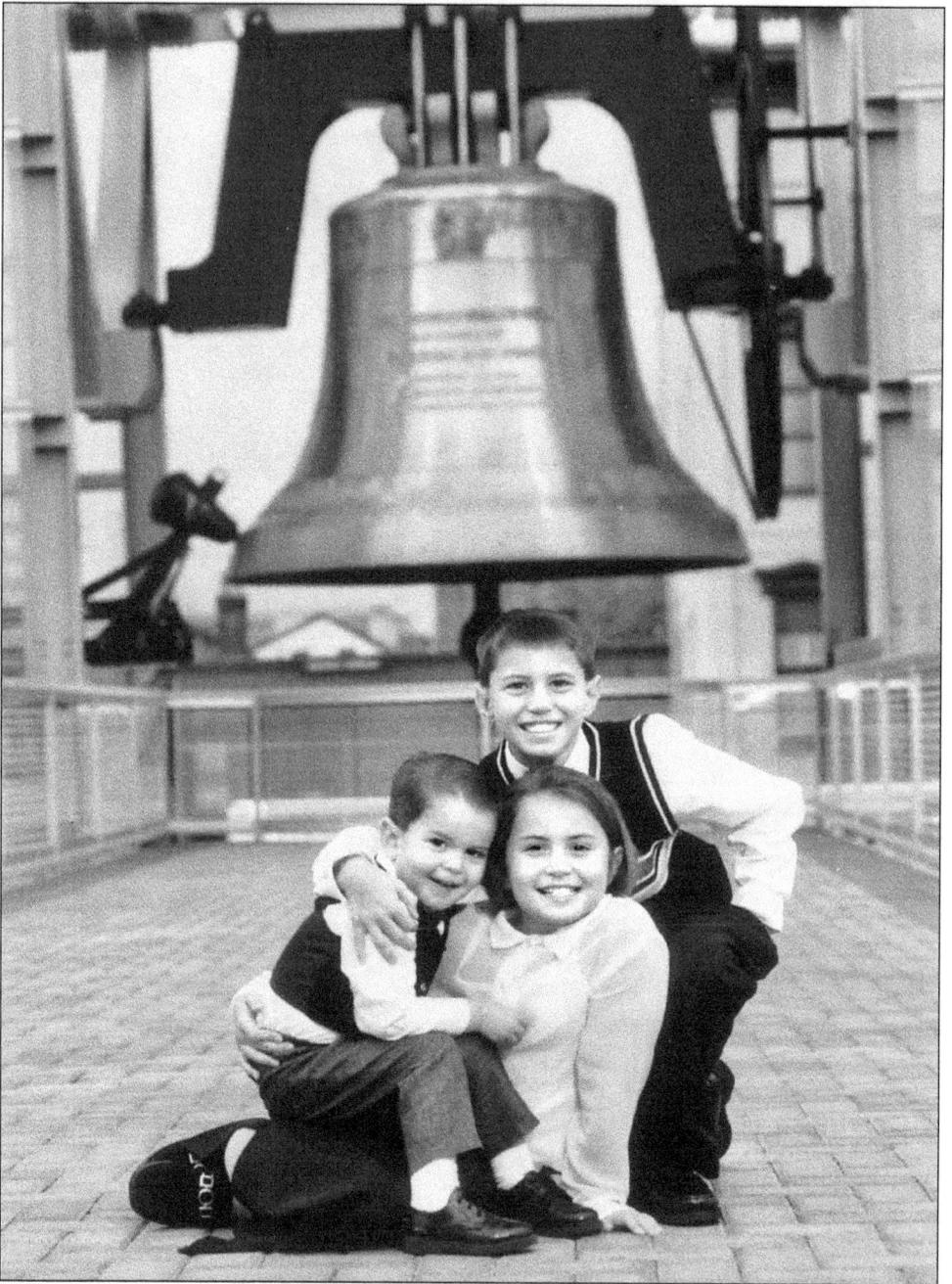

WORLD PEACE BELL, 2000. The World Peace Bell includes four small pictures on the front representing harmony, technology, exploration, and invention, and three small pictures on the back of the bell representing exploration, creativity, and leadership. The large front picture (not shown) of the World Peace Bell includes three children of different cultures holding hands, standing on a depiction of the world, symbolic of harmony critical to our future. The World Peace Bell serves as a symbol of freedom and peace, honoring our past, celebrating our present, and inspiring our future. Pictured here are third-generation Italian Americans Vincent and Christine holding Dominic, the children of Phil and Mary Rawe Ciafardini. (Courtesy of Mansion Hill Studio.)

BIBLIOGRAPHY

Digital History: Using New Technologies to Enhance Teaching and Research. University of Houston. www.digitalhistory.uh.edu.

Forte, Henry, interview. Fort Mitchell, Kentucky, March 8, 2006.

Gassmann, Karen Pompilio, interview. Alexandria, Kentucky, June 13, 2006.

Heyman, Neil M. *World War I.* Westport, CT: Greenwood Press, 1997.

Hickey, Michael. *Essential Histories: The First World War.* Vol. 4: *The Mediterranean Front 1914–1923.* Oxford, England: Osprey Publishing, 2002.

Kenton County Kentucky Library Newspaper Index. *Kentucky Post, Kentucky Enquirer, Kentucky Times Star, Cincinnati Enquirer,* and *Cincinnati Post* newspaper articles.

Lestingi, Joseph, and Mary Lee, interview. Covington, Kentucky, March 16, 2006.

Library of Congress. www.loc.gov.

Lombardo, Aldofo, interview. Alexandria, Kentucky, May 25, 2006.

National Italian American Foundation (NIAF). www.niaf.org.

Pangallo, Anthony, interview. Newport, Kentucky, April 11, 2006.

St. Vincent de Paul Parish. Church directories for the years 1960, 1970, 1980s, 1991 (the 75th Anniversary).

The Marian Library. International Marian Research Institute, Dayton, Ohio.

The Statue of Liberty–Ellis Island Foundation. www.ellisisland.org.

Reis, Jim. *Pieces of the Past.* Covington, KY: *The Kentucky Post,* (Volume 1) 1988; (Volume 2) 1991; (Volume 3) 1994.

Ryan, Rev. Paul E. *History of the Diocese of Covington, Kentucky, 1954.* Covington, KY: The Diocese of Covington, Kentucky, 1954.

United States Census Bureau. 1910, 1920, 1930, and 2000 Censuses.

Visit us at
arcadiapublishing.com